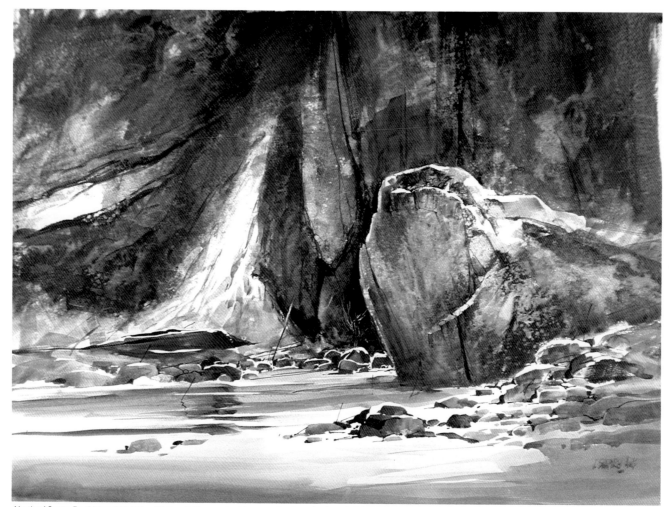

North of Santa Fe, 26″ × 34″ (66 × 86.4 cm), Crescent cold-pressed watercolor board. Private collection.

How to Make a Painting

by Irving Shapiro, AWS

President and Director, American Academy of Art

WATSON-GUPTILL PUBLICATIONS/NEW YORK

My thanks to John Krupka, who photographed the step-by-step demonstrations of paintings almost without my knowing that he was there. A few words of special and warm thanks also to Bonnie Silverstein, my editor for this book. She has proven to me how invaluable the qualities of patience and counseling can be to a fellow human.

First published in 1985 in New York by Watson-Guptill Publications,
a division of Billboard Publications, Inc.,
1515 Broadway, New York, N.Y. 10036

Library of Congress Cataloging in Publication Data

Shapiro, Irving, 1927–
 How to make a painting.

 Includes index.
 1. Watercolor painting—Technique. I. Title.
ND2420.S52 1985 751.42′2 84-27087
ISBN 0-8230-2454-7

Distributed in the United Kingdom by Phaidon Press Ltd.,
Littlegate House, St. Ebbe's St., Oxford

Manufactured in Japan

First printing, 1985

1 2 3 4 5 6 7 8 9 10/90 89 88 87 86 85

To my wife, Syril, and my children, Paula, Pete, Diane, Gail, Rhonda, Mike, and Stephen—my love and thanks to them all.

To my students, with whom I've shared such special and enjoyable painting times.

Contents

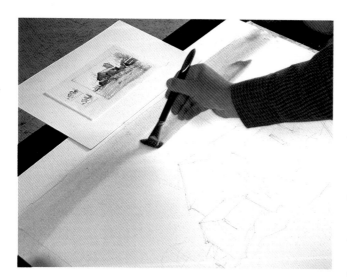

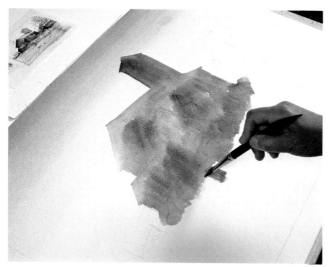

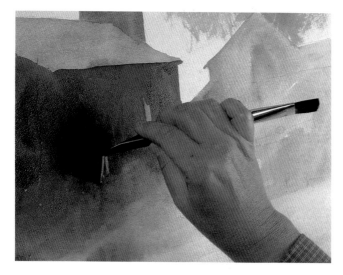

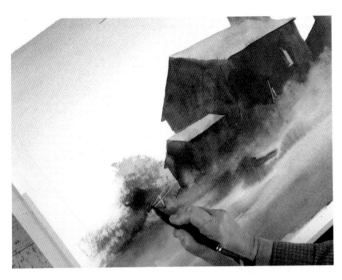

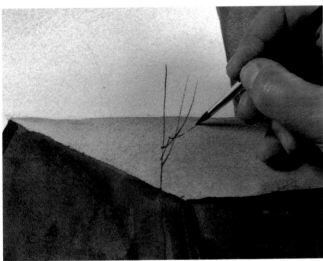

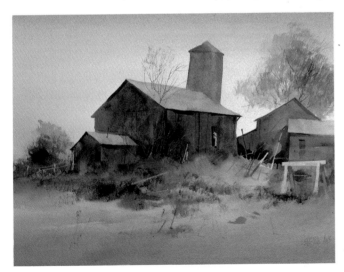

Confessions of a Teacher/Artist

After so many years of teaching at the American Academy of Art, you'd think I would have enough confidence as a teacher to feel no discomfort. Yet I don't really know who is edgier in the first few sessions—my students or I. What I see is a classroom full of eyes staring at me with unspoken but nonetheless readable thoughts. Summed up, the thoughts plead for the secrets of watercolor to be revealed. Of course, as it soon becomes distressingly obvious to my students, there are no secrets. There are, however, loads of *discoveries* ahead, and that's what makes painting in watercolor so exciting.

What, then, can a teacher do?

- A teacher can teach principles.

- A teacher can demonstrate methods.

- A teacher can try to create an atmosphere in which curiosity becomes an almost tangible energy.

- A teacher can goad and prod.

- A teacher can hope to instill a desire to reach beyond, toward what is still unknown.

But there is one thing no teacher can do. I cannot force my students to open doors to undiscovered wonders and revelations unless they eagerly want to explore.

Strange as it may sound, one of the most important encouragements a teacher can give comes from creating a feeling of dissatisfaction and discontent within the studio classroom. I don't mean dissatisfaction and discontent in a self-defeating sense. It's more an attitude in which the present moment is seen as only a prelude to something else, something beyond. Basking in past accomplishments tends to anesthetize the excitement of what remains to be explored. "Success" is not to be thought of as some shapeless goal; it should instead encompass the entire process of our development, discovery, and accompanying attitudes. In fact, what I think we ought to celebrate is our *capacity* to explore and discover!

The balance between the traditional and the new is delicate, to be sure. To start a voyage, one needs more than a sense of adventure. Unless one charts a course, one may end up not only disappointed but dispirited. It is with these thoughts in mind that I work with my students. While concepts of classic importance are observed and respected, investigating intriguing mysteries is vital to the total painting involvement.

Students come to my classes with the widest possible range of experience. But when they begin their studies with me, I tell them that I will assume that they have had no prior experience with watercolor. By assuming that they are novices, I set two kinds of stages.

First, I know that by beginning with the fundamentals of the painting experience, I will give them a more total awareness of painting, from the basics to advanced techniques. If a student is experienced, then this will be a review—*but* with a different slant from what was learned before, simply because I am a new voice expressing attitudes not previously heard. Besides, a periodic review of essentials is a great cleansing and restorative process.

Second, and of tremendous importance in my teaching method, I feel that by wiping the slate clean and asking my students to set aside their prior habits, they will find themselves more receptive to unfamiliar ideas and techniques. Of course, they will always be drawing on their previous experience, whether consciously or unconsciously. But stretching our minds to take in new ideas is one of the most important exercises that can be imagined, for it increases our ability to explore and makes us realize that

there is no limit to the possible attitudes and directions of painting.

As I said earlier, the balance between the traditional and the new is delicate. I do teach that a painter's integrity stems in good part from a recognition of and respect for the craft. Yet at almost the same time, I try to give my students a glimpse of the endless experiences and attitudes that must be explored for each painter's individual contribution to be brought into focus. I aim for the yin of resting on a secure foundation and the yang of striving for a personal statement. Thus, in my studio classroom there is a continual shifting between the anchors and the voyage. The anchors of skill and knowledge, which lend substance to students' work, combine with the personal exploration that will mark future work.

Often, in the classroom, I find myself urging, "Let's try it!" or reflecting, "Why not?" It's all too easy to seek security in fixed procedures and neatly packaged instructions. Sure, we must keep in touch with essentials, but we're going to soar only when we realize how vast the heavens are. "Be bold—adventurous—assertive." These are among my words of encouragement to students. By blending these attitudes with knowledge and skill, you will be on your way. Easy? Of course not. Practice and stubbornness, my friends . . . the magic recipe.

I've been asked many times why I've chosen to live my life as a watercolorist. I didn't deliberately decide on watercolor as my medium, any more than I decided to be right-handed. I extended . . . gravitated . . . unfolded toward watercolor, realizing that what I wanted to say in my paintings could be said only with this medium. It is watercolor that seems to mirror my painting self. The moment my watercolor brush begins to speak, no other materials exist. My absorption in the medium is complete.

I marvel at those who have cultivated virtuosity in more than one medium. I don't envy them, mind you, but I am impressed. With few exceptions, though, when an artist is involved in more than one medium, there is *one* that invariably supersedes the others in excellence. It's the same with the linguist. A linguist can often communicate quite well in more than one language or dialect, but only in one does he or she truly expound. Only in one are depths reached that reflect the speaker's soul. And that brings us back to our definition of painting. At its height, painting is an expression of knowledge and skill, with the spirit of the artist contributing profundity.

Elements of the Craft

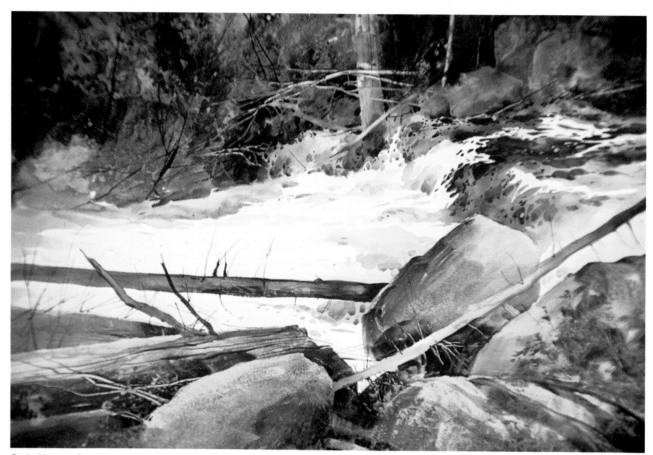

Rocky Mountain Stream, 24″ × 32″ (61 × 81.3 cm), Crescent cold-pressed watercolor board. Private collection.

Over the many years I've worked with students, I've found that it's impossible to teach the full art of watercolor. What *can* be taught is the craft—the character of materials; the concepts of composition, drawing, color, and value relationships; and certain techniques and attitudes. This is the information students need to observe, absorb, sift, contemplate, accept or discard.

When, however, we describe certain watercolor paintings as creative, sensitive, distinctive, or simply important, we are speaking of qualities that have not been taught. Artists reach these heights on their own, by evolving from what *could* be taught. The emergence of something previously undiscovered or untapped comes from within; it is not teachable. Nevertheless, this artistic flowering is generally rooted in the painter's knowledge and study of the craft.

Thus, learning the craft and developing one's skills are important, even for the "natural" artist. Just think of the giants of the music world—they could never stir us with their sounds without the hours of study and practice that lie behind their performances. Nor could writers set our hearts pounding a little faster through "mere" words without their intense involvement in their craft.

So let us look at those aspects of art that *can* be taught—the craft itself. Among the most important components in the evolution of a painting are:

- Concept
- Drawing
- Value relationships
- Techniques
- Color interpretation
- Composition

By examining these elements carefully, we'll see how each contributes to the final product and to artistic control of our visual story, the painting. Of course, another aspect of mastering our craft is knowledge of the actual physical materials we use—our paper, pigments, and brushes. For some guidelines on their character, as well as the ways they allow us to explore different interpretations, you can turn to the Appendix on Materials and Preparation at any point.

Concept

One of the most unsettling moments for every artist occurs even before a brush is picked up. It is then that you must tackle the most elusive element of painting. Something is there, waiting for you to give it form. But what is it? You need to find the concept—the idea—for your painting. Indeed, for a watercolor to become more than a mere exercise in technique, it must have a concept—a good concept.

What exactly is a concept for a painting? My dictionary defines *concept* as "a thought; that which is conceived in the mind; a general notion or idea." But how does that work for the artist? Let's look at a couple of examples.

My painting *American Mosaic* (described in detail on p. 44) translates a busy subject into an intriguing poetry of patterns. Looking at this intricate, bewildering man-made construction, what came through to me was the incredible energy of shapes, directions, overlapping dynamics—all flavored by a delicate, spidery filigree. It was from this view—this mental image—that my concept for *American Mosaic* was formed.

American Mosaic.

Colorado.

Compared with *American Mosaic*, my painting *Colorado* (discussed on p. 48) represents almost a reversal of roles. Here there was no question of discovering poetry in what others might see as an eyesore. Instead, nature's monumental presence took over and I became a tiny creature awed by its vast beauty. For me, the voice of nature was almost audible, urging, "Here is my beauty. Here is a glimpse of the eternal. Try to tell my story."

The concept is not just the content or subject matter. It's the determination of not only what story we want to tell, but how, why, and with what visual qualities and purposes. A writer does more than arrange words into comprehensible sentences; he or she orchestrates ideas, with the words serving as vehicles to carry the message and transport the reader. A musician can issue sounds, but the term *music* can't be properly applied to what is heard until these sounds have been sorted, patterned with rhythm, and designed with a tempo and mood—conveying the musician's concept.

And so it is with the artist. The very marrow of painting lies in the principles of drawing, composition, value pattern, color relationships, and technique. But it is the weaving of illusions and the offering of interpretive statements—the concept—that allow a painting to become an entity in its own right rather than simply a display of dexterity.

Drawing

The concept is the starting point. But underlying every great painting, in whatever medium or style, is the ability to draw. What do I mean by *drawing*? For me, drawing is the act of defining content, executed on a two-dimensional surface but frequently conveying a three-dimensional illusion. Drawing is the use of symbols for the eye to respond to and accept as an intended meaning. When we draw a tree, the result is, of course, not an actual tree. It is a *symbol* of a tree. As artists, what we try to create is a visual impression or message that the eye will recognize as a tree.

Taking a pencil in hand, we may choose to draw our tree with line. Line is drawing in its purest and most academic form. Yet there are innumerable ways to draw—innumerable ways to symbolize our sought-after images. With line, yes. But also with volume, as well as departures from the principles of classic realism.

Drawing ability is not simply skill in the literal translation of subject matter. Although expertise in drawing enables us to delineate what is "there," it also promises much more. Consider such drawing possibilities as manipulating form, accentuating contours, designing and juxtaposing shapes, enhancing the perspective, or creating a compositional plan that includes several levels of images. Having said this, I want immediately to add that departures from literal imagery are artistically valid only when backed by sound traditional knowledge. We must cultivate the fundamentals before exploring the mysteries and charms of what lies beyond if we intend to be more than stylists who focus on superficial concerns.

Whatever medium you choose as your drawing tool—pencil, pen, brush, or some other combination—as you arrange the elements of the chosen subject, you will also be establishing concepts of composition. In the very act of thoughtfully presenting size and shape relationships to develop and enhance visual interests, you are already designing. Moreover, to expand the imagery, you may begin to flavor the drawing with tone, establishing value relationships. Thus, drawing is both a keystone and a bridge to other important elements in the craft of painting.

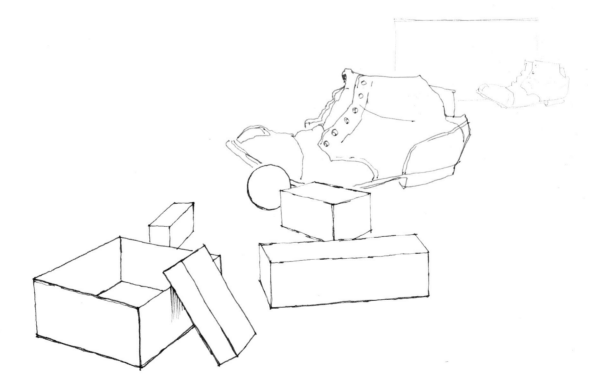

EXPLORING THE RANGE OF DRAWING

To show different drawing expressions, I've chosen a subject that's dear to my heart. This isn't just any old shoe; it's the one that was in the very first still life I drew back in my art school days a zillion years ago. Its origin has always been a mystery. Surely it belonged to a grizzled old prospector who ranged the wilds of the West. Or perhaps it covered the lucky foot of a World War I flying ace. When my family disagrees with these romantic thoughts, I reply, "If you want Cinderella's slipper, find me a glass shoe, but it wouldn't look good on my prospector or flying hero!"

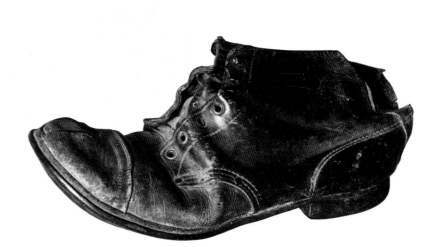

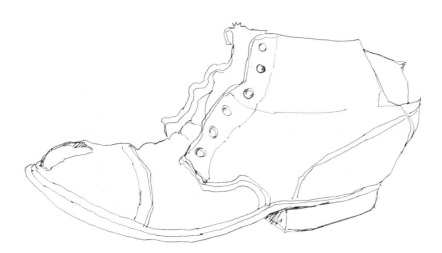

Defining Shape through Line
This contour drawing was done with a beautiful little pen called simply Le Pen, made by the Marvy company. The resulting line has a fixed weight with no thick or thin variance. The study thus focuses on the shoe's basic shape with particular attention to the character of its contour. Shape rather than personality of line is what matters here.

Using Expressive Line
As a contrast to the preceding example, this drawing was done with a Mars Graphic 3000 pen, one with a flexible pointed nib. It's as close to being a brush as any pen I've come across, and you can manipulate it to get a variety of weights. Here the contour is "lyricized" by the rhythmic flow of the thick and thin line, created by applying different pressures to the pen. The line "moves."

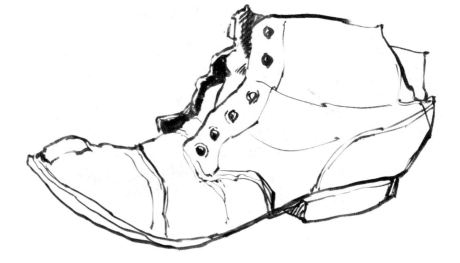

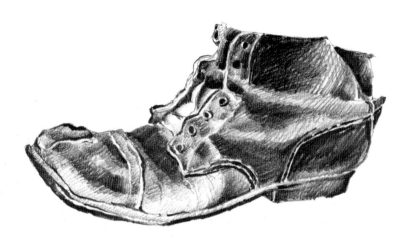

Stating Volume

In this classical drawing done with a 2B pencil, the shoe is translated with an intended fidelity to what my eye saw. This manner of drawing tests the artist's ability at the most academic level; it represents a fundamental expression of skill and insight into the literal subject. As you can see, the drawing makes a statement of volume, capturing dimension and form through the use of a complete value range. Although this drawing is classical, it is not a mirror image. I allow some degree of variance from the subject itself when I feel this will enhance the drawing without destroying the literal illusion. I see no virtue in attempting to slavishly copy your subject matter.

Drawing with a Brush

Like the preceding example, this drawing is a full tonal statement, conveying form and dimension. As a genre of interpretation, it, too, is academic, with a classical flavor. The fact that it is drawn with a brush and expressed in washes makes it no less a drawing than any of the other examples. I started by brushing large washes into the shoe, adding more water or more pigment to get different value gradations. When this blocking-in had dried, I introduced more subtle contours. Letting the surface dry again, I came in with the dashing accents of the darkest darks. The result is a brief and directly stated value sketch.

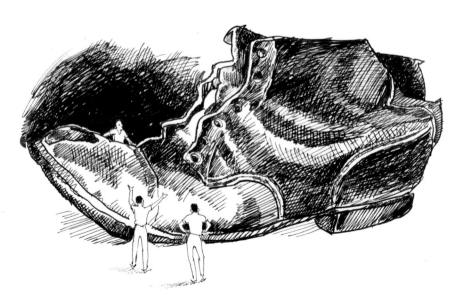

Orchestrating Illusion

This drawing mingles various features from the other examples and adds some new flavors. Again, tonality is suggested, but because I drew in ink, the values are dramatically stated. Notice the dark value I introduced behind the shoe; it helps to project the shoe into a forcefully identified foreground, creating a sense of space. It also serves as a negative shape that defines the figure on the far side. What the figures do is identify the scale—the shoe now appears to be immense. Of course, that's an illusion. But the orchestration of illusion is one of the artist's tools for bending the viewer's eye.

Value Relationships

We've already glimpsed a few ways in which tone can affect a drawing. Actually, to be more academically accurate in our terminology, let's describe tonal statements as value relationships. Darks are low values, whereas lights are higher values. What must be remembered, of course, is that the eye will "read" value in relation to other values. You therefore must provide potent contrasts for any value you wish to accentuate. By the same token, if you want to create subtlety, consider the possibility of reducing your value contrasts.

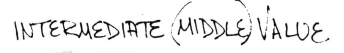

INTERMEDIATE (MIDDLE) VALUE.

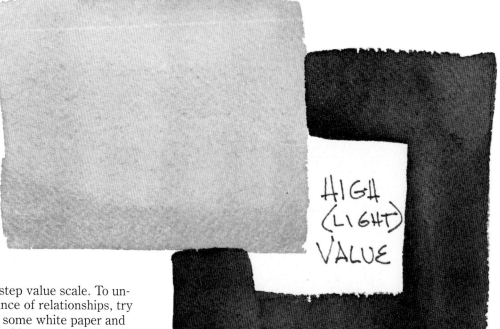

HIGH (LIGHT) VALUE

LOW (DARK) VALUE.

Here's a basic three-step value scale. To understand the importance of relationships, try an experiment. Take some white paper and cover all the black on this page (including the type). Now the intermediate value will read as your dark.

What possibilities are opened up for drawing as a result of introducing value relationships? The illusions of volume, substance, solidity, and spatial dimensions may all be enhanced by value relationships. Although these qualities can be inferred from a linear drawing, their promise is more deeply fulfilled with value.

CREATING ILLUSIONS WITH VALUE

Making Edges Expressive
Value relationships can define the edges of forms in different ways. The cube on the left is an exercise in a subtle high-value statement. The value contrasts are reduced to a degree where the form is discernible but not commanding. You can see some of the edges, but others are only inferred, creating a sense of the lost and the found.

In contrast, the cube on the right asserts its identity through value contrasts that portray substance and accentuate volume. Here some of the edges are pronounced and unmistakable. Others, however, are more diffuse, although recognizably stated, and one is suggested but not delineated.

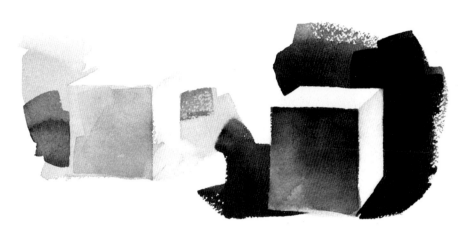

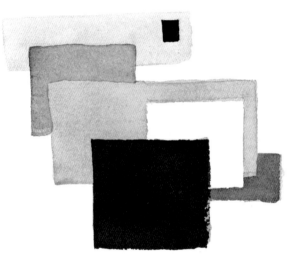

Projecting the Foreground
In this series of planes, the value relationships force the projection (or forward thrust) of the very dark foreground shape. Notice how the white square immediately behind the black one augments the projection by providing dramatic contrast. However, you can also see an accent of the dark square in the most distant plane. Although it isn't large, it declares itself a feature of interest by its pronounced value contrast. Just cover the small dark square with your finger and you'll have an undisturbed progression of planes. This is an example, then, of how value can direct interest and focus within your composition.

Adding Interest
This sketch also contains a progression of planes. Here, however, the major dark value lies in the most receded plane. It's just not true to say that your composition must go from dark to light, or light to dark, or any other cliché. What matters is *how* you create the relationships of value, edge, and so on. For example, to make the foreground project in this sketch, I introduced the very dark circle in front. This variation in the otherwise straightforward progression from light foreground to dark background sets up a feature of commanding interest. Once again, cover the circle with your finger—the progression then presents itself without accentuated interest in any particular plane.

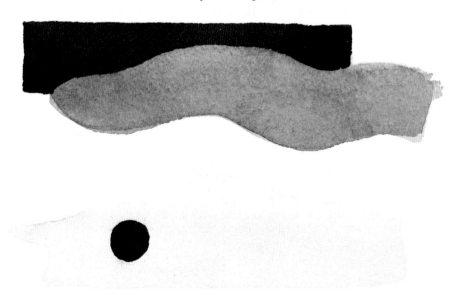

BUILDING FORM WITH VALUE

Value relationships are crucial in giving dimension to form. We'll look at washes in detail in the next section, but first let's see how they can be used to clarify value relationships as you build your forms.

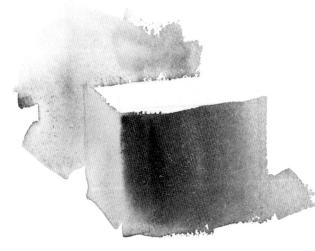

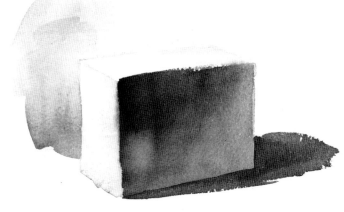

Making a Direct Statement

This sketch directly states the value relationships: it's all been painted in one, rather quick handling, using one color—ivory black. The variations in value result from either more water or more pigment being added as the area is being painted. Notice that I've added external foils to the box to give some sense of its location in space.

Developing the Initial Statement

Here the form is developed further by letting the first wash dry and then using additional washes to enhance the value relationships that define volume and describe edges. In the small sketch on the top right, you can see how this technique applies to a landscape setting.

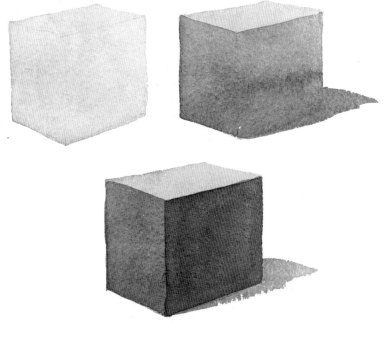

Working Less Directly with Glazes

These three steps show how to build a cube by using a series of overlapping washes, or *glazes*. First, the overall form is given a local value. This might also be described as toning the total form with what will serve as its lightest value. When this tone has dried, an additional value is given to two of the exposed planes, as well as the cast shadow. What you see in the top plane is the original value. Finally, when all has dried, still another glaze is added, indicating the darkest plane and completing the suggestion of solidity and dimension. In most of my watercolors, I find that I use both methods described here, painting some elements directly in a single wash and applying glazes in other parts.

Watercolor Techniques

It's time to become more aware of the nature of our medium—watercolor—and to have some fun with it. In exploring the possibilities of washes and brushstrokes, remember that practice counts. Much of the visual effectiveness of your watercolors will depend on your mastery of rhythmic brushwork, fluid action, assertive handling—a kind of balletic grace. A good painting isn't just something you stumble into. Nor is it the result of crossed fingers (although a little prayer never did any harm). Yes, there will be times when wondrous accidents just happen on your paper—that's the capriciousness of our medium. I can assure you, though, that the best watercolors—even those that seem marvelously free and casual—flow from artists who are *directing* their skills and craft.

Flat wash on Arches cold-pressed paper.

Graded wash on Arches cold-pressed paper.

Laying a Flat Wash

Let's begin with a flat wash, one that creates a uniform value within a given area. Choose just one color and put a generous amount of it on your palette. Now dip your brush into the pigment, bring the brush to the mixing area, and add the amount of water that will give you the value you want. Remember that your value will almost always appear darker in your mixing area than it will be once it dries on your paper. Mix your color well enough in the mixing area to prevent clots of color from being transferred to your paper. Now you are ready to start "laying a wash."

Tilt your paper slightly and, using a fully charged brush (one that's loaded with wet color), start at the top of the area you intend to cover. With *no* hesitation, put down a wet brushstroke the full width of the area. Work with some speed to prevent the bottom of the brushstroke from "setting"—that is, from standing long enough to permit a hard edge to form and dry. Now scoop more of the liquid color from your palette into your brush and follow the first brushstroke with another—and another, and another, until the intended area has been covered. A bead of liquid will settle at the very bottom of your last brushstroke. Don't worry—this *should* happen if you've been working wet enough. However, if you want a truly flat wash, you have to equalize the wetness of the painted area. To do this, quickly rinse your brush after your last stroke, wipe it on your paint rag, and touch the damp—*not* wet—brush tip to the bead of liquid resting on the bottom. The damp brush will absorb the excess liquid, leaving a more uniform value.

Creating a Graded Wash

For a graded wash, begin as you did for the flat wash—but then, as the wash progresses, add water to the pool in your palette for each successive brushstroke. In this way you'll get an increasingly lighter color. You can control the degree of gradation, of course, by the amount of water you add to your pool of color. If you want to take the other direction and gradually darken your wash, just add more pigment to your pool of color for each successive brushstroke.

Working Wet-in-Wet

In laying a flat wash, we worked on a dry surface. It's probable that even though you intended to create a uniformity, you could still see some brushstrokes. For me, being able to discern such brushwork adds a characteristic flavor of our medium. Nevertheless, you can create an absolutely uniform value, without any evidence of brushwork. To do this, repeat the process of laying a wash just described, but this time wet the area that's to receive the wash first. Dampen the paper with a brush or sponge. Then lay the wash rapidly within this wet area. Because of the paper's moist condition, the brushwork will diffuse, pretty well eliminating any brush-stroked look within the wash area. Simply put, this technique is called *wet-in-wet*. Try it with the graded wash as well.

EXPLORING WASH EFFECTS

Variegated wash on Arches rough paper.

Experimenting with Variegated Washes

Still another type of wash is the variegated, or varied-value, wash. Using your brush, with varying proportions of pigment and water, you can sculpt your wash to create an informal, free mingling of value and shape. Try the process used for the example shown here. First wet the overall area with a 1″ (25 mm) flat brush and clean cold water. Then, with the paper lying flat, apply different amounts of water and pigment to the already wet surface. The rhythm and action of your brush will determine the shapes you create. Loads of fun! Be direct, though—don't hesitate. If you dab half-heartedly at the paper, you'll wind up with an insipid, uncommitted painting.

Incidentally, when you're working wet-in-wet, it's well to keep in mind that the water on the paper surface will dilute your color. To compensate for this "double-dilution," use more concentrated color in your mixing tray. I've seen students puzzled and dismayed when their washes lighten far beyond their expectations. They've forgotten how much the wet paper will affect the value.

Trying out Different Surfaces

To explore and discover variances you may encounter in laying your washes, experiment with a variety of paper textures. Both the examples shown here were done on a hot-pressed surface: the one on the top was painted on a dry surface; the one on the bottom, wet-in-wet. On a hot-pressed surface, which has very little "tooth," you'll find that your color reacts and flows much differently than on more traditional cold-pressed or rough surfaces. It's more difficult, for instance, to blend color with the uniformity possible on these other surfaces. On the other hand, the "runs," veining, and erratic edges that so easily form make for some exciting painting experiences.

Variegated washes on hot-pressed surface.

Handling "Blooms"

In describing flat washes, I mentioned the bead of liquid that settles at the bottom of the last brushstroke. If you leave that bead, it's apt to back up. Then you have a *bloom* or *flower* (also called a *watermark* or a *backflow*). What it represents is an unequal degree of liquidity within the painted surface. In the example shown here, I deliberately created this "flower" effect by allowing my wet brush to touch a damp wash of color. Since "blooming" is a characteristic personality feature of our medium, you may at times want this to happen. If you don't—just see to it that you either work wet into freshly wet handling or wait until the surface has completely dried before continuing.

Bloom on Arches cold-pressed paper.

Applying Glazes

In addition to even and graded washes, you can work up to the desired color and value by layering your washes in a process known as *glazing*. Although glazing is not a direct approach by some definitions, it may give the flavor that's absolutely right for the illusion you intend.

In the example here, a glaze of one wash was applied transparently over another wash once the first wash had thoroughly dried. The overlapping area typifies the transparency oī watercolor in taking on the combined value of the two washes. The smallest rectangle, however, shows a different result from glazing. Here the dense pigment of the glaze obscures the wash underneath. This kind of glaze can be useful in accentuating a particular value or color statement. Don't shy away from using potent, dense color just because you're afraid of tampering with the integrity of our transparent medium.

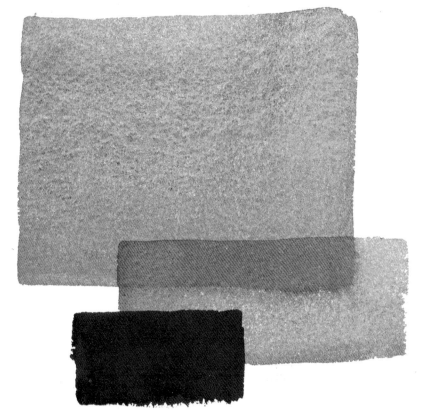

Glazes on Arches cold-pressed paper.

The Issue of Transparency

Obviously transparency is integral to the watercolor medium, but how much of a purist should you be? If you place transparency on an altar of superimportance, you may cheat yourself of dynamic, vigorous dashes of value and color. As a whole, a completed watercolor can very well convey the liquid and transparent qualities of the medium, even though, if you look closely at some passages, you'll see that dense color has been used.

Do I mean that opaque areas are OK? Yes, if by *opacity* we mean the result of covering over an underlying wash with denser pigment and *if* this adds to the emotional impact of the painting. But I am *not* advocating the use of white paint. Introducing white paint to your palette at this point may subvert your exploration of the medium and curtail your sensitivity to its transparency. In fact, I myself almost never use white—not because the pigment itself is taboo, but simply because I'm so fascinated with the range of possible effects without it.

CONTROLLING EDGES

Softening Edges

Painting watercolors requires thinking ahead and anti-
cipating the temperament of the medium. If you want
to soften or blend the edge of a wash or brushstroke,
you can't wait until later. After laying in the area,
quickly rinse your brush, wipe it to remove much of
the moisture, and carry the damp brush along the wet
edge you want to diffuse. Continue to rinse and extend
the blend until it has lost its clarity as a crisp edge. But
remember to be quick. Once an edge is left to set for
very long, especially if it isn't wet enough to begin
with, you can't extend it; it won't soften or blend. In
the examples here, one brushstroke is blended at the
short, right edge; another is blended the full length of
the stroke on its under edge; still another has just a
part of its underside softened.

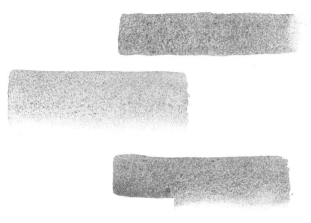

Softened edges on Arches cold-pressed paper.

Discovering the Principles of Blending

To learn more about blending edges, try
practicing different methods. In the top ex-
ample, I've tilted and tipped the paper to
direct the paint's flow. You'll be surprised
at how much control you have.

In the bottom example, the modeling of
the coil gives a sense of its movement in
space. The foil of somewhat darker value
at the top and the more accentuated dark
behind and around the lower area drama-
tize the coil's three-dimensional shape.
Moreover, some of its edges are clarified
by the "negative" shapes. At other points,
however, the coil's edges are only in-
ferred—there is no graphic identification at
all, but the eye "reads" these lost edges to
fill in the form. By the way, to get the tex-
tured edge at the bottom of the dark foil, I
carried a wet brush very quickly across the
paper. At such speed the color hits only the
high spots of the paper. Working more
slowly allows the color to settle into the
low spots, giving you a solid or untextured
statement.

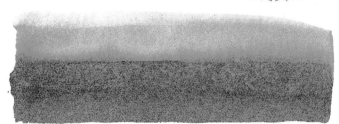

Blending on Arches cold-pressed paper.

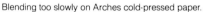

Blending too slowly on Arches cold-pressed paper.

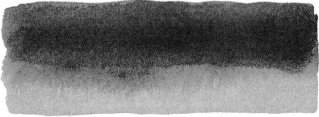

Blending Too Slowly

Here you can see what happens if you're slow about
blending. Edges will set and not be extendable;
"flowers" will crop up where you don't want them. All
in all, if you take too much time, you'll see all sorts of
things happening that you probably don't want.

DEVELOPING EXPRESSIVE BRUSHSTROKES

Your brushwork will contribute much more to the quality and temperament of your final watercolor than you probably imagine. Once again, don't dab at the surface. Be bold and assertive with your brush. I think some of the most distressing displays of busy technique arise when the painter is super-cautious—too tentative and picky. Remember, you want to paint, not crochet. Of course, I'm not arguing against works that, by *design* and *concept*, are intended to be highly descriptive. It doesn't matter whether your technique has a "tight" or "loose" flavor. Choose your language—but speak it with fluency.

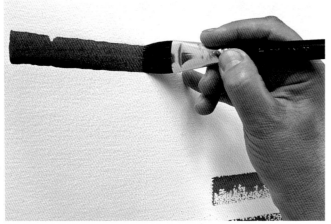

Vertical brush on Arches cold-pressed paper.

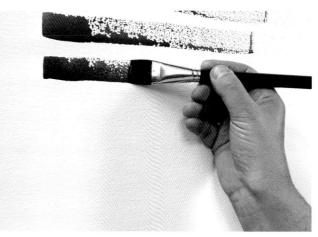

Slanted brush on Arches cold-pressed paper.

Carrying a Vertical Brush Slowly
To get this "solid" brushstroke, choose a flat brush and load it with wet color. Hold your brush almost perpendicular to the paper. Then carry it across the paper slowly enough to permit liquid color to flow everywhere that the brush makes contact with the paper, including the wells or deep spots in the textured surface. Notice how I steady my hand by letting my little finger touch the paper. Of course, be sure your finger is clean and dry, and that the paper is not wet with color where your finger is going to rest.

Carrying a Slanted Brush Rapidly
Here you can see the uneven stroke created by a slanted brush. Notice how my hand is lying almost back-down on the paper. From this position, you can hold the brush at an angle that's quite low to the paper, so that the color is dispersed not by the brush's tip but by its broad side. Then, when you carry the wet brush *quickly* across the paper, the liquid simply doesn't have a chance to settle into the indented parts of the paper surface. The liquid color hits only the high spots so you get a textured, glistening brushstroke. Remember that although this brushstroke looks dry, it's the result of a *wet* brush being carried quickly, at a low angle, across a paper that has "tooth"—some degree of roughness.

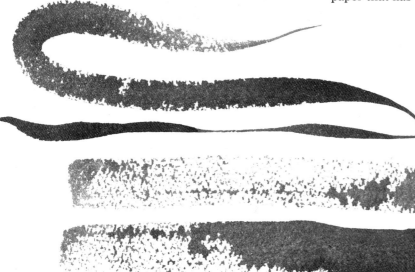

Playing with Different Rhythms
To get these different brushstrokes, I carried the brush vertically at times and more horizontally at other times, without lifting it from the paper. Try this out as an exercise in rhythm within a single brushstroke. Also, try easing up and bearing down on single brushstroke movements for a variety of weights and rhythms. Practice, practice, practice.

Brushstrokes with no. 12 round Kolinsky sable on Arches cold-pressed paper.

Color Interpretation

For a long time I've felt that students who profess to having a rough time conceiving and expressing color in their paintings are really allowing themselves to be *intimidated* by color. Yet color, like so much else in painting, is an exciting garden bursting with offerings for the painter, waiting to be adventurously explored. Naturally, undisciplined use of color will invite a fragmented composition. So we must observe some of the principles of color and their application.

Classically, the discussion and contemplation of color begins with the color wheel. A color wheel is simply a tool to describe the relatively few distinct colors that the eye recognizes among the almost limitless colors within the spectrum. It's a convenient way to begin discussing the interrelationships among colors.

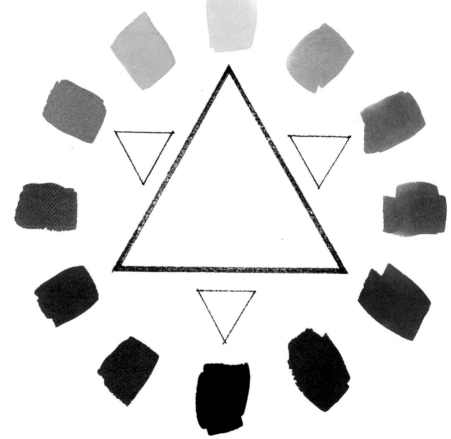

The points of the large triangle on this color wheel identify the *primary* colors—red, yellow, and blue. The small triangles identify the *secondary* colors—the colors you get simply by mixing one primary with another: violet, green, and orange. The remaining six colors on this wheel, arrived at by mixing the primary on one side with the secondary on the other side, are called *tertiaries*: violet-red, red-orange, orange-yellow, yellow-green, green-blue, and blue-violet. In addition, note the colors that lie opposite each other on the wheel. These pairs of opposites are called *complementaries*—for instance, red/green, yellow/violet, and blue/orange.

IDENTIFYING HUE, VALUE, AND CHROMA

There's much to consider when you're envisioning and planning color. How, for instance, do you begin to describe the color of a particular pigmented area? As a start, you'd probably refer to the *hue*, which is the common name of a color (such as *red, yellow,* or *blue*).

Another reference point is *value*—the lightness or darkness of the hue. We've already looked at value relationships in terms of white and black, but how does this relate to color? Imagine that we create a tint of cadmium orange by adding a lot of water. In this case, we have a light (or high) value. If, however, we use the cadmium orange straight from the tube, adding only enough water to make it workable, we have a dark (or low) value. Yet all this is relative: as dark as our cadmium orange may appear to be, it is lighter in value than, for example, pure cobalt blue.

Yet another way to describe color is in terms of its *chroma*, or *intensity*. Primary colors that do not have other colors mixed with them and are not diluted any more than is necessary to make them workable are the purest, most chromatically intense colors. As a color is grayed, it becomes less intense.

EVALUATING TEMPERATURE

You can also describe color in terms of temperature. The colors on one side of the color wheel—the reds, oranges, and yellows—are referred to as *warm* colors; those opposite—the blues, greens, and violets—are considered *cool* colors. Once again, however, everything is relative. For example, permanent blue is a warm blue because it has some red in it, even though it's on the cool side of the wheel. But remember it's still a *blue*; it's cooler than alizarin crimson, which is on the warm side of the wheel. Now this may sound confusing: we call alizarin crimson a cool red, since there is some blue in it. It's not as cool as a blue, but it's cooler than a red like cadmium red light, which has no blue in it. To give another example: olive green has a good deal of yellow in it, which makes it a warmer green than Winsor green, which contains more blue. Yet both of these greens are found on the cool side of the wheel.

NEUTRALIZING COLOR

Color theory states that a color becomes grayed or less intense as the complement is added to it. Although this principle is certainly valid, before you start mixing your complements, consider what you want to achieve in terms of the painting's overall color balance and interpretation. Instead of choosing the direct complement, you might want to use an earth color (see the discussion below). You also need to decide *how* you want to neutralize the color. In addition to mixing colors in your palette, you can do this in two ways: indirectly, by glazing one color over another, or more directly, by letting the colors mingle—intermix—on your paper.

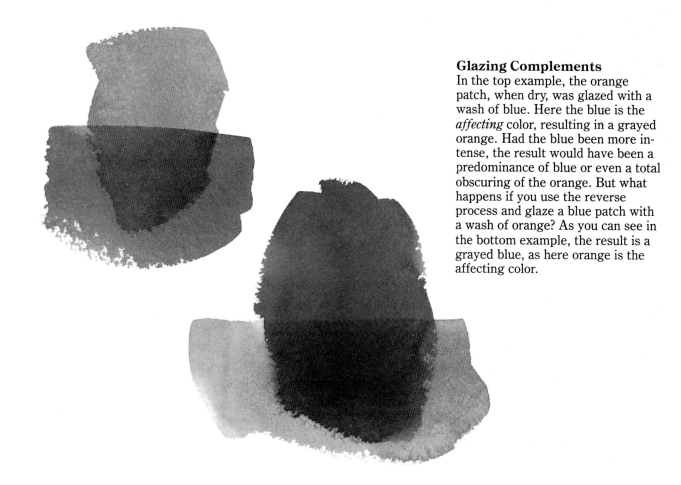

Glazing Complements
In the top example, the orange patch, when dry, was glazed with a wash of blue. Here the blue is the *affecting* color, resulting in a grayed orange. Had the blue been more intense, the result would have been a predominance of blue or even a total obscuring of the orange. But what happens if you use the reverse process and glaze a blue patch with a wash of orange? As you can see in the bottom example, the result is a grayed blue, as here orange is the affecting color.

NEUTRALIZING COLOR

Letting Complements Mingle
Here the complements—red/green, blue/orange, and yellow/violet—have been applied directly and allowed to mingle on the paper. The result is a more animated statement of color, with differing degrees of grayed color at various points. Look closely and you'll see that in each example there's an illusion of earth color, for, in fact, earth colors can be closely approximated by mixing complementary colors.

Learning the Effect of Paper Surfaces
Your choice of paper surface will affect the way your colors mingle. The example on the left is painted on rough Arches paper, which has a classic "tooth," readily allowing the kind of blend and brushwork traditionally associated with watercolor. In the example on the right, you can see the effect of a cold-pressed Crescent surface. Because this surface is quite smooth, the washes flow and mix in a more free-running, less predictable fashion. Of course, in both these examples, what you see is the intermixing of primaries, resulting in the recognizable secondary colors orange, green, and violet. Look closely, however, and you'll detect, once again, the earth colors created as the secondary colors mingle further.

Muting Colors with Earth Colors
What we call the *earth colors*—burnt sienna, burnt umber, raw sienna, and raw umber—are simply neutral versions of more intense colors. Burnt sienna, for example, is a muted (grayed) red; burnt umber, a muted orange; raw sienna, a grayed yellow; and raw umber, a form of yellow-orange. To see how this works, try mixing cadmium red light (a red-orange) with cobalt blue (which is of a complementary nature). You'll arrive at an approximation of burnt sienna. Why, then, have burnt sienna on your palette? First, because it's more convenient to have it at hand. Second, it's more transparent than the combination of cobalt blue and cadmium red light (one of the least transparent colors).

We've already seen how you can mute a color by adding some of that color's complement. Thus, blue is grayed by the addition of orange. *But*, if burnt umber is a grayed orange, we can also gray our blue with burnt umber. If a violet is to be grayed, we might consider adding raw sienna, a muted yellow. If the violet is a blue-violet, it can be grayed with raw umber, remembering that raw umber is, essentially, a yellow-orange.

EXAMINING COLOR INTERRELATIONSHIPS

In applying color principles, you have to remember that a color is always affected by the other colors around it. *Local color* is the term we use to refer to the actual color of an object or surface when it's not being affected by the qualities of light or the painter's interpretation. In reality, however, the situation is hardly that simple. When you paint, you have to capture the way one color influences a nearby color.

Dealing with Reflected Color

In this example you can see how one color may be reflected in another. First, look at the blue rectangle in the back and notice how a glow of yellow indicates the influence of the cube. If you focus on the cube, you'll see that there's a glaze of yellow-green on the top plane, suggesting a reflection of the blue. The shaded areas are more complicated. Here I wanted to both gray the color and convey the influence of other colors. On the cube's dark side, for instance, violet (the complement of yellow) and raw sienna (a grayed yellow) are mingling, but near the bottom there's a touch of red—showing the reflection of the rectangle on the ground.

Conveying Light and Shadow

In capturing the play of light and dark, you always have to consider the interaction of color. Although the temperature of natural light varies, it usually has a somewhat yellow cast. If you look closely here, you can see that the lightest plane of the cube—the top—is a more orange red (it's painted with cadmium red light). To accentuate this, I used a cooler color—alizarin crimson—for the front side of the cube. But notice that I've added cadmium red light toward the bottom to indicate the reflection of the yellow plane. The darkest plane is also created through the interaction of color, with the reds mingling with olive green (a complement). Again,

a touch of cadmium red light at the bottom gives a hint of reflected color.

The green sphere shows even more clearly how color enhances light and shadow. The lightest area is the yellowest. Now look at the touch of red at the darkest edge, which suggests the reflection of the cube. The result is more than a grayed green; through the combination of red/green complements, the green becomes an earth color at this edge. Remember that color can add vibrancy to your lights and spirited interest within your darks.

CREATING ILLUSIONS WITH COLOR

Thoughtfully characterized and insightfully stated, color can speak a powerful compositional message. We know that in a painting illusions of space and distance can be created through size relationships, foreshortening, and overlapping planes. But color can also be a forceful means of punctuating the illusions of perspective and atmosphere. One of the fundamental principles of color is that warm colors project (come forward) whereas cool colors recede. Before, however, you take this neatly packaged thought and make all your foregrounds warm, remember that all principles are open to interpretation. Let's look at a few examples of uses of color that seem to break the "rules."

Playing up Contrasts in Intensity

Here the distant color, though warmer in temperature than the foreground, still recedes because it's *grayer* than the cooler color. In other words, by graying (muting) a warm color, you can provide the illusion of receding planes. Even though it's cooler, the more intense (less gray) color will, by comparison, appear to come forward.

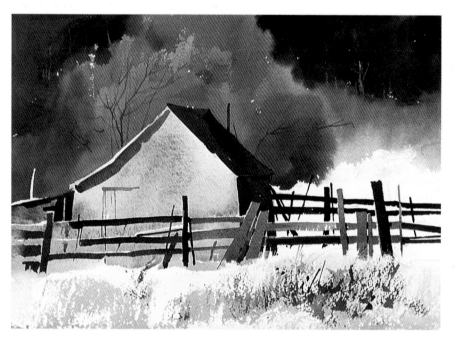

Emphasizing Value Contrasts

Let's suppose that you want a cool, grayed foreground and a warm, ungrayed background. In this example, the value contrasts are emphasized in the foreground but diminished in the background. Even though the colors of the foreground are relatively cool and muted, the visual impact of the value contrasts is commanding, thereby projecting the foreground.

Accentuating Edges

Continuing to play the devil's advocate, I'd like to show how the magnetic quality of crisply defined edges will attract the viewer's eye. Here the foreground color is both cooler and grayer than the background color. *But* notice the highly descriptive definition of content in the foreground, with its unquestionably harder-edged presentation. By underscoring description in the foreground, you can dramatically carry this plane forward, regardless of the color in the receding planes—as long as you keep the background edges softer and reduce objective description there.

Choosing Unorthodox Colors

Almost any combination of colors can be used in a painting—as long as they are handled sensitively and with skill. In fact, it's a good idea for us to rock the boat now and then by choosing a combination that seems "off-beat." Looking at this subject, you may be surprised at the colors I've used—Payne's gray, burnt sienna, and olive green—but I think these unorthodox colors appear comfortable and natural here. Try an experiment using green, brown, and black. It may sound astonishing, but you can create lush-looking foliage that is, in effect, brown and black; or a light that seems rich and intense even though there are no yellows, blues, or violets.

BUILDING A LANDSCAPE IN COLOR WASHES

At this point you may be wondering how to lay in color as you develop your painting. We'll explore this in more detail later, but here's a preliminary example.

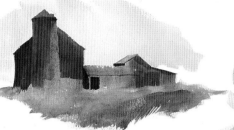

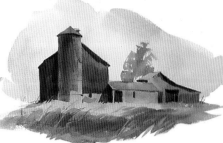

First, I drop washes of color—cobalt blue, a little raw umber, and generous amounts of water—into the sky and allow them to mingle. (You can use your brush to coax the direction and degree of mingling, but don't overbrush an area or you'll end up with a labored statement.) I let the sky dry so the edges of what will come below won't lose their clarity. Then, for all the buildings and the ground surface, I continue with a wet handling, using raw umber, cobalt violet, raw sienna, alizarin crimson, and cobalt blue. Sounds like a lot of color, doesn't it? As these colors fuse and interact, though, they lend radiance to the study.

Once the paper has again dried, I begin to add dimension to the buildings and texture to the ground. For the silo, I choose burnt sienna, cobalt blue, and olive green; for the barn, raw sienna, cobalt violet, alizarin crimson, and permanent blue. The touch of higher color just to the left of the silo is cadmium red light. The dark shadow and interior of the center structure are painted with alizarin crimson and permanent blue. All the while, I've been using only my large brushes, especially the 1″ (25 mm) flat.

I bring the study to a finish by accentuating the darks, providing contour and cast shadows. In selected areas I introduce linear statements to add focus and refinement. But I limit this—with too much line, my study might look like a filled-in line drawing. To project the foreground, I give a little more description to the grass, but notice that the background tree is stated with the simplest of handlings. Remember that suggestion can be tantalizing. If you go into too much detail, there's nothing for your viewers to imagine; you'll shut out their participation in the total experience.

POINTERS TO REMEMBER

- Keep temperance in mind in selecting your palette. I feel that a palette should not exceed sixteen colors (give or take a couple), lest you find yourself overwhelmed by color. You're more likely to become a color virtuoso as you explore a limited palette.

- Mixed color can look more interesting and spirited if you let the color mingle on the paper rather than doing all your mixing in your palette.

- In watercolor, a color with high chroma can later be muted or altered by glazing. However, you cannot extract high chroma from an area that's been painted with muted color.

- Don't give masses of complementary colors equal visual importance. Either alter the size to permit one color to dominate or alter one color so that true complements are not represented. Although a dash of a neighboring complement can heighten the supremacy of a color, equally important complements create a dissonant, fractured color statement.

- Effective color—color that is "right"—will be whatever expresses the idea or emotion you intend, provided there is thoughtful planning of harmony and cohesion.

Composition

I define *composition* as a studied arrangement of elements, following recognized principles of design. I say *principles*, not *rules*, because rules allow no room for interpretation and such inflexibility is, I feel, antithetical to the freedom of personal expression inherent in art. In contrast, a principle, which is a concept of historically proven worth, offers unlimited possibilities for artistic exploration: it is something to meditate upon, digest, and interpret. Let's look at some basic principles regarding line and value in composition.

BRINGING OUT ANGULAR OR ROUNDED FORMS

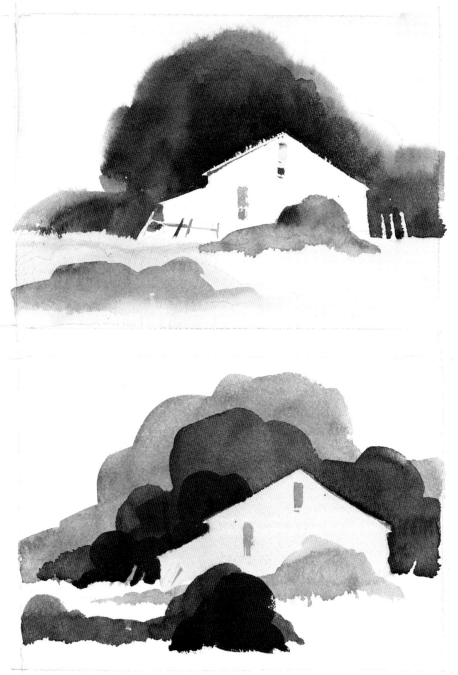

Here angles tend to dominate the arrangement not only because of their dynamic interest but also because the soft, rounded shapes act as a foil to the angles, without being too contrasty. The dark shadow under the roof dramatizes the structure's strong light and furthers its angular impact.

Although the basic arrangement here is similar to the first sketch, the lighting is weaker and so the value contrast has been reduced. Also, the rounded shapes have a more clearly defined form, which is reinforced by the introduction of overlapping planes of trees and shrubs. In addition, the fence is more incidental and the windows more casually indicated, which helps to reduce the impact of the angles. In all, the interest is shifted to the rounded shapes.

WORKING WITH DIAGONALS

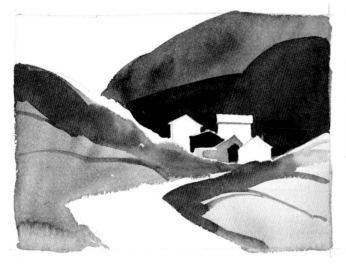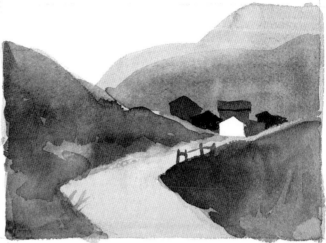

In this study the diagonal movement creates force and tension, commanding attention. The strong value contrasts and rhythmic contours of the hills add to this emphasis.

In contrast, here the muted value contrasts diminish the diagonal thrust, as does the diffusion of some of the strong diagonals in the hills. The suggested verticals of the grass and fencing deliberately break the otherwise uninterrupted diagonal movement of the road.

HANDLING HARD EDGES

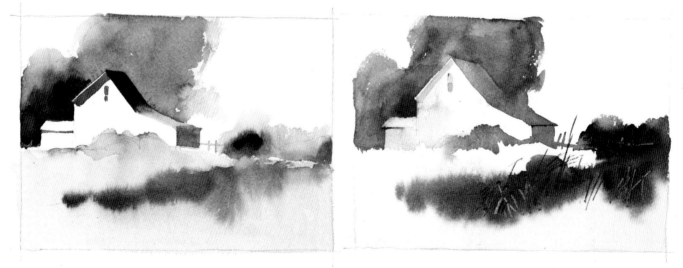

Hard edges invite attention and project interest, almost regardless of size and shape. Here, however, the hard edges are so pronounced that they distract from other elements in the design.

Playing devil's advocate, I can't resist pointing out that the edges of this building are less interesting than in the preceding sketch because of the reduced value contrast. By "losing" its edges, the structure seems of only secondary importance. On the other hand, the soft-edged foreground patterns have become compelling through sharper value distinctions and the inclusion of crisp lines suggesting blades of grass. Though the grasslike forms seem incidental, they do coax the eye into focusing on the soft-edged mass.

MOVING AWAY FROM SYMMETRY

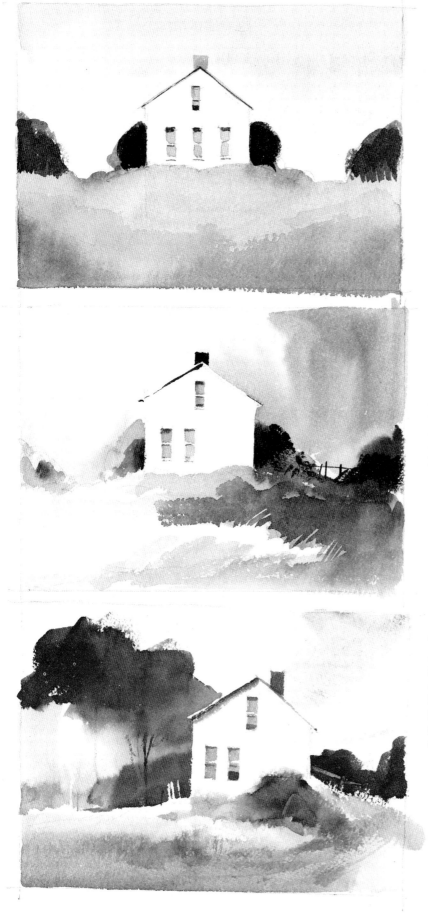

The static quality here is perhaps exaggerated—few artists would compose a painting in this way. But I wanted to underline how you're apt to end up with an actionless, spiritless painting with such formal symmetry.

Even though the arrangement of masses here is basically the same as in the preceding sketch, the subtle value differences and suggestion of asymmetrical patterns in the ground and sky provide some animation and movement. Note how the deletion of one window provides an off-center feeling and lessens the static quality of the house.

This sketch is clearly the most visually effective of the three sketches. The structure has been moved off-center, the window placements offer variety, the chimney is less formally positioned, and the large trees and shrubs are more individualized in shape. Even the sky and cloud shapes take on more flowing, lyrical movements.

AVOIDING REPETITIVE SAMENESS

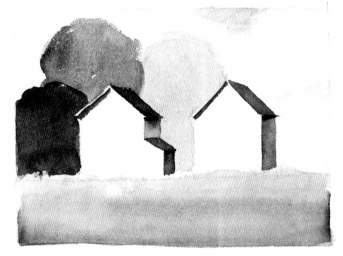

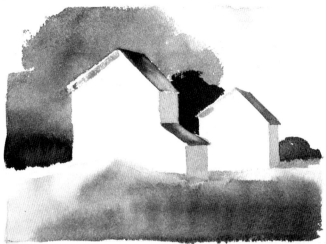

In a word, this sketch is stagnant. The buildings are too similar in size, the tree masses too similar in volume, and the cloud and trees too similar in mass and shape. To make matters worse, almost equal measurements are used for the width of the buildings, the space to the edge of the paper on the left, and the depth of the foreground. In all, this example is a disaster in terms of adding rhythmic movement and dynamics to your composition.

This composition is much more animated than the preceding one. Not only do the two buildings vary in size, but overlapping them emphasizes their different positions in space. Reread the caption for the preceding sketch and you'll see how alterations have breathed life into this study.

ELIMINATING THE DISCOMFORT OF TANGENTS

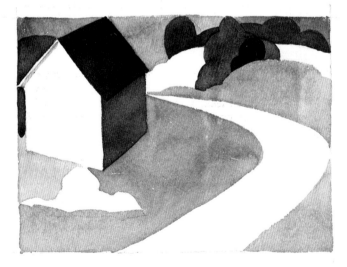

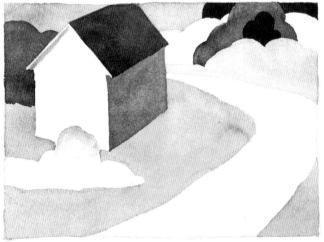

This is almost a caricature of the visual discomfort created by tangent points (where the design elements barely touch each other). The tangential touching makes for such a minimal relationship that it's like an unpleasant poke in the ribs. How many times can you find elements just meeting at a point? If you find thirteen, you've come up with the right number.

Here, each of the tangents in the preceding example has been eliminated either by overlapping forms or by separating them. Note particularly the shift in the relation of various forms to the picture's edges.

CREATING VALUE DOMINANCE

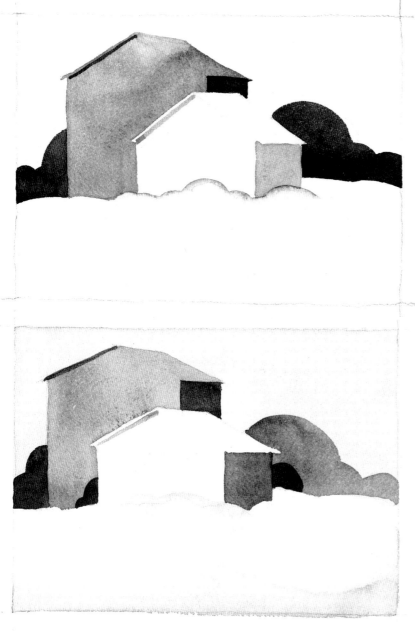

The darks and lights are unequally distributed here, which tends to prevent a strong value interest and gives an asymmetrical balance. In value statements, either light or dark should dominate, with the middle value used to facilitate eye movement.

You can create value dominance in many ways. Here the darks have been muted in order to let the lights "sing." The contrast within the dark areas has also been reduced—a most important factor in giving dominance to the lights. In addition, darkening the sky minimizes the impact of the darker structure by reducing the contrast between the two areas. At the same time, the darker value in the grassy foreground helps to dramatize the clarity and vigor of the lighter areas, making them stand out.

Now try some sample sketches on your own, exploring compositional problems like these. You can use ivory black, as I did, or choose other colors as you wish. Either way, I think you'll be surprised by the insights you'll discover.

WHEN TO SIMPLIFY

Simplicity is often cited as a basic principle. Let's discuss this for a moment. A friend of mine has a bold poster in his studio with large black letters on a stark white background that read "K.I.S.S." Beneath these letters, in much smaller type, are the words, "Keep It Simple Stupid." Catchy? It certainly makes a point. Yet, if we were automatically to emphasize simplicity, almost as a reflex, we might very well find ourselves creating barren, sterile paintings. Instead of cultivating simplicity for its own sake, we should direct ourselves to our objectives purposefully, without meandering—eliminating nonessential or noncontributing qualities. Sometimes, however, we may want to create a painting in which there is a great deal of intricacy. The crux of the matter lies in our intention. Aimless involvement leads to busyness. Unstructured intricacy will spell confusion. In short, if something is not meaningful, if it contributes no constructive interest or flavor, it should be omitted.

CREATING A CENTER OF INTEREST

The center of interest is essentially whatever the artist wants to develop as the element of cardinal importance within the composition; it is an integral and dominant part of the design. One might call this the focus, catalyst, or nucleus of the painting—but, whatever word one chooses, the meaning is the same.

In determining *what* the dominant interest is to be, you also have to decide *how* you're going to give it life. The following sketches each show a different way in which you can reinforce the center of interest. Mind you, there can be many directional elements, all working in visual concert. What these examples underscore, however, is the individual use of line, value, color, description, or dynamism.

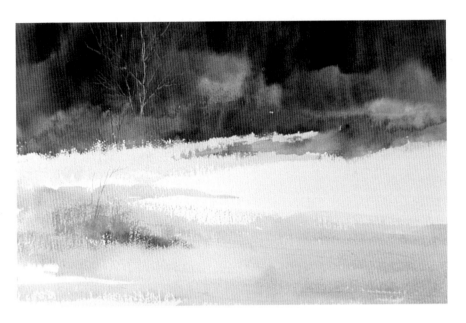

Line
In this sketch the linear construction of a tree, as delicate and subtle as it is, establishes a focus that is enough unlike the other painting elements to make it the unmistakable center of interest.

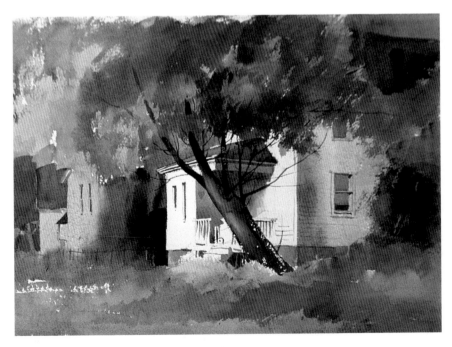

Value
Although the color is chromatically high in various passages, the accentuated value contrasts in the front portion of the house emphasize this area over others.

Color

The strong geometric shapes and overlapping-planes make this study quite potent. What lends certain areas arresting importance here is their aggressively interpreted color. Although shapes are assertively stated throughout the composition, the color is purest under the eaves, where the eye is intended to settle.

Description

Both the color and value contrasts are strong in several passages here. However, delineation of content is reserved for the boulder that's the center of interest. Even the brushwork of the ground becomes more defined as it approaches the boulder.

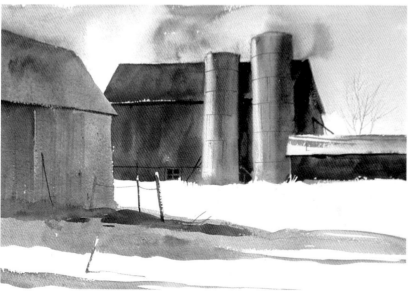

Dynamism

In this sketch the shapes are all assertive, with pronounced edges and little variation in description. The value contrasts are largely powerful. What, then, has been done to focus interest? It is the dynamics of color and the dynamics of the angular barns against the rounded silos that activates optical interest.

These examples are only a few possibilities to consider and ponder. The range of what can be created is infinite. The skillful painter will pluck chords from this range that filter his or her observations through a special vision.

FINDING THE EYES OF THE RECTANGLE

An important concept in establishing a center of interest is the principle of the eye of the rectangle. As with all principles, it's not a rule etched in stone, but a *possible* road to follow. Sometimes it's useful; sometimes you may take a different route.

The principle of the eye of the rectangle is based on the finding that the eye tends to gravitate to certain parts of a rectangular area and rest there. These parts are called the eyes of the rectangle, and there are four within any rectangle. To find them, imagine a line traveling diagonally from corner to corner. Then, imagine another line drawn from one of the remaining corners to the diagonal and intersecting at a 90° angle. The point of intersection is an eye of the rectangle.

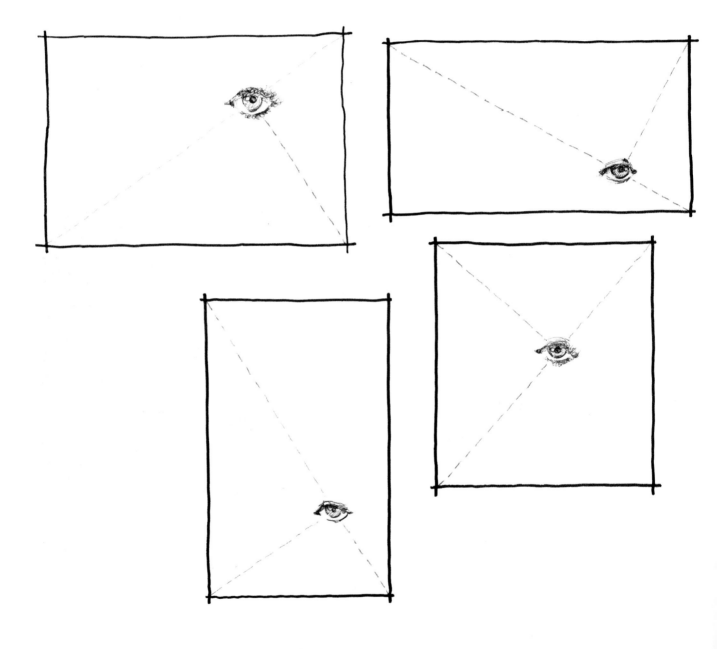

Gloucester Patterns.

As you can see in *Gloucester Patterns* (discussed on p. 104), I further reinforced the intended area of dominance by introducing a figure at the junction of the two diagonals that form the eye of the rectangle. This note of animate interest—which alone would attract the eye—evokes an unmistakable visual impact when combined with the eye of the rectangle principle.

In *Near Rockport* (discussed on p. 105), I've actually exercised the eye of the rectangle principle *twice*—within the area of the large tree, as well as in the dynamically contrasted and more descriptive house. It was essential, however, that only one of these interests dominate, with the other playing a more supportive role. Equalizing these interests would have created friction and destroyed the cohesion of the composition.

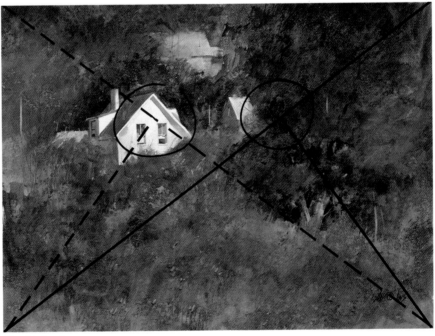

Near Rockport.

Approaching a Painting:

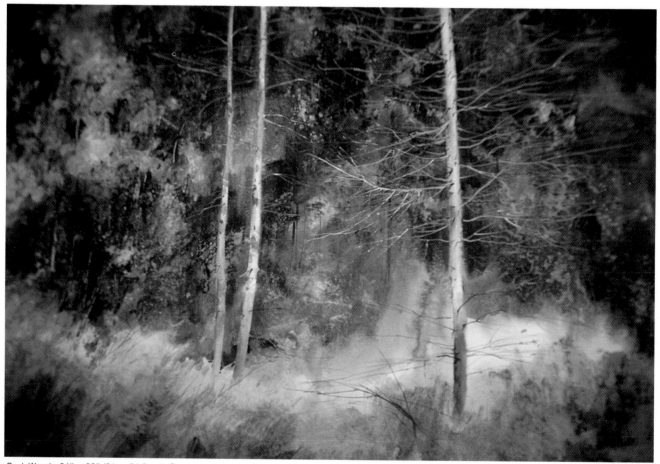

Back Woods, 24″ × 32″ (61. × 81.3 cm), Crescent cold-pressed watercolor board. Private collection.

Thought and Action

As you approach a painting, all the elements of the craft come into play—from the concept through the planning of composition, value relationships, and color combinations to the use of watercolor techniques in developing the painting itself. One of the very first steps, of course, is selecting your subject matter. If you want to paint an abstraction without any objective content, then subject matter per se is immaterial. But once you choose to paint representational subject matter, you are committed to portraying the personality and character of your subject, no matter what the interpretation.

A painting begins with our desire to tell a story. Sometimes this story may be our response to man-made forms: we may want to describe the solidity (or perhaps dilapidation) of constructed or assembled shapes. And we may want to dramatize these shapes with clearly defined lights and darks—or present them as wonderfully obscure and mysterious, seen under a diffused or undefined light. On the other hand, we may want our story to tell of nature's forms and textures as they stirred us at a particular moment of observation. Or we may be emotionally moved not only by our vision but also by the manner in which we anticipate translating it, in our mind's eye.

Subject matter can be found everywhere. Everything is paintable. Of course, we are more stimulated by unfamiliar surroundings, but we can be turned on by just about anything, if we open ourselves to it. In fact, some of my most profound painting experiences have resulted from subjects within a few hundred yards of my home.

Developing Your Subject

Sometimes we respond to a subject so strongly that we can hardly wait to paint it. At other times, we can appreciate a subject that may not move us at the time, but may ignite us later in the studio when we ponder photographs and conjure visions.

TAKING REFERENCE PHOTOGRAPHS

Whether I'm close to home or in more distant parts, I always pause to take photos of anything that interests me. Don't be stingy with film. Just respond and react to subject matter. Sense and feel the possibilities of a subject. Emile Zola once said, "A work of art is a corner of creation seen through a temperament." We must try, through our paintings, to capture and express what we ourselves feel.

This is why I think it is essential that the photos you choose to paint be your own, of something you yourself have selected and observed. Although clinical exercises or studies can evolve from photos taken by others, the information there is second-hand. As a painter, you should communicate an intimacy with your subject, a truly communal spirit, and you can only do this with subjects with which you have had personal experience. A "direct line," so to speak, with your subject will instill your paintings with a quality of truth, conviction, and sensitized response that will raise your painting above a mere display of style and technical dexterity, and will captivate your viewers' attention as well. This is one of the differences between real painting and an exercise.

I advise you to get a good-quality 35mm camera—even if it means doing without lunches for a while. I have a 35mm Canon that I bought without the 50mm lens it came with; instead, I purchased a 35mm to 105mm zoom lens. Despite its substantially heavier weight, the zoom lens gives me a flexibility that more than compensates. I use 35mm slide film and later, in the studio, project the slides onto the screen of a rear-projection viewer, blown up to an 18″ × 24″ (45.7 × 61 cm) image that more closely captures the spirit of my subject matter than a photographic print would.

By the way, if you intend to wander on private property, be sure—if possible—to ask the owner's permission. Upset property owners—and even worse, upset German shepherds that gnash their teeth at you—can quickly dampen your interest in sketching or taking photos. In all the years that I've gone scouting for painting material, I've been refused permission by the property owner only once. That was because she thought her place was a mess, declaring, "I'd be too embarrassed to have anyone poking around." In fact, for a lot of people, the artist seems to have a special charisma. I can think of times when I've wound up being offered a glass of iced tea on a hot day, while chatting with new acquaintances.

Using vs. Copying Photographs

My suggestions on using photography as a tool bring up another issue: the controversy regarding photography and the artist's integrity. The thought of the painter using a camera to record images bothers some people, but artists have been using cameras for as long as they've been around. In fact, several years ago, when the Art Institute of Chicago was about to open an important exhibit of Toulouse Lautrec's works, I was startled to learn that Lautrec had used a camera. I subsequently found that many of the French and American Impressionists—as well as other artists—used the camera freely to help fulfill their objectives.

What I think bothers people is the inference that by using a camera, the artist is copying. But if the objective is to copy, this can be done on the spot as well as from a photograph. To create a compelling pattern, design, or other illusion within the painting requires the desire and ability to rise beyond mere mimicry. In short, sterility in painting reflects the shortcomings of the artist, whether or not photography is involved. As I said earlier, I think that the role of an artist is not to be a reporter of facts, but rather a storyteller weaving tales with interest and invention.

I take photographs of any spot of interest that catches my eye, recording as much as I can while absorbing the character and temperament of the area. All the while, I'm not only looking at subject matter, but at what—in my mind's eye—the subject can become as a painting.

SKETCHING ON LOCATION

I usually augment my photos with quick sketches done on the spot. These are likely to be no more than jottings that are meaningful only to me—they are my own immediate and insightful responses to the subject. But you owe yourself the experience of sketching on the spot: it provides you with an intimacy with the landscape. Just remember that you're making a sketch, not a painting.

By *sketch*, I mean a quick drawing that sensitively captures the essence of the subject, its distilled character. Subtleties, embellishments, and refinements should all be left for later, in the studio—for your painting. Of course, you also need to avoid an overstated or labored painting. What you're aiming for there is a delicate balance, combining the freshness of a sketch with the illumination of further thought.

MAKING INITIAL STUDIES

In the studio I ponder my photographed subject, my jotted notes, and my recalled impressions as I go about developing preliminary studies. I begin with rough sketches as I try to determine the basic design. These are line drawings in which I look for the rudiments of spatial arrangements and arrive at initial size relationships between elements in the composition. Then I make a value plan to determine the patterns of light and dark. These value studies are often incorporated right into the line sketches.

The studies are small, usually only a few inches large, and done with a 2B pencil or softer. I'll usually make several such studies before I find what I want. I'm looking for a good pattern of light and dark relationships and interesting rhythms. If lights and darks are so disseminated in a painting that no pattern of continuity, dominance, or cohesion is discernible, then the composition is weakened, if not actually fragmented. Of course, at times you may want to create a subtle study in which neither lights nor darks are strongly evident—for example, you may want a painting featuring a narrow range of middle values. But even then you'd need some key note of interest—be it value, color, or some other statement—to give the painting interest. Remember, dominance!

Although color studies can be helpful, I don't usually stop the momentum of the value study by adding color. Instead, the colors in the painting grow out of my mental images visualized throughout the process of selecting, studying, and planning my subject. And these mental images continue as I bring my brush to the paper, attempting to rekindle my sensory reactions to the subject. It was Plutarch who once said that painting is silent poetry.

TRANSLATING THE POETRY OF PATTERNS

Forming the Concept

Along the California coast, a few miles north of Monterey and Carmel, I came across the setting for *American Mosaic*. It was totally unlike the usual coastal scene of bays, cliffs, and fishing towns. Yet there it was: a tapestry of the positive and negative, an excitement of powerful geometric and eccentric contours. Within all the man-made constructions, I saw a poetry of patterns. My immediate response was to the complication of shapes, which I wanted to interpret as abstract and intriguing involvements.

Deciding on Composition

As I studied my subject, I decided to make some changes. I shifted the large tangle of forms (1) to the left to offer more room for the eye to comfortably discover the shapes to the right (2). To invite an exploration of this maze, there had to be a "felt" relationship among the shapes rather than a clutter of aimless forms.

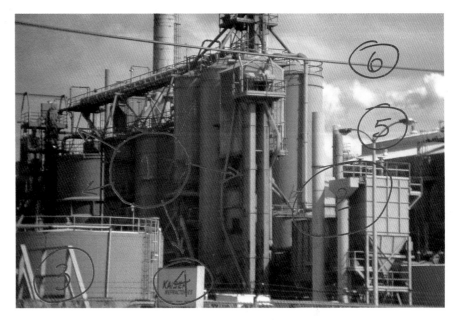

I also eliminated some "superficial" items: the angular shapes (3) and the sign (4) in the lower left; the streetlight (5), whose sleekness seemed out of character with the other shapes' ruggedness; and the detached, seemingly purposeless cable above (6). Admittedly, an engineer might be horrified, for I probably made the whole installation useless by removing and rearranging various parts. But, for me, the pictorial and design qualities were what was important. To rephrase Shakespeare: The painting's the thing!

The Pig and the Squeal

I'm reminded here of an incident during my first one-man exhibit. One of my paintings showed a railroad siding, with the tracks sweeping toward the horizon, punctuated by railroad cars of various types. At the opening of the exhibit, I noticed an elderly man who stared at this particular painting for long periods of time. He'd move on to the others, but he kept coming back. Finally, he came up to me and declared, "Young man, that painting is all wrong! I'm a retired railroad man and . . ."—whereupon he proceeded to admonish me for all the things that were "wrong." What he wanted to see, of course, were the very real "things" his expertise had conditioned him to see. Probably he would have been more gratified to see a photograph hanging there.

In my paintings now, as well as then, what I aim to capture is the spirit of the subject as I see it. It is an interpretive statement in which I create—through drawing, composition, value structure, and color qualities—the personality of the subject as I react to it. I once had a painting teacher who repeatedly instructed, "Study the pig, but paint the squeal."

American Mosaic, 24″ × 32″ (61 × 81.3 cm), Saunders rough watercolor board.

Taking Action with Paint

As the momentum of excitement and power built in my painting plan, it led very naturally to my decision to use powerful and somewhat unorthodox color. First, I brushed the sky with clear water and then introduced Winsor red, Payne's gray, and Winsor blue—rich, angry color in large pools, not too diluted in the mixing tray. By tilting the wet surface this way and that, I animated the color movement. The sky became an energized mass of color that mingled and contrasted with radiant darks.

I did not use masking liquid to protect the lighter parts, deciding instead to paint around them. After the sky had dried, I blocked in the largest areas, painting around the lighter, more delicate constructions. Spurred by my intention to create a vigorous statement, I chose to accent the larger forms with complementary colors. The glow of cobalt violet, for instance, was laced with raw sienna and raw umber (which are yellow enough to identify as complementaries to violet). Also, to dramatically set off the central patterns, I kept the right and left sides of the composition cooler in temperature and grayer in color. Finally, as I introduced the smaller constructions, I again resorted to "negative" painting, identifying the lighter shapes by painting the darker values around, between, and behind them.

INTERPRETING A SUBJECT'S PERSONALITY

Determining the Character

When I came across the view that inspired *Away from the Road*, I was taken by its classic content and the dramatization of planes, forms, and textures in the low-angle light. It was, if I remember correctly, about three o'clock on a crisp autumn day—the kind of day when part of the delight is hearing the snap and crunch of dried leaves as you walk. The magnificent fall foliage was no longer at its peak, but, with what was left, I envisioned a range of muted colors punctuated by dashing color accents.

Altering the Composition

Looking at my subject, I decided right off the bat to eliminate the automobile (1). As I saw the personality of my subject in my mind's eye, it didn't include the suggestion of gas fumes or noisy motors. Moreover, the car was badly placed as an element of composition. For similar reasons, I eliminated the road in front (2), extending the grassy area to make the foreground less "disruptive."

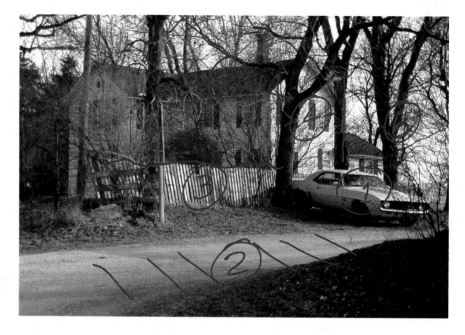

The fence (3), in contrast, seemed to me an ornament that properly belonged. Particularly appealing was the rhythmic note of its wavy contours—an effective counterpoint to the substantially structured house. By exaggerating its sway, I could direct the eye to the house in an easy passage from the unruly grass in front. Then, instead of making the verticals of the house parallel (4), I decided to lean them a bit to suggest a remote vanishing point somewhere above. This was done to add a feeling of foreshortening, making the house above the viewer, beyond reach.

With the trees, I felt that the design would be clearer if only the major ones appeared. To go along with the foreshortened perspective, they needed to diminish quickly in size and spacing (5). The tree just to the left of center became the weightiest one, with the one to its right somewhat less massive and the next, the least imposing. I eliminated the tree mass at the far right (6) to add some "air" toward the edge.

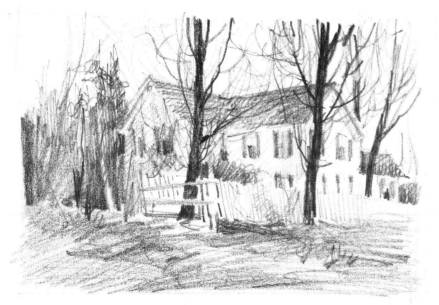

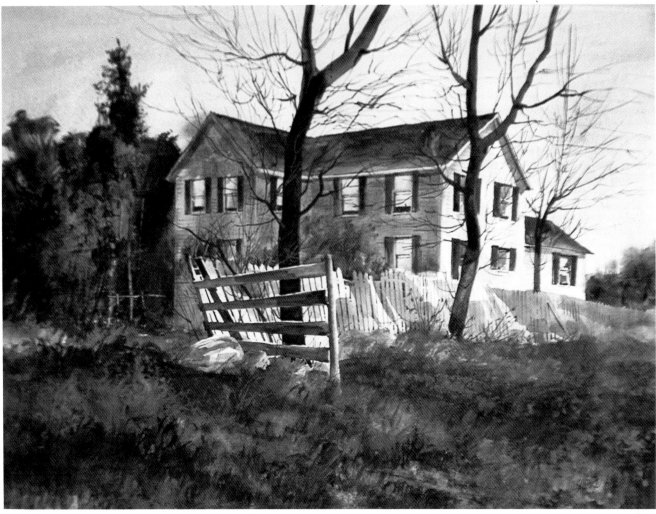

Away from the Road, 24" × 32" (61 × 81.3 cm), Crescent cold-pressed watercolor board.

Moving from Thinking into Painting

To get the painting off the ground, I drew the subject with a 2B pencil. For the fence, I indicated only a bit of detail—just enough to suggest the general direction of the pickets. Be careful that you don't "overdraw." Had I studiously detailed each and every picket, I might have been tempted to simply fill in my drawing with paint.

Taking a large brush, I began to mop a bit of cobalt blue, raw sienna, and *lots* of water into the sky. I carried this thin color right into the shadowed planes of the house and the trees, introducing other colors as I went along. Blues, violets, umbers, siennas, and greens all mingled in this first sweeping block-in. At the same time I began to make my value statement. I was careful not to work into the lighter house planes, the fence, and the light bit of rock, but just about everything else received a statement of color in the first three or four minutes of painting.

Turning to the lower parts of the house, I suggested the color reflected from the ground in order to anchor and secure the house. Some of the tree and grass textures were scumbled by pushing the brush against the paper's surface. To dramatize the scumbling effect, I used a slightly drier brush than usual. For other textures, I sprayed water into moist color and then blotted it with tissue. The spraying can be done with an ordinary garden spray bottle with a trigger handle.

The shadows playing on the fence were boldly brushed, using a sweeping hand and wrist movement. After they had dried, I "drew" the picket separations with a no. 5 red sable round. The dark trees and branches were painted last, going right over the lighter values of whatever lay beneath.

CONFRONTING A DRAMATIC SCENE

Finding a New Subject

Although, as I've indicated, subject matter is everywhere for us to observe, absorb, and translate, it's always stimulating to travel to less familiar areas. Often our eyes open wider before a fresh landscape. I love painting Colorado and I return there as often as possible. It is the perfect landscape counterpart to the simpler contours of my midwestern environs.

Exaggerating Compositional Elements

I decided to lift the tallest peak here (1) to suggest an even more dramatic and monumental form. The wisp of cloud that I've introduced (2), embracing the mountaintop, offers an ethereal note—an effective counterpoint to the stolid shapes of granite. Notice that I've reduced the height of the trees in the foreground (3) to further accentuate the immensity of the mountains.

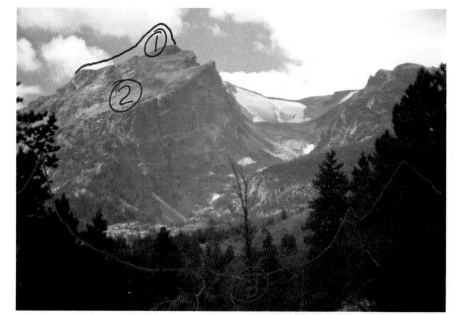

Translating Ideas with Paint

I wanted the huge mountain shapes to contrast with the less defined, almost nebulous sky and its wispy cloud. With this in mind, I began by painting the sky wet-in-wet, as though the mountains weren't there at all. The fusion of cobalt blue and cobalt violet, with just a trace of raw umber, was extended all the way down into the trees, where I interspersed olive green, burnt sienna, burnt umber, and Thalo green.

Only when the surface had dried did I introduce the mountain shapes and the low-hanging cloud, letting forms and edges blend into and fuse with the already painted sky. For the mountains, I chose cooler blues and earth colors to make these distant forms recede. As you can see, with the exception of a few snow patches, the value contrasts were also reduced to add to the feeling of distance. In the last step, the smaller, darker notes within the trees were brought out to further focus and project the foreground.

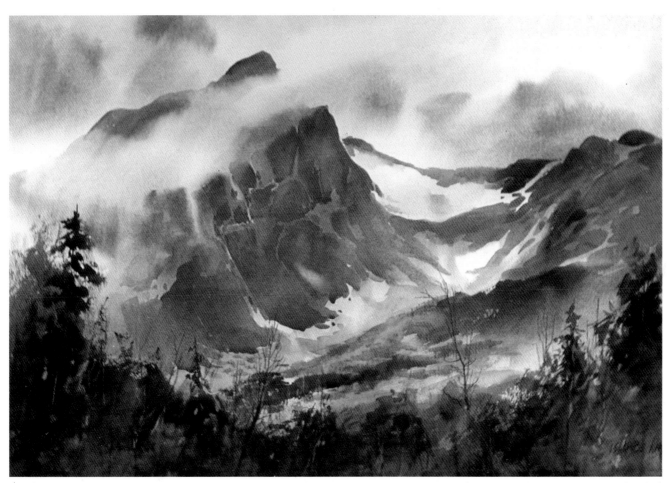

Colorado, 20″ × 28″ (50.8 × 71.1 cm), Whatman rough watercolor board. Courtesy of the Gallery of the Ravens, Estes Park, Colorado.

BRINGING OUT UNDERSTATED QUALITIES

Focusing on a Classic Subject

For me, the little town of Richmond, Illinois, has an irresistible painting presence; it seems almost eerily designed for the artist. Although I've found this aura of classic calm everywhere in my travels, it's especially prevalent in my native Midwest, where so many parts of the landscape are subtle rather than dramatic, refined rather than craggy, orderly rather than wild. It becomes a special challenge to interpret these understated qualities, with their characteristic flavor, in a way that brings out their visual and painterly interest.

Fitting the Concept and Composition

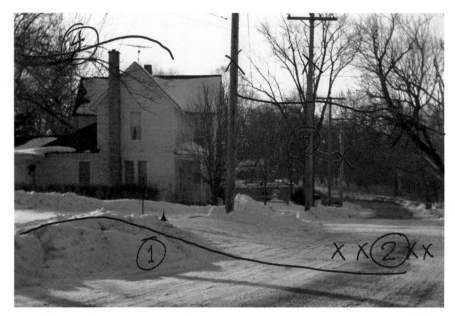

In contrast to the excitement and dynamics of *American Mosaic* (p. 44), in *So Quiet* I wanted to transmit the glow, the luminosity, of Richmond on a peaceful winter day. Looking at the scene, I saw the undulating contours of the ground as a foil for the contrasting geometry of the old farmhouse. At the same time the crisp, almost dazzling foreground was seasoned by the soft-edged middle distance and background.

Still, several adjustments were needed. I decided to give the mound of snow in the foreground (1) more fluid contours to echo the undulations in the middle distance and background. Also, by raising the contour of this mound, I created an overlap with the middle-distant plane, thus emphasizing the progression of planes in space.

To make the foreground plane more assertive as a mass, I eliminated the road (2), thereby creating an uninterrupted sweep of snow. I also took out the telephone poles (3), which disturbed the graceful flow of the composition. Moreover, I wanted to reduce the impact of man-made statements.

Finally, I embellished the contour of the distant trees (4) so that they, too, would add to the sinuous movement of the composition. Even the house was given a slightly nebulous contour here and there to reinforce the lyrical motion.

Developing the Painting

To begin, I wet the entire upper area of the paper with a soft sponge. Then, using a 1″ (25 mm) flat, I brushed in large passages of color, letting the cobalt blue, raw sienna, cobalt violet, and burnt umber mingle. I used an equally wet brush for the foreground, but here I kept the paper dry so that I could control hard as well as soft edges. For the foreground, I used the same colors (mentioned above), but with less burnt umber so that the overall color would be less gray and the plane would project.

When all this had dried, I returned to the farmhouse and its surrounding interests to refine their character. I concentrated on the roof, the windows, and accents of value contrast. Then, in the foreground, I introduced the darks of the grass and earth peeking through the snow. The fine tree shapes in the middle and distant planes were painted last, using a small brush called the Repique.

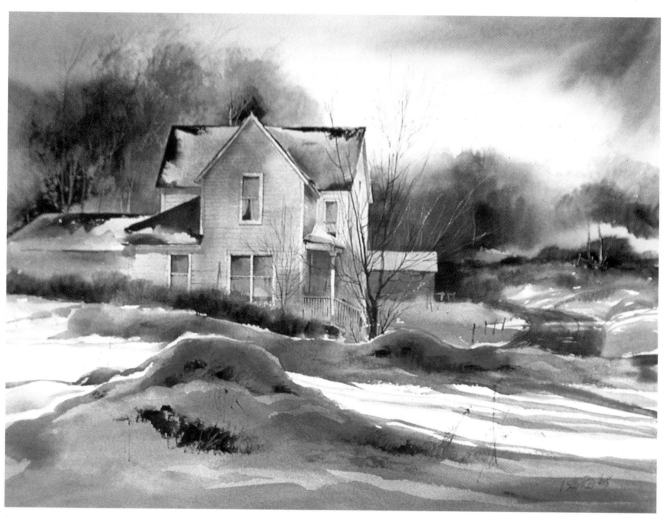

So Quiet, 20″ × 28″ (50.8 × 71.1 cm), Whatman rough watercolor board. Courtesy of R. H. Love Galleries, Chicago.

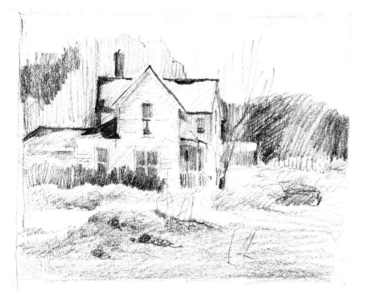

Demonstrating Painting Techniques

I've always felt painting demonstrations to be an essential feature of my teaching. Some contend that providing examples of painting approaches lures students into imitating the teacher. But don't we also learn through imitation? Shouldn't we be allowed to recognize influences where we can, and then thoughtfully determine how we'll use them for our own ends and advantage? Aren't those who dispute the value of demonstrations doing a tremendous injustice to the students, in effect saying that they do not have the ability to determine how to investigate and use the teacher's example without simply mirroring it?

Of course, at first, students are very likely to show the teacher's influence. In fact, I've always felt that if the paintings of those who are at the start of their studies with me do *not* carry flavors of my work—some reflection of my attitudes—then there is a problem. Either the student is resisting my message, or I'm not communicating. On the other hand, I am disappointed and disturbed to see that someone who once studied with me has stopped evolving his or her own personal style. It saddens me to see those who are no longer curious, who have muffled the excitement of exploration. Without an eager inquisitiveness and interest in experiment, there can be no individualization of painting style.

How, then, should you look at my demonstrations? Remember that observing a demonstration is not an observance of gospel. It is simply the viewing of a possible approach to a painting problem. Watch what I do, figure out if and how it relates to your intentions, and then take a leap forward and begin exploring on your own.

CAPTURING THE FLOW OF A MOUNTAIN STREAM

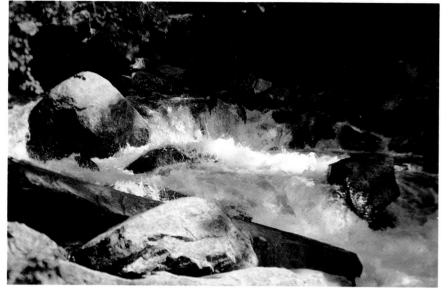

Standing next to (almost *in*) a mountain stream in Colorado, I was entranced by the movement of the water against the immovable granite. The lacy filigree of the water struck a note of whimsy, as though nature were frolicking in between the no-nonsense stoicism of the boulders. The smile and the frown. The elusive and the forthright. How could I translate the chords of these emotional responses into a visual language? My view of the subject began to blend with considerations of pattern, color, and composition. I wanted to intensify certain elements to evoke sensory responses—enriching the light, exaggerating textures, and tuning up the rhythms.

I begin the painting by working into the water with a range of colors that includes cerulean blue, olive green, burnt sienna, and raw sienna. I dilute the colors somewhat in my mixing tray, but I don't mix them there—instead, I let them mingle and flow together on the paper. Encouraging color to mix on the paper often gives it a radiance and clarity, which can be lost in the common tendency to overmix color in the palette. Notice that my pencil drawing is minimal, simply establishing the placement of the main shapes. The brush I'm using here is the Morilla no. 202 1″ (25 mm) ox-hair flat. It's a super painting tool for broad, sweeping statements!

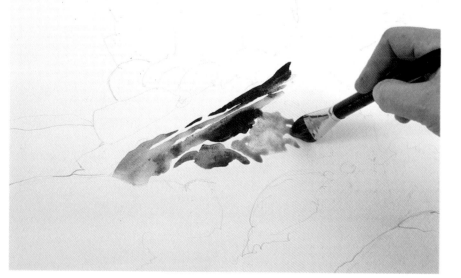

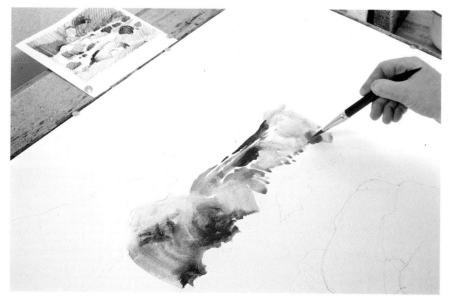

Color continues to be added—*lots* of it. Remember that the dynamic qualities of painting can be smothered by timid approaches. Note that I don't keep the water and the large rock to the left separate at this stage of the painting. On the contrary, I try to determine how inclusive the handling can be as the painting is blocked in. You can see how I've tacked my value sketch to the top edge of my drawing table. My paper surface—Crescent cold-pressed watercolor board—is secured to the drawing table by letting the heads of tacks grip its edges; the tacks aren't driven through the surface of the board.

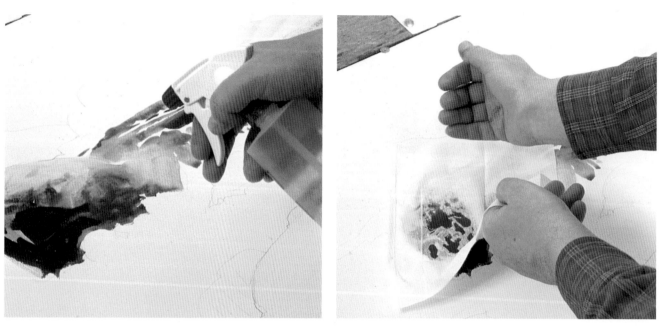

After introducing Thalo blue and burnt sienna in an almost undiluted state within the rock, I dilute the rich, dark color by spraying water into it. Splashing water into color in this way creates fascinating textures as the droplets of water run and merge on the paper. It's an excellent way to capture textured surfaces like rock. Then I use facial tissue to blot the water sprayed into the rock. In the closeup on the right, you can see the mottling that the spraying and blotting technique has created in the rock's surface. I continue, now, with the churning water, using cerulean blue, cobalt blue, cobalt violet, and olive green.

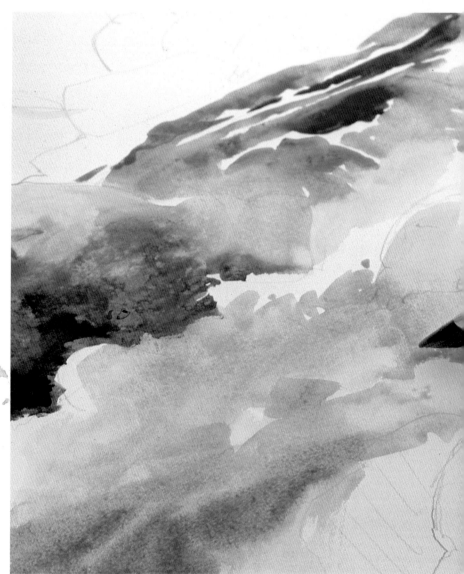

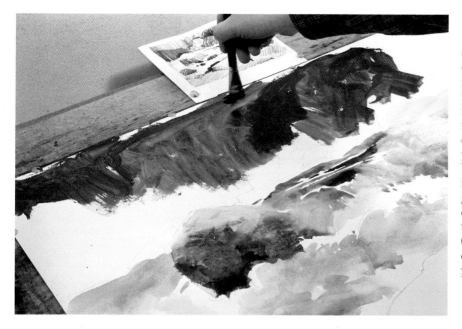

Leaving the water for the moment, I brush liberal amounts of potent color and value into what will become the background plane and the far shore of the stream. The colors include Thalo green, Thalo blue, olive green, burnt sienna, raw sienna, raw umber, and burnt umber. I don't use much water because I plan once again to dilute the colors by spraying water into them. Spraying will not only texturize the background, but it will allow the various colors to fuse and mingle—avoiding the feeling of partitioned colors (colors that are too removed from other colors within the overall plane.)

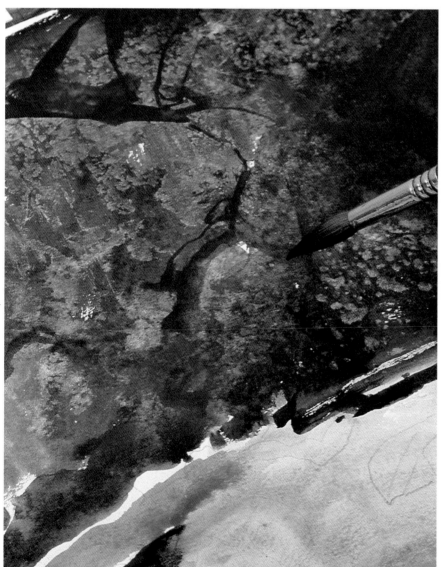

In this closeup you can again see the mottling created by spraying and blotting. The surface has dried, and I now define some of the individual forms within the mass with a no. 12 round brush.

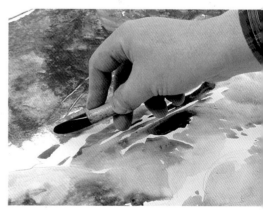

While the surface is still moist, you can scratch it to bring out delicate light shapes. I'm doing this with the back of my Morilla no. 202 brush, which is beveled expressly for this purpose.

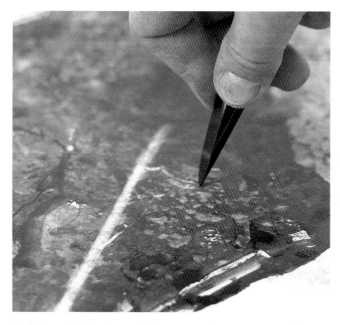

The large light shape that you see here, representing a fallen tree, was wiped out with a damp brush. With a relatively smooth surface like the Crescent cold-pressed watercolor board, you can wipe out lights more readily than on more textured, "toothier" surfaces. I continue to scratch out more delicate lights with the back of the brush.

Another trusty tool for scratching color when the surface is still damp is your fingernail. I tell my students that they can forget about manicures once they begin their studies with me. Actually, I've pondered the possibility of a special painting manicure, trimming each fingernail to a different shape so that I can *really* be inventive when scratching color. Convention, so far, has gotten the better of me. And when I'm finished painting, I take up a small scrub brush, the kind used by doctors and nurses, before facing the world outside.

Leaving everything that's been done so far, I lay in the mass of the foreground rocks, using warmer colors to reinforce the projection of these elements. Notice how the direction of my brushstroke follows the contour of the rock. There are many times in painting when you can think of your brush as a sculpting tool as you "carve" the forms. The water in my water container isn't as dirty as it looks, by the way. My rule of thumb is that if the brush stands up in the water by itself, it's time to take that trek to the sink for a fresh supply. Kidding aside, if you think your water is dirty, test some of it on a scrap of paper. You might be surprised to see how clean it still is. A large water container will keep your water fresher longer.

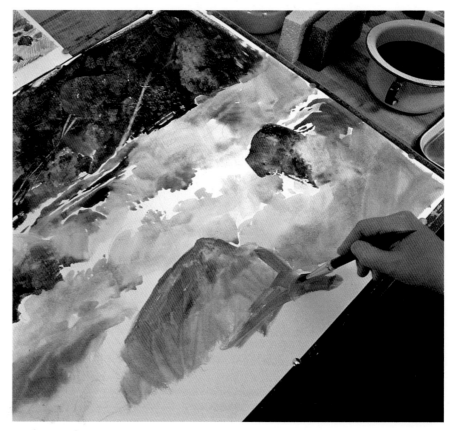

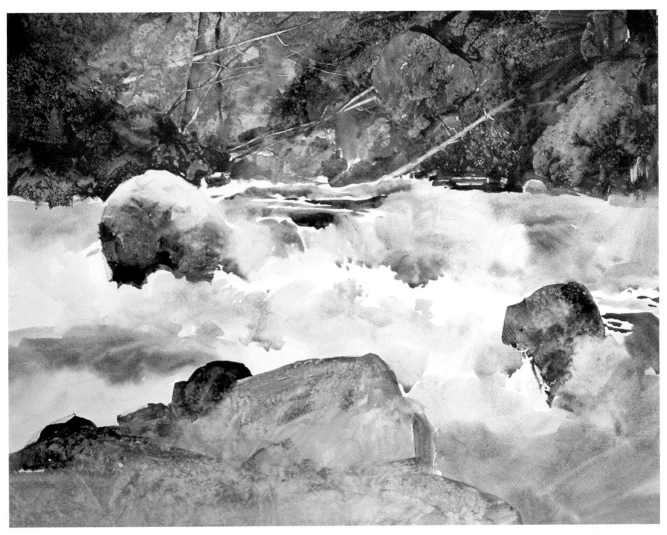

Let's pause here to survey all that's happened so far. Compare this with the original photograph and the finished painting (p. 61).

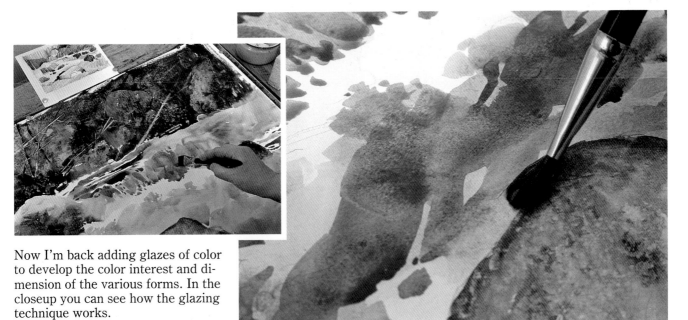

Now I'm back adding glazes of color to develop the color interest and dimension of the various forms. In the closeup you can see how the glazing technique works.

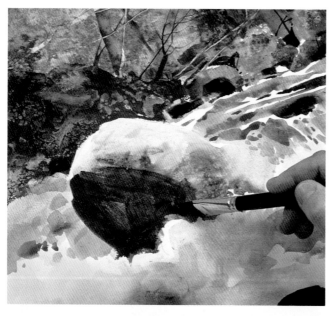

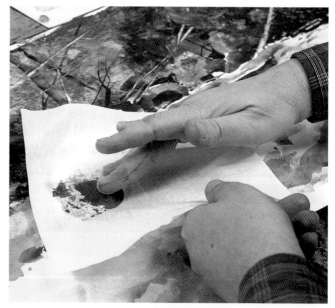

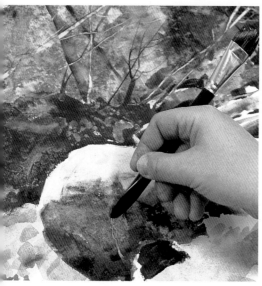

I've decided that the rock is not dark enough, so I deepen it with Thalo blue, alizarin crimson, and burnt sienna. After spraying the dark with water, I again blot it. While the surface is still damp, I scratch out a bit of light reflecting from the water with the back of my brush. Then I indicate crevices and cracks with darker color and a smaller brush.

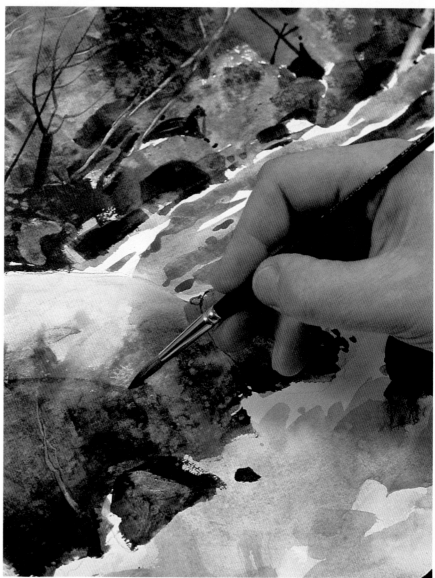

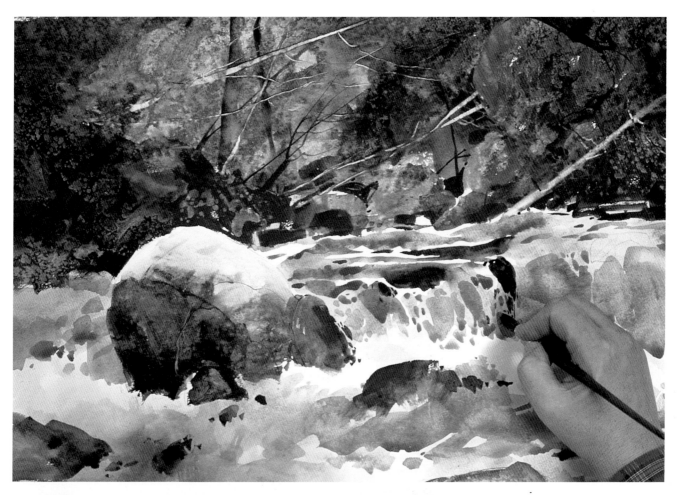

This is the area of the composition I want to be the most commanding, so it gets special attention. I concentrate on the character of the rushing water. The play of dappled light, the faceted shapes in both the water and the rock, the transparency of the water, the swirl and dash of the water's movement—these are the qualities and feelings I hope to capture. As you can see, the paper itself plays an important role in the painting. I consider that the white paper is part of my palette.

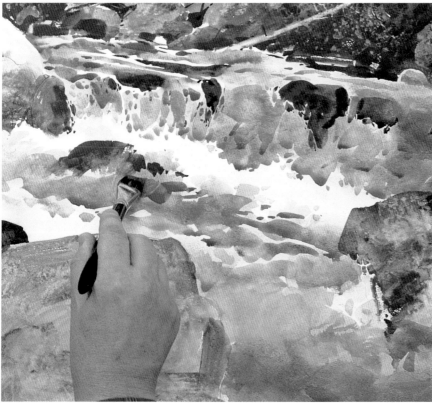

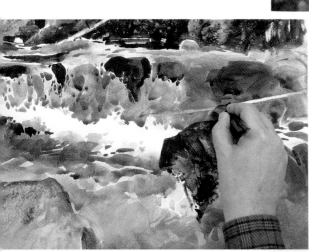

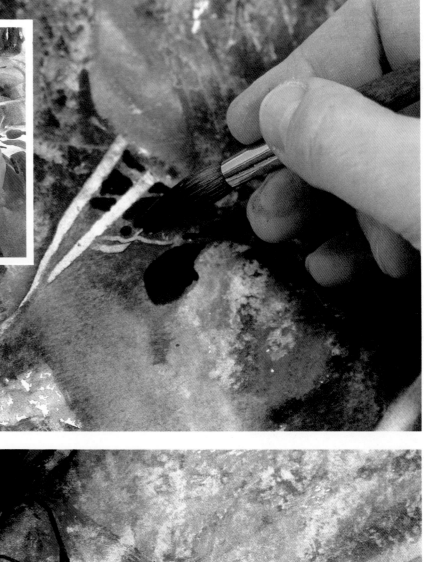

Here I wipe out a light with a damp Morilla no. 202 brush. Lifting lights in this way gives them a soft edge, so that they seem somewhat diffuse.

At the right you can see how I paint behind and around parts, identifying them by their negative shapes. The forms emerge here not by my painting them directly, but by my painting in the space *outside* them.

In this closeup you can see how the calligraphic use of the brush suggests fractures and patterns within the masses of the rock.

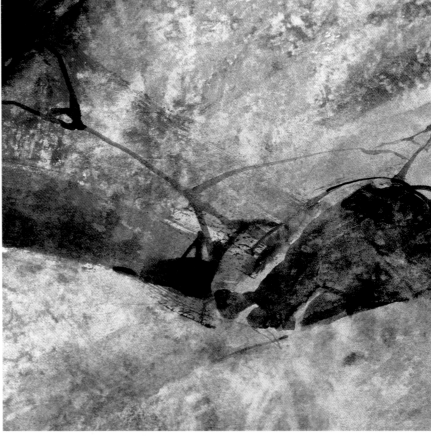

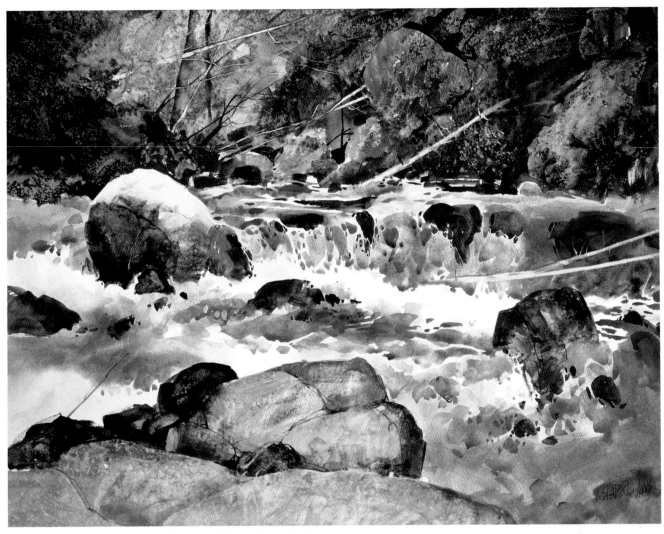

White Water, 24″ × 32″ (61 × 81.3 cm), Crescent cold-pressed watercolor board. Collection of Mr. and Mrs. Clinton E. Frank.

Here you can see some changes I made to translate my feelings for the subject. The shift in the boulder's contour (1) makes it less of a clumsy lump, and the altered rock shapes in the lower left (2) avoid the slablike appearance of the "real thing." Simplifying the background mass (3), while enriching its color, lends animation to the more distant elements. The design of the water surface (4) also provides a sense of pattern and heightened movement. To capture the subject's radiance, the lights (5) are developed as abstract shapes and made more contrasty. Areas of secondary interest (6) are reduced in contrast, color, and definition, thus strengthening the center of interest. In all, the composition is deliberately arranged to encourage the eye to flow (7). Even the fractures in the boulders elaborate on the sinuous rhythm.

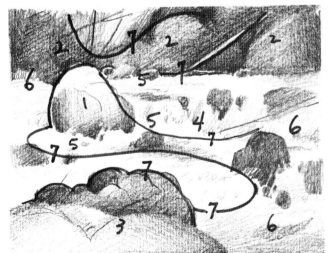

Note what I've been looking at all along— the image on my rear-projection screen.

DEPICTING A BARN IN QUIET LIGHT

This subject typifies, for me, the midwestern rural theme. At the time I saw it, the almost iridescent glow of light further dramatized the forms of the landscape. It was all waiting to be painted.

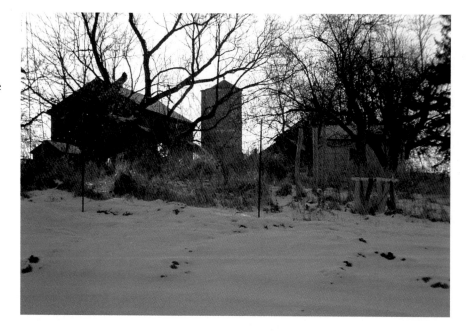

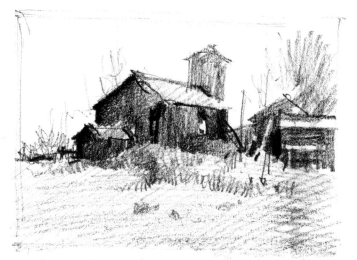

The preliminary value sketch is a must in helping me decide how to present my subject. The eye sees the subject, but the mind orchestrates the artist's intention, effort, skill, and—*so* important—spirit. The value sketch sets all these wheels in motion, but perhaps its chief importance is that it helps detach you from the literal features of the subject. Compare this sketch with the photograph. Can you see what liberties I took with the arrangement and composition of the original subject? Note how I try out these ideas on the left of the sketch. I wanted to see what would happen when I emphasized the contour or crest line of the major structures. I also wanted to develop an informal rhythm. The sketch is broad and roughly prepared, but it's the nucleus of the painting as I envision it. By the way, I use a mechanical pencil, the Koh-I-Noor no. 48. It's made in Italy and holds extra-heavy graphite and crayon sticks. It's a superb tool for broad, quick, bold notations.

I develop the drawing underlying the painting with a 2B pencil. In this shot I was demonstrating in one of the studio classrooms at the American Academy of Art, so I am working from a 5″ × 7″ (12.7 × 17.8 cm) print to avoid the encumbrances of a projector and rear-projection viewer. (You can see the print in my left hand.)

I squeeze generous amounts of fresh color into each of the wells in my palette, a sixteen-section Grumbacher slant tray. I insist on painting with freshly squeezed color so that I can count on the full potency of my pigments. If any of these colors remain after the painting's completion, I simply put some more fresh color on top at the next painting session.

To let the first wash of color flow and blend freely, I wet the entire surface, going right over my drawing, with a 1½″ (38 mm) Winsor & Newton no. 631 ox-hair brush that I keep for this purpose. Now I brush a large graded wash of cobalt violet and raw umber into the wet surface, working quickly so that the board doesn't dry, and adding water so that the wash lightens as it continues downward. (Incidentally, the watercolor board has been taped at the edges to a large piece of lightweight ¼″ [6 mm] Upsom board for additional stability. The Upsom board has been propped slightly at the top edge so that the washes will settle downward.)

After letting the first wash of color dry, I apply another wash (or glaze) right over the first, using cobalt blue and raw umber. The surface is dry at this point, so I have to be quick in adding the next stroke of color or water, or edges will form.

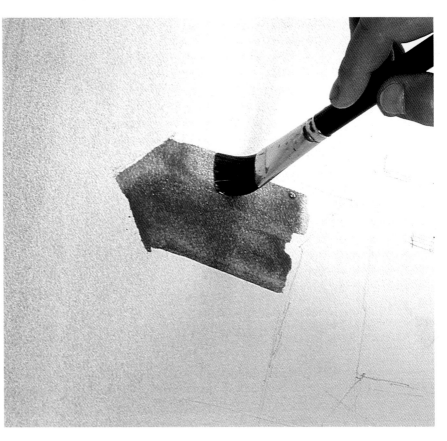

After letting some of the drying take place naturally, I speed up the process by using a hair dryer. Don't use the dryer too soon, though, or the value of your color will dry much lighter than you expect. (To test the dryness of your paper, use the *back* of your finger, not your fingertips. The back of your finger is more temperature-sensitive than the tip; it's also less oily.) On the dry surface, I start painting the local color and value of the silo. I'm not going to develop it too much, though, since I want it to feel more recessed than the foreground elements.

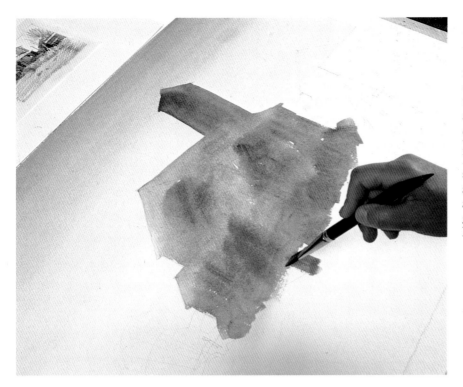

At this point I'm not concerned with "things," but rather with the overall mass. I'll pull specific interests out of the mass later. I do, however, introduce a variety of color as I go along in order to provide at least the essential beginnings of what will later become more descriptive. Here permanent blue, alizarin crimson, burnt sienna, and raw sienna are allowed to flow and mingle. As I approach the dried shrubs and grass, I add a bit of cadmium red light for warmth.

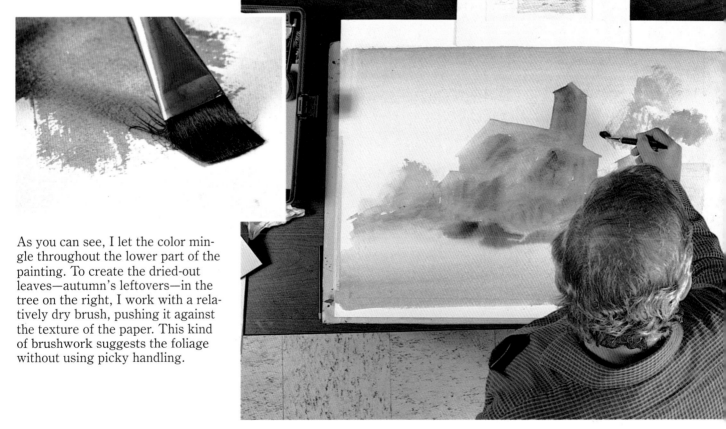

As you can see, I let the color mingle throughout the lower part of the painting. To create the dried-out leaves—autumn's leftovers—in the tree on the right, I work with a relatively dry brush, pushing it against the texture of the paper. This kind of brushwork suggests the foliage without using picky handling.

Take a close look at the silo; I've given it another wash to add form and substance. Except for final details, it's now complete. The first large wash gives the color and value I want for the barn's roof. Now it's time to turn to define the left plane of the barn.

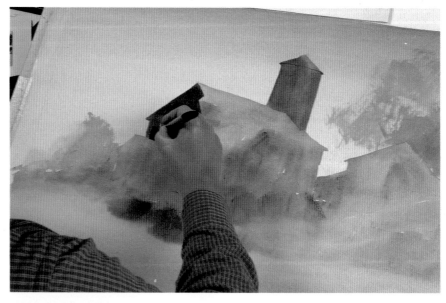

As I deepen the value on the side of the barn, I keep the handling wet. Observe the pools of liquid color settling at the bottom of the brushstrokes.

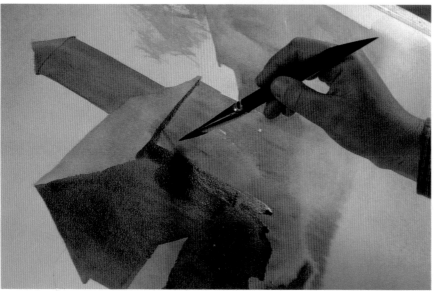

I continue the wet handling right into the browns and oranges of the ground scrub and also into the cooler snow colors. These patterns add interest to the foreground plane.

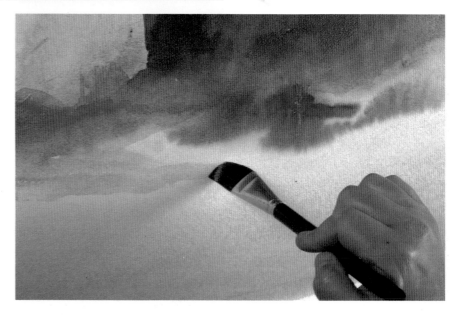

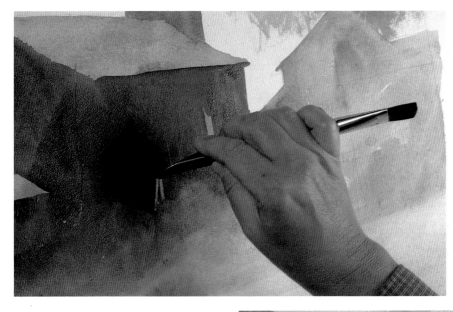

While the surface is still damp, I scratch out a couple of lights with the brush handle to bring a note of relief to the dark mass.

Now I start to glaze other parts, keeping the reflective roof areas the original color of the first large wash.

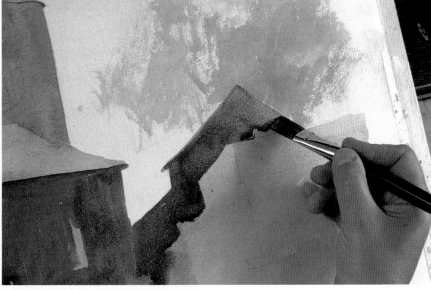

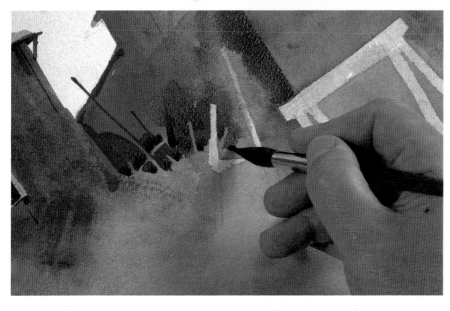

Notice how I paint around certain shapes, revealing their silhouette through "negative" painting.

I lay in another bold wash to bring the color and value of the foreground plane to its final statement.

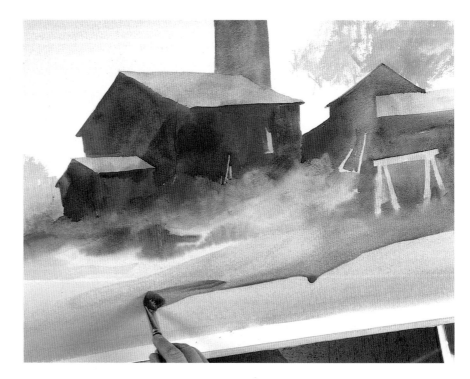

Now I push darks into the trees at the left. By this point I've also added a few watercolor stains to my hand.

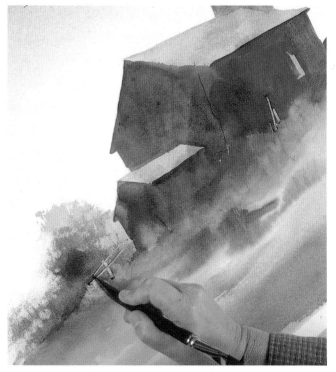

With the beveled edge of the back of the Morilla no. 202 brush, I bring out some of the fence patterns.

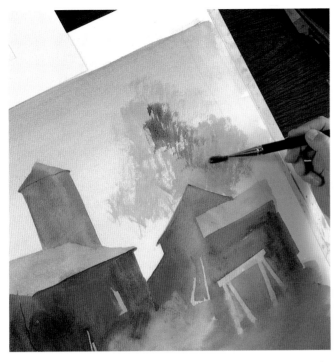

To give the tree in the back a hint of texture and volume, I again push damp color into it.

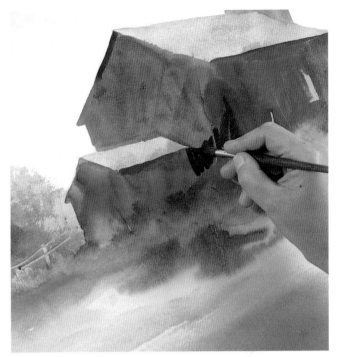

It's time to strengthen and further describe the key elements. Here I add form and detail to the large barn.

Using a no. 12 Kolinsky round, I continue to refine the painting. Notice where I've lifted color for subtle statements within the grass and the branches of the smaller shrubs.

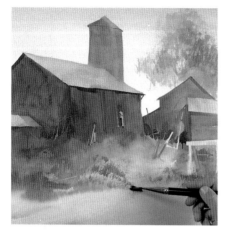

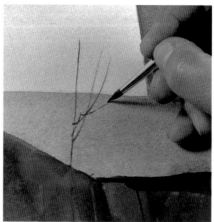

Pushing a damp brush is similar to scumbling in oil painting. Here it helps to lend character to the ground plane.

For the delicate branches of this small tree, I choose a brush called the Repique. It's shaped much like a sharpened pencil—ideal for detailed statements. Beware, though! The overuse of any small brush may invite a supercautiousness and pickiness that can well destroy any feeling of dash and vitality within the painting.

A single-edge razor blade is used to scratch out a few delicate lights when the paper has dried.

To relieve the solidity of the grass, I lift and blot a diagonal of light with the damp edge of a flat brush.

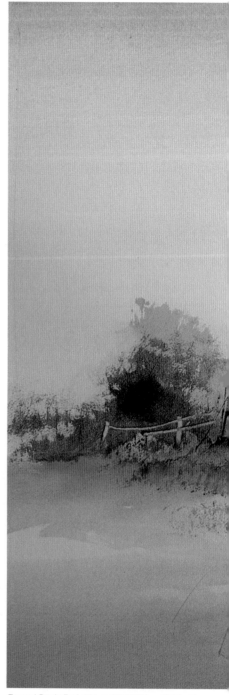

Toward Day's End, 20″ × 29″ (50.8 × 73.7 cm), Whatman rough watercolor board.

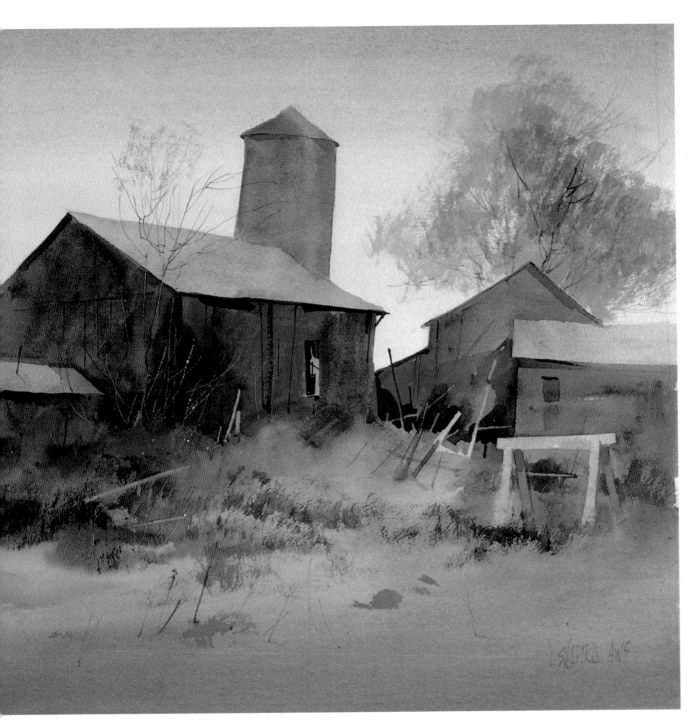

The moment of truth comes with the finished painting. Has the painting become what I wanted it to be? Simply enough, I saw my subject as a landscape in repose, blanketed in the not-uncomfortable chill of a fresh snow cover. Dashes of contrasting warm color coupled with structures that had gained character and patina through age. I wanted to present strong shapes with foils of subtle shapes, dynamic contrasts harmonized with muted statements. And I wanted to capture the quiet mood as the day's end approached. I think I got it.

DESIGNING THE PATTERN OF FISHING BOATS

I found this subject in Gloucester, a medium-size town on Cape Ann, just north of Boston. It's a classic New England fishing community, offering painting subjects that seem to have been created expressly for the watercolorist. Although the years have taken their toll, what with the incursion of shopping malls and superhighways, the town has somehow hung onto its character to a surprising degree. The golden arch has not yet, at least, crowded out the boiled lobster. There's an earthy feeling of old New England lore despite the modern trappings.

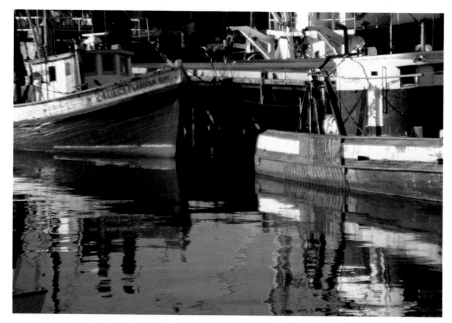

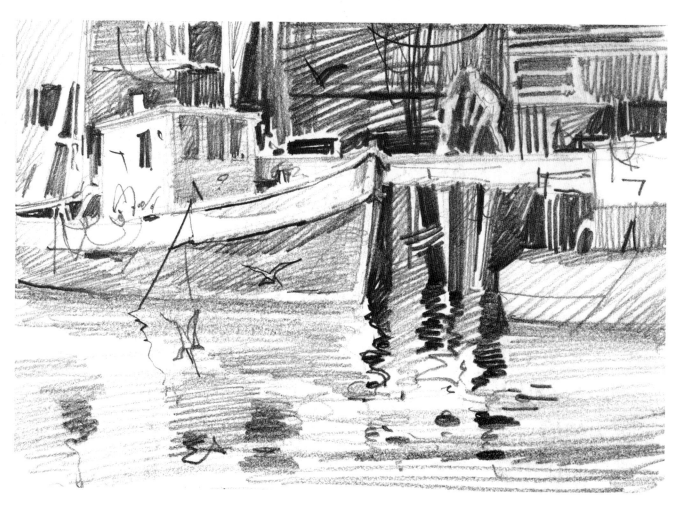

I decide to introduce a couple of shore birds and a small figure to animate the scene. But I don't want to worry about painting around these elements—that would restrain the handling too much, interrupting any large, rhythmic brushwork. So I choose a masking liquid, which provides an easily removed shield that protects the whiteness of the paper underneath. Here I'm using a brand called Maskoid. First I wet and thoroughly soap my brush; then I dip it into the well-mixed liquid latex. I've already masked the two birds; now I'm protecting the figure. Remember to wash the masking material off your brush right away. Although there are solvents that will remove dried latex from your brush, it's better not to let the substance dry there in the first place. Also, whichever masking liquid you try, read the directions carefully. With softer-surfaced papers, it's a good idea not to use masking liquid at all. You'll find that when you later remove the frisket (another name for masking liquid), you're likely to pull some paper fibers with it. Test your paper first. With Arches, a hard-finished paper, I've never had difficulty with shredding when the frisket is removed.

With my painting plan in mind, I establish a rich dark right away. This helps to set the value key for the painting. Here I choose Winsor blue mixed with burnt umber and alizarin crimson for the background plane. The fishing nets are suggested with raw umber, cobalt violet, and raw sienna.

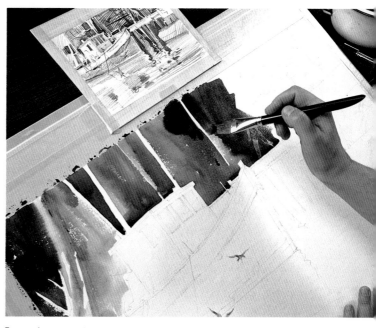

I continue to develop shapes and patterns within the distant planes, establishing the design and characteristics I want to suggest rather than depicting literal form and content. I simply find it more interesting to explore feeling than to report fact.

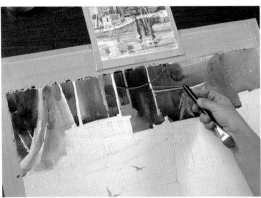

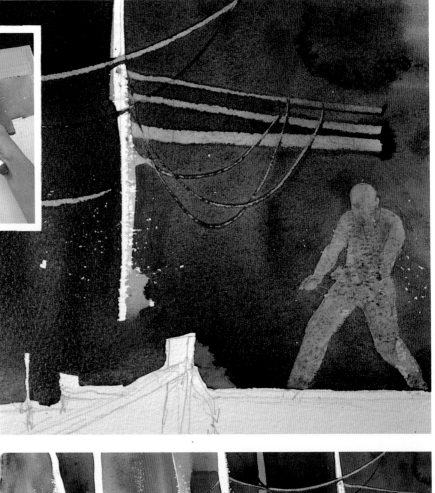

As you can see, the washes have "slashed" right across the masked figure (who might be called Zorro). Now I use the back of the beveled handle of the Morilla no. 202 flat brush to scrape out lights. Although this suggests the ropes and poles, what's most important for me is the statement of pattern and rhythm. Look closely at how the figure has been painted over. Also note where the brush handle removed color to draw form.

In the background I intentionally muted the color. Now, as I begin to paint the boat, the color is less grayed. This helps to project the boat as a central interest. My colors are cobalt violet, cobalt blue, and raw umber.

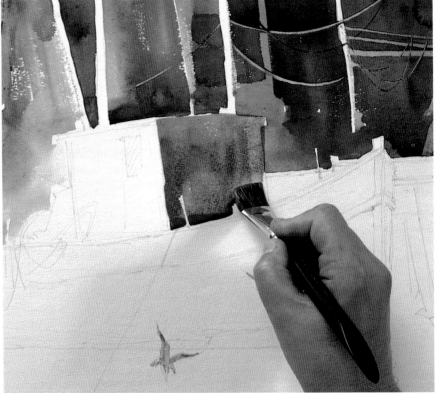

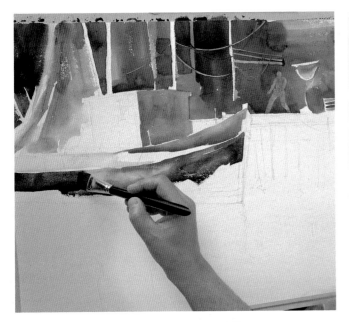

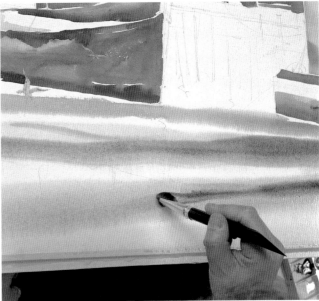

Continuing to paint the boat, I allow Winsor green, olive green, burnt sienna, and raw sienna to mingle on the paper.

After wetting the water area with my Hake brush, I sweep in strokes of burnt umber, olive green, and cerulean blue. Because the paper is quite wet, I keep it in an almost flat, untilted position to assure control in handling the dripping wet color.

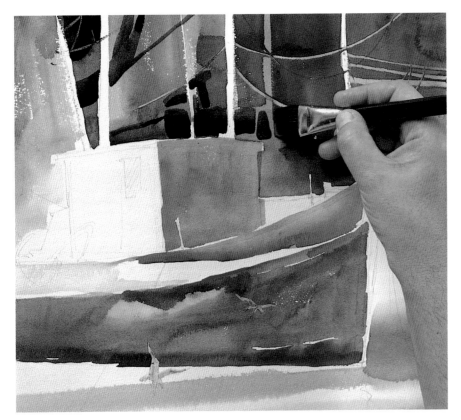

Leaving the water for a while, letting it dry, I go back into the background to bring out additional shapes and patterns. The background is now becoming more three-dimensional in character and feeling.

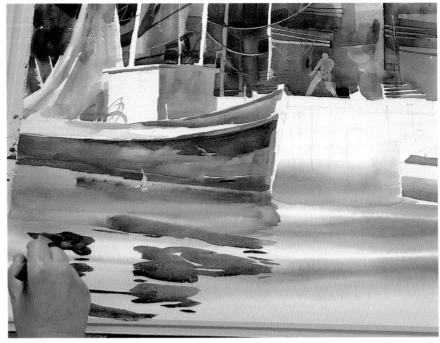

More geometric patterns emerge. This kind of emphasis simply feels right for the personality of the painting. Once the water area has dried, I begin suggesting reflections (right). I keep the color of the reflection grayer than the color of what is being reflected. Notice how the distortions of the reflections suggest the undulations of the water surface.

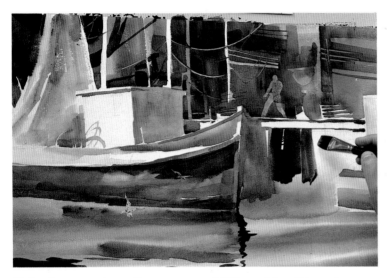

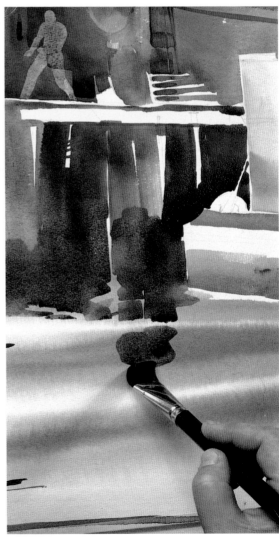

Using burnt umber, olive green, and Winsor blue, I introduce the dark, but colorful pilings.

As the pilings are painted, I carry the brush right into their area of reflection, to convey the feeling that the pilings are *in* the water, not *on* it.

I continue to develop the shapes and patterns of the reflections. Note, by the way, that I've used only the 1″ (25 mm) flat brush so far. No commandments are broken if you use smaller brushes, but I like to use larger brushes for as long as possible. It helps to create bold statements, with an eye to the overall images.

To check if the paper is dry, I use the back of my hand. Remember that the back of your hand is more sensitive to dampness and less oily than your fingertips.

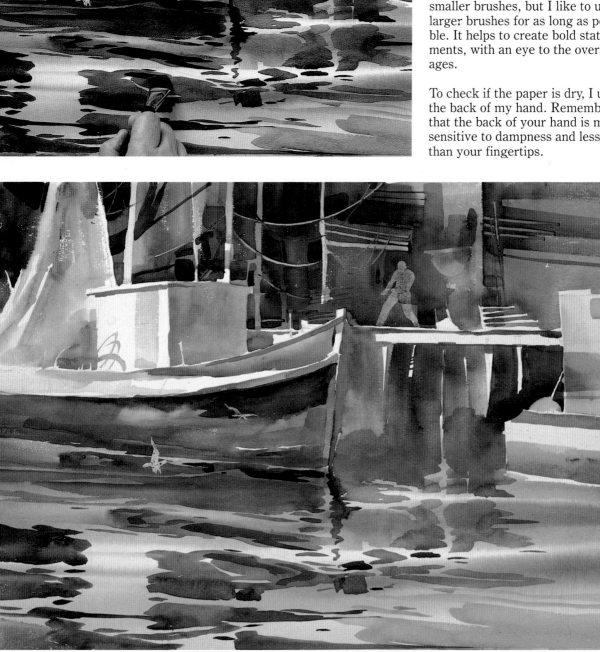

When I'm about halfway home, I loosen my hold on the painting momentarily to reflect more objectively on where it's going. Does it feel right? Yes, so let's go on.

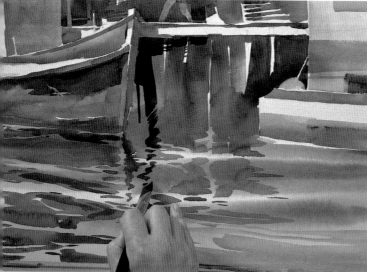

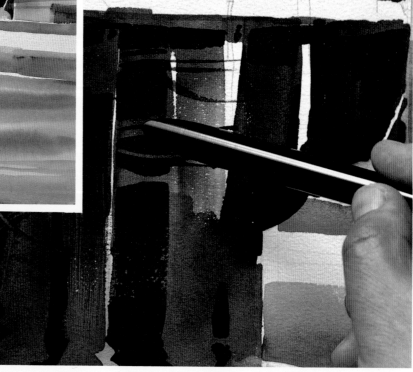

I accentuate the darks in the pilings and their reflections to increase the feelings of depth and further dramatize the value scale. With the back of the brush handle, I then scrape out the rope and tethering from moist color.

Using a small, pointed brush, I now suggest the netting. Be careful at such moments. It's easy to overdo this kind of detail and wind up with tedious busyness.

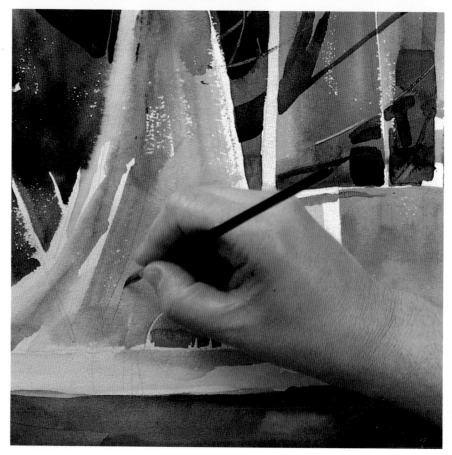

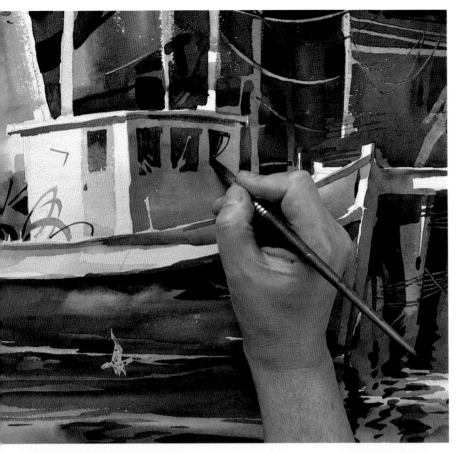

For this kind of detail, I use a no. 12 Kolinsky sable. Here I add patterns within the window shapes to bring out the lively play of light.

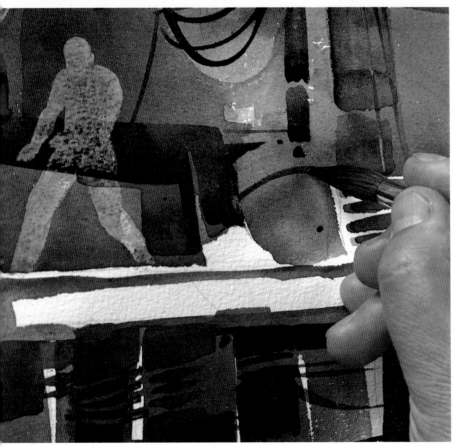

Now I turn to details around the figure. Then, when everything is dry, I lift the Maskoid with a pick-up eraser, which is simply a square of crepe rubber.

By introducing a little color within the birds, I lend them some substance.

Our friend Zorro also gains in stature with some detailed brushwork.

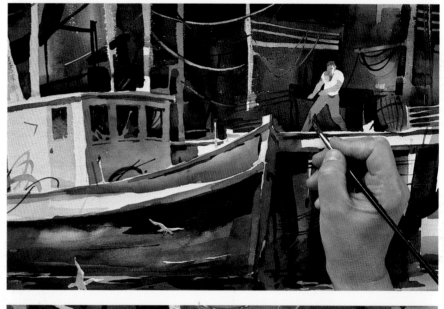

Our friend seems to be pulling something, so I gently scrape out a line of rope with a mat knife. The paper, remember, is dry, which permits the scuffing you see here—the scratching of dry paper so that glints of unpainted paper are revealed.

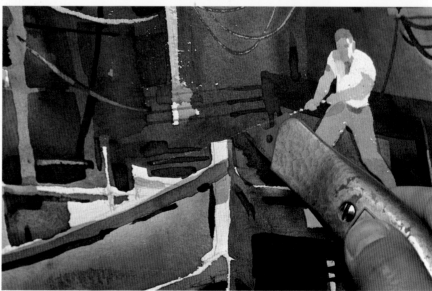

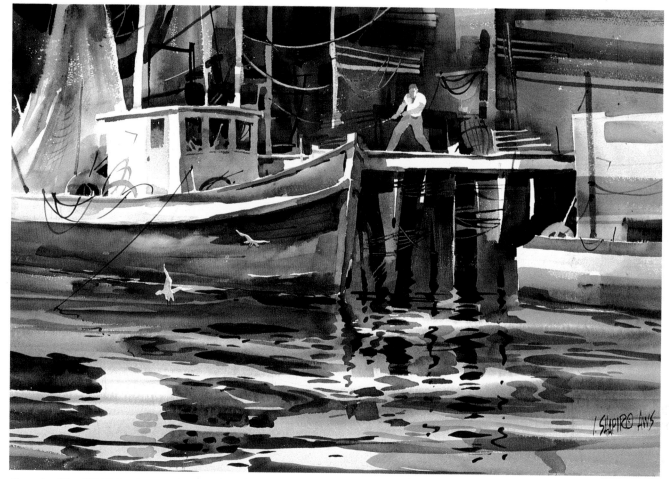

Gloucester, 18″ × 28″ (45.8 × 71.1 cm), Arches rough watercolor board.

Here's the completed painting. In evaluating a demonstration painting, I ask myself whether or not I've imparted certain messages concerning technique and purpose to the student or viewer. What I hope I've shown is how to use masking liquid, when to abstract and simplify shapes, and a few considerations in translating water surfaces. If, in watching me, you've had a bit of sheer fun, then that's an extra dividend.

RENDERING PEACEFUL HOUSES AT DAWN

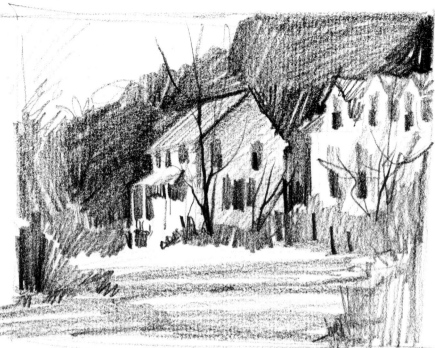

I don't usually get up early enough to watch the sun rise. But it can be a stirring experience to wait, full of anticipation, for the first glance of morning light and then watch it creep slowly onto the landscape. I knew when I saw this subject in Rockport, Massachusetts, one afternoon that I wanted to see it in the still, pristine first light of the next morning.

I begin with a pencil drawing based on my value sketch. To establish the appropriate atmosphere and light, I broadly sweep cobalt blue, a little cobalt violet, and a touch of raw sienna into the sky area, which I first wet using my 2″ (50 mm) Hake brush. The masking tape that you see at the edge holds the watercolor board to a wooden drawing board. Later, when it's peeled off, it will provide a mat of sorts, enabling me to view the result without the distraction of crude, messy edges.

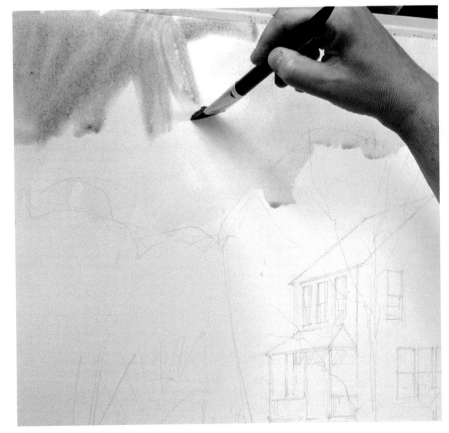

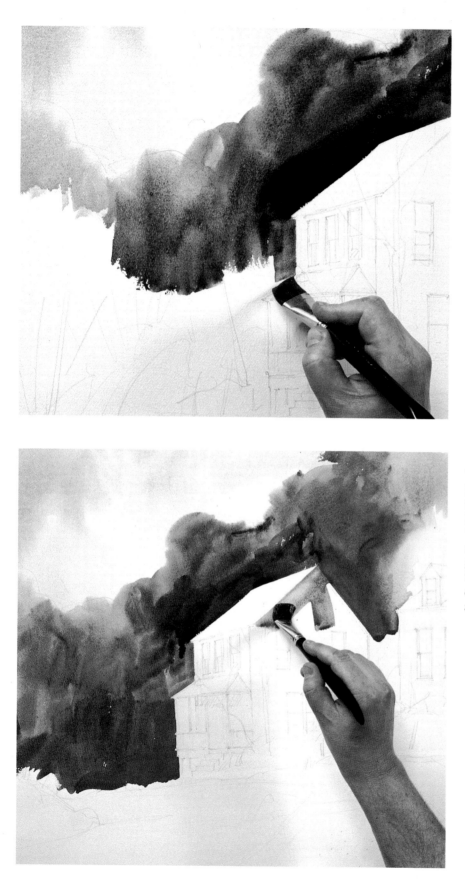

Before the sky dries, I begin to introduce bold shapes of color for the planes of the trees in the middle distance and background. The fusing of color as the wet trees touch the wet sky enhances the sense of distance and atmosphere.

While the colorful mass of foliage behind the house is still wet, I start to lay in the shadowed plane of the house. Don't just think of painting "things." Unless you first seek out and paint large patterns, without regard for their edges and inner details, you'll end up with a fractured composition in which the parts are all detached.

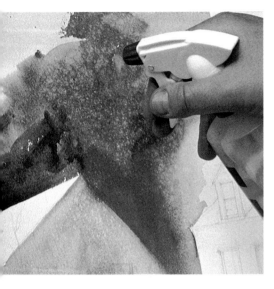

I spray droplets of water into the still-damp color of the foliage and, by blotting with a tissue, augment the texture created by the spray.

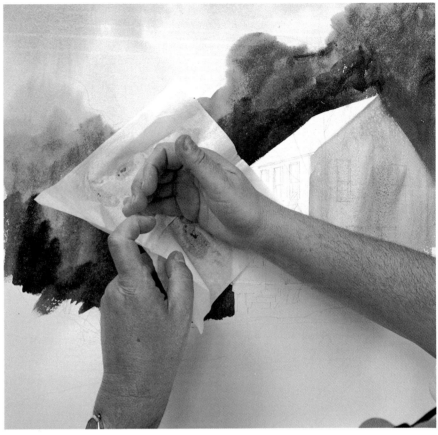

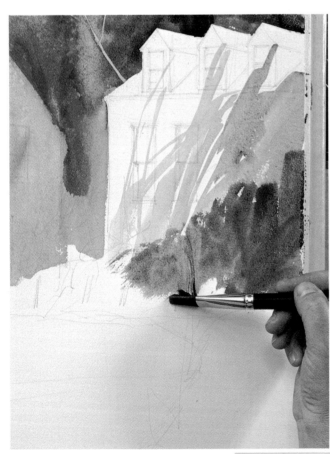

After loosely brushing in some strokes across the left building to suggest the shadows from trees and shrubs, I start on some of the shrubbery itself. Notice how the colors are mingling. The colors here—alizarin crimson, burnt sienna, raw sienna, and cobalt violet—begin to suggest the drama of the early morning light.

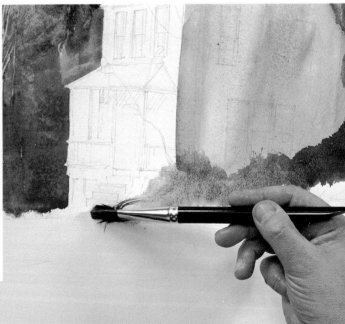

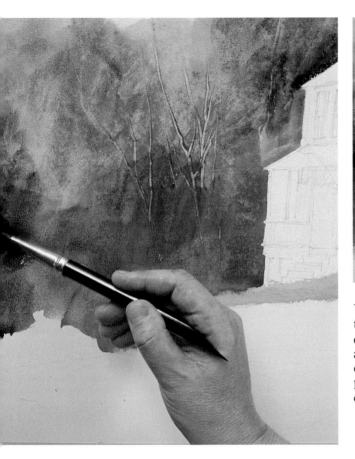

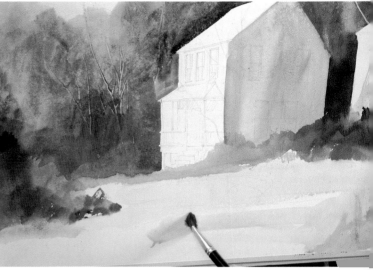

You can see that I've scraped a few tree shapes out of the damp color area. For pattern and volume, I introduce burnt umber and brown madder (a color that I added to my palette for this painting). For the road, I choose a light tint of raw umber and cobalt violet to provide some warmth. It also reflects the expanse of color intended to permeate the composition.

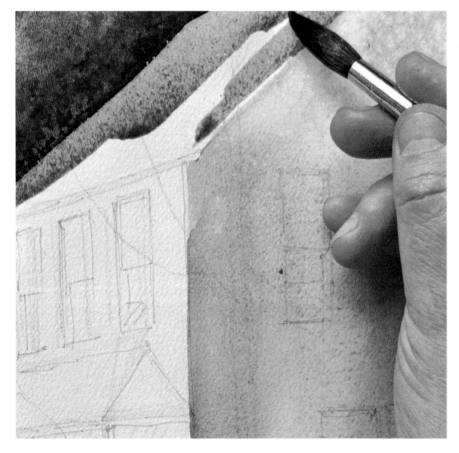

The roof takes on a green cast, but I keep its temperature warm, in line with the surrounding color. Olive green, cerulean blue, and burnt umber are used.

Turning to the other structure, I gray the color even more. I want this shape to be less important in the composition.

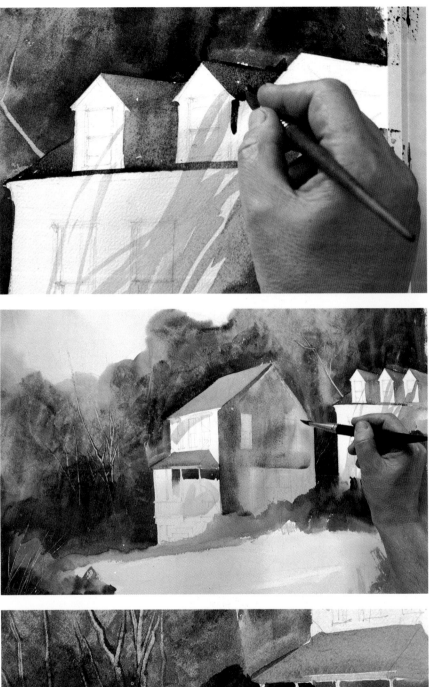

I apply another wash to the shadowed plane of the left house and use the original wash for the lighter values in this area.

Against this rich, dark foil of Winsor blue and brown madder, the contours of the porch emerge.

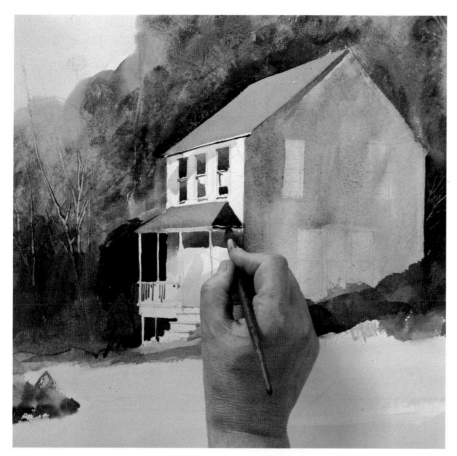

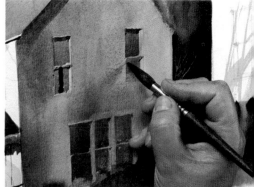

Now I suggest additional architectural elements. This is what I call necessary detail. I don't want to get caught up in tiresome descriptions, but I need enough indication of character to make the house come "alive."

Once again, I paint behind a form to identify a contour and to create a harder, more specific edge.

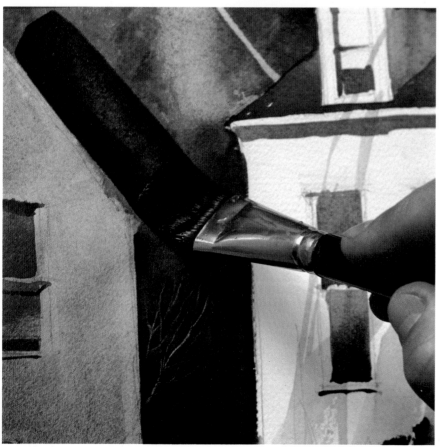

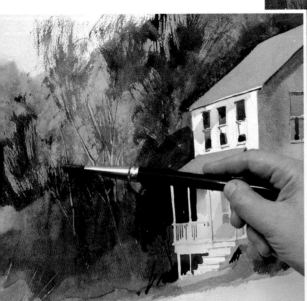

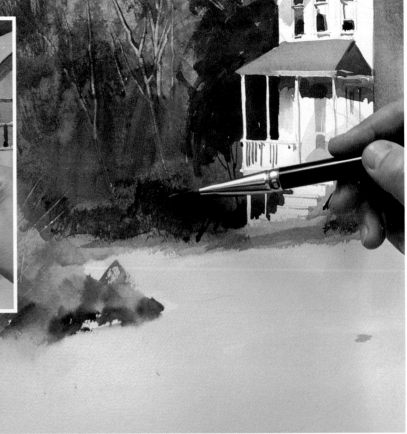

Now I scumble the paint by pushing the edge of a brush wet with dark color against the texture of the paper. I let the brush lightly skim the paper. Notice how I hold it to avoid too much weight from my hand. More scumbling suggests the airy shrublike shapes.

Using permanent blue, alizarin crimson, and burnt sienna, I carry a few long shadows across the road. Here I keep the color fairly pure, not muting it too much, in order to forcefully indicate how the road extends into the foreground.

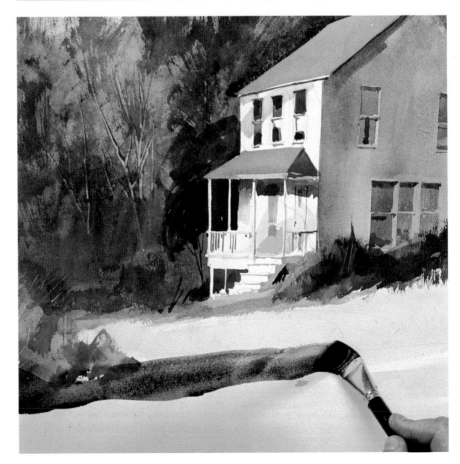

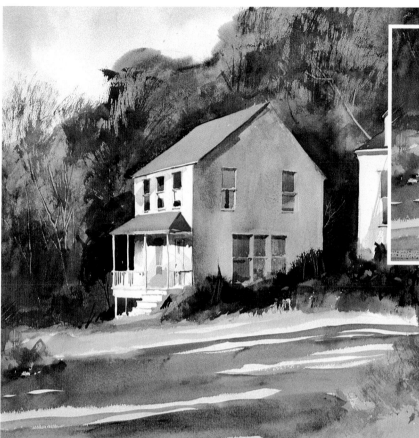

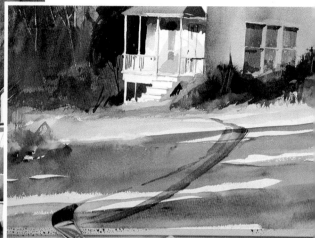

Observe how the shadows on the road in front are broader than those in the middle distance. As they become shallower and more foreshortened, these shadows convey the spatial progression of the plane. It's a matter of a basic principle of perspective. Once the road is dry, I clarify its progression from the foreground to the middle distance with strokes that follow its direction back.

By adding details—the posts, branches of shrubbery, and other accents—I provide a little seasoning, augmenting the flavor of the landscape. Notice that a few blades of grass were lifted out in the foreground toward the left in order to project this plane even more.

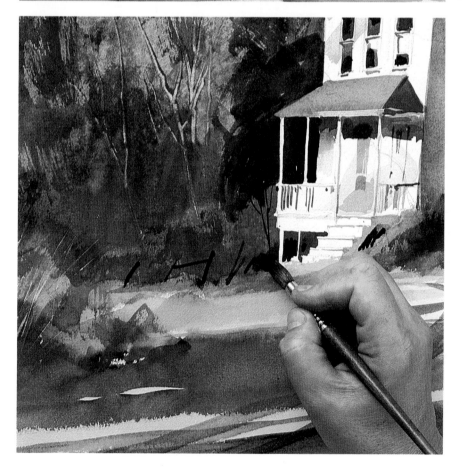

Using a smaller brush, I delineate the tree limbs and finer branches. The drawing of the tree shapes and the way they overlap other elements adds dimension to the study.

To add spice to the color range, I use a touch of cadmium orange here and there. Not indiscriminately, but where it will punctuate features in the composition. To get these dashes of rich color accent, I use hardly any water.

After surveying the painting, I decide to reinforce the projection of the foreground by darkening some of the values.

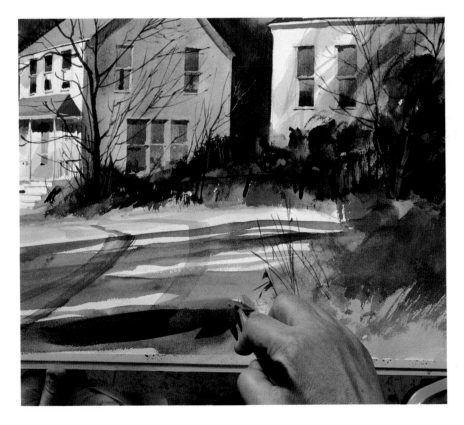

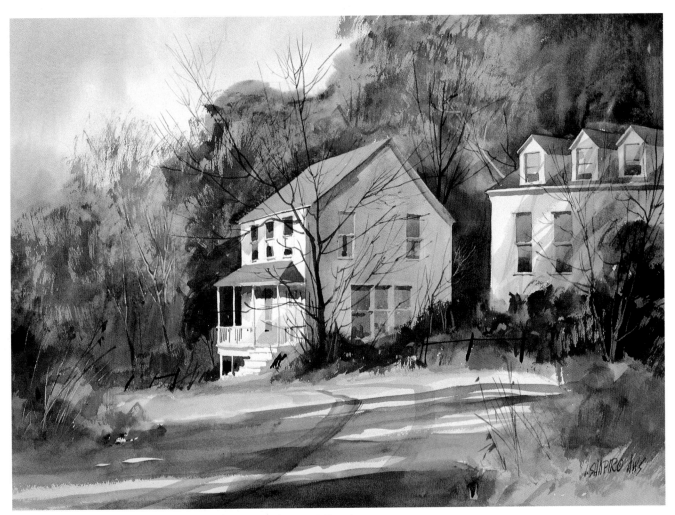

Morning on the Cape, 21″ × 29″ (53.3 × 73.7 cm), Saunders rough watercolor board.

When I look at the finished painting, I must admit that it was worth getting up at 4:00 in the morning! I wanted to convey the geometry of the houses, while setting them off with counterpoints of light and color.

Painting in the Studio

One question that comes up with some frequency is: What is the difference between a painting done during a demonstration and one done in the studio? To me, the answer is that demonstrations are ways of carrying on a visual discourse intended to inform, enlighten, and trigger the observer's awareness. I aim to stimulate feelings that students can then relate to their own efforts, however they choose to paint. Using this definition, a demonstration is visual commentary offered as example; it is meant to be a shared experience.

In contrast, in doing a studio painting, my total focus is on what is going on for me—there is no other onlooker. The studio painting is, then, a completely introspective effort. Energies flowing from inside take expressive form, which in turn feeds my senses and evokes my reactions.

In short, demonstrations are concise announcements of purpose and method, while studio paintings are thoughtful statements intended to fulfill the painter's aims. Thus, my demonstrations fail when they don't advance the interest and comprehension of my students, and my studio paintings fail when they don't achieve my intimate, personal objectives. Of course, I hope viewers will enjoy both types of painting at a purely sensory level.

INSIDE MY STUDIO

Whenever I see a photograph of an artist's studio showing ORDER and looking like the ultimate in architectural and interior design, I react.

First, I find myself recoiling at the thought of painting in a setting that seems to demand tidy work habits. I break into a sweat just thinking of the possibility of dropping brushes or splashing walls and floors. I would be intimidated by surroundings that call for tailored jeans and a Bill Blass shirt.

Then comes the gnawing realization that I'd like to try it—for a while, at least. My problem is that I'm sure that in about one hour that designer's gem would become the studio I'm known for among my family and dearest friends—a mess. Not exactly a disaster, more the result of a smallish tornado. To those whose eyebrows lift even slightly when they see my studio, I respond, "But I know where everything is."

Walls of books, cabinets upon cabinets, closets stuffed to overwhelming—all this and more occupies my studio, which measures about 16 feet (5 m) square. It's not really a small studio, but it's filled with decades of memorabilia and equipment. The uncharitable have called it debris. To me, it's special—my painting home. It's the place where parts of this book have been written and where most of the paintings in it have been created.

1. My *drawing table* is stained with mementos of about twenty years of painting. It measures 32″ × 42″ (81.3 × 106.7 cm) and is mounted on a cast-iron base with a ball-and-socket connection so that I can tilt the tabletop in any desired direction.

2. The *white porcelain butcher tray* that I use for mixing colors measures 13″ × 19″ (33 × 48.3 cm). These trays aren't easy to find anymore, but plastic trays are almost as good. I would suggest, though, that you roughen the plastic slightly by wiping a bit of moistened scouring powder into it when it's new. This will prevent the pools of liquid color from crawling—gathering into a single ball. But test the palette first to make sure this procedure is necessary.

3. I put my colors into the wells of a sixteen-section *Grumbacher slant*, which is placed along one of the longer edges of my mixing tray.

4. My *water container* is a training pot or, as it's known in less discrete circles, a thunder mug; I've had it for almost forty years. I remember searching through shops for the ideal water container—something that wasn't too heavy, that wouldn't break if dropped, and that would hold a fair amount of water. It also had to be clear or white, so that I could see the condition of the water easily. Not only did I find the potty that met all these demands,

but it even had a handle for easy carrying in the field.

As an aside, I was once speaking to a friend about the difficulty of sketching in the field because of the glare of sunlight. A short time later, my friend, at the time a hat manufacturer, surprised me with a baseball-type cap with one unusual feature: an enormous brim that fanned out to cast a shadow on any paper that I might be sketching on. Another handy item for outdoor sketching is a large hot-water bottle, which I fill with my water supply, since it can't be assumed that water will be available at the sketching site.

5. For *studio lights* I have two different fixtures. In the two-bulb fluorescent one, I use either Duro-test or Verd-A-Ray bulbs. These, as well as others made by General Electric and Sylvania, are manufactured specifically to approximate as closely as possible natural northern light. However, I still find them a bit on the cool side for my taste, so in the fixture above my drawing table, I use the Sylvania circle fluorescent bulb. This lamp also takes a single incandescent bulb. That one 60-watt bulb provides the note of warmer temperature I find necessary.

6. This is the *rear-projection viewer* that I use for my slides. What you see in this photograph is the outside screen that I can see from my chair. I set the screen at a distance far enough from my working area to give me room for comfortable movement. (Some advice: If your projector has a cooling fan and it stops while you're working, turn the machine off immediately or your slide will melt! Also, keep a spare projector bulb on hand—should it burn out, you'll kill the momentum of your painting by the time you get a replacement. Talk about frustration!)

7. Although you can see several dozen *brushes* stuck into a variety of mugs and jars, I paint with only the three or four that are next to my palette: a 1″ (25 mm) flat ox-hair, a no. 12 round Kolinsky sable, a no. 5 or 6 round Kolinsky sable, and a no. 6 Kolinsky sable Repique. The latter is a short-bristle brush, almost pencil-shaped, which is great for stating the most descriptive detail. It's also ideal for signing your paintings.

8. The *shutters* on my large windows, which overlook Lake Michigan, have adjustable louvers so I can control the amount of outside light. At times the bright light reflected off the lake is far too brilliant for studio use.

COMPARING STUDIO AND DEMONSTRATION PAINTINGS

You may be surprised to see two paintings of the same subject. As I've indicated, there's a difference between demonstrating in the classroom and painting alone in my studio. For me, a demonstration is a "to-the-core" experience, demanding a direct statement that involves and enlightens the onlookers. A studio painting is a more intimate experience, providing gratification only for me as the painting develops. If it's to be shared, let those happy times come later.

Changing My Mind
I started with this value sketch for *Early Morning on the Cape*, but after a few seconds I knew it would never do. The rooftops, the distant crest of the trees, and the embankment at the foundation of the buildings all lined up in parallel movements (1). Instead, I wanted enough variation to let the eye circulate within the composition. Moreover, the road (2) was too centered in the foreground plane, which was, in turn, parallel to the bottom edge (3). These static features were aggravated by the strictly horizontal cast shadows on the road. The lack of fluidity really bothered me.

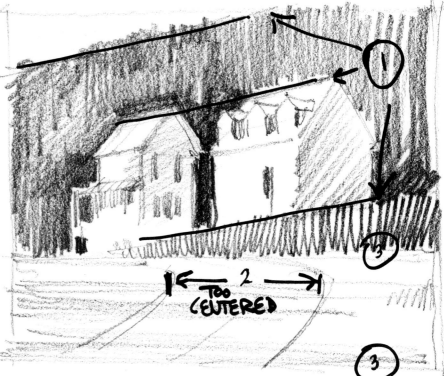

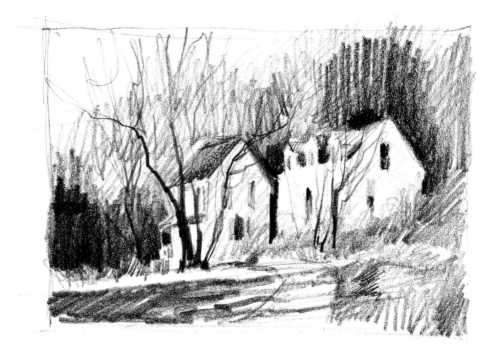

94

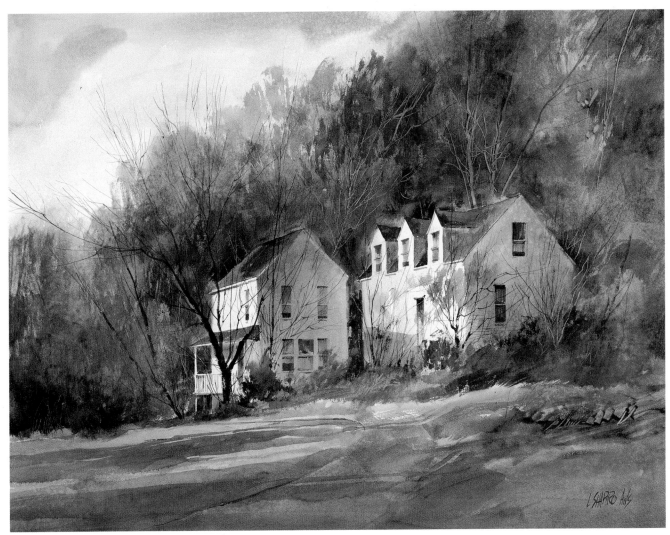

Early Morning on the Cape, 24″ × 32″ (61 × 81.3 cm), Saunders rough watercolor board. Collection of Mrs. Diane Jastromb.

Adding a Personal Flavor

When you compare this studio painting with the demonstration of the same subject, you'll find that the methods and techniques are the same, the order of presentation is the same, and the interest in light and atmosphere is the same. Nevertheless, certain differences immediately stand out. In the studio painting I've decided to show all of both houses, and there is more subtlety in the foreground color and shapes of the shadows. Most important, this painting has been carried to a level of introspection that is not possible in an open-forum demonstration. Many of the refinements here reflect very personal touches that serve no real function in a demonstration.

Morning on the Cape.

PAINTING SIMILAR SUBJECTS

Certain subjects hold a particular appeal for me. I've already described what drew me to *Gloucester* (see p. 72). On the other side of the country, just north of San Francisco, Bodega Bay presents an equally intriguing melange of shapes and action. Like other coastal towns that depend on the fishing industry for their survival, it has a no-nonsense singleness of purpose. I like that purity of objective.

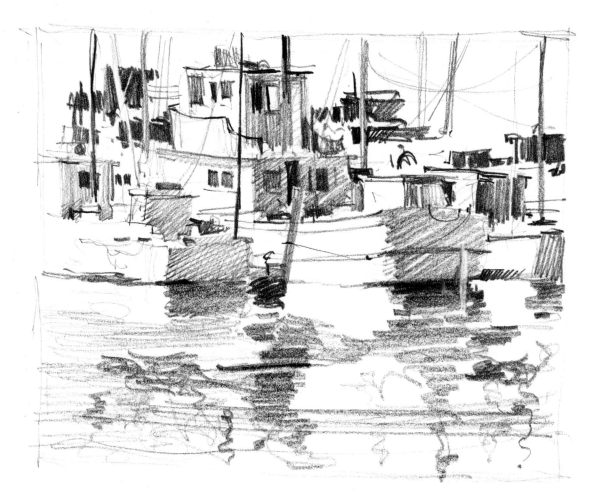

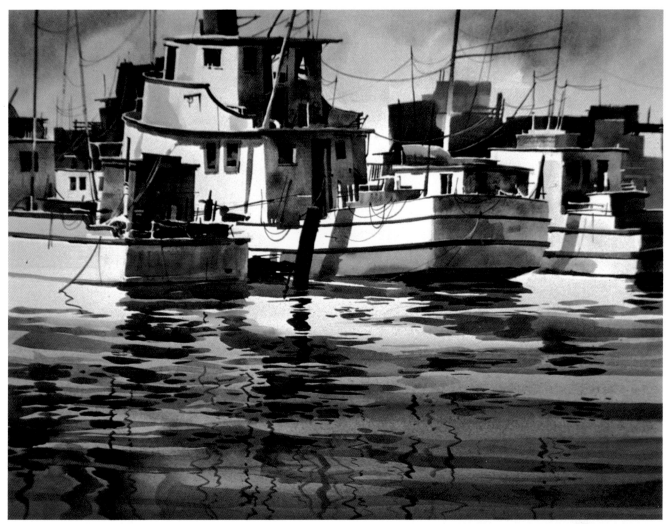

Bodega Bay, 20″ × 28″ (50.8 × 71.1 cm), Saunders rough watercolor board. Courtesy of R. H. Love Galleries, Chicago.

Capturing the Spirit

As man-made constructions, boats have precisely defined shapes with clearly delineated planes. Thus, my drawing for *Bodega Bay* was more studied than it would have been for natural shapes and textures. I do not, however, feel a compunction to be literal in expressing these forms. Know them, yes. Understand them, yes. But if my painting is going to have impact, the graphic interpretation must echo the *spirit* of the subject.

Be Daring

William Merritt Chase once said, "Don't hesitate to exaggerate. Don't worry about stretching the truth. The most tiresome people—and pictures—are the laboriously truthful ones. I prefer a little deviltry." And these words were spoken by an academician, not by someone who advocated a casual painting approach.

Painting in my studio, I feel free to experiment and perhaps take more liberties than I might in a demonstration painting. With *Gloucester*, you saw, step by step, how I handled the painting of boats and water. Here the technique is similar, but it's a more personal statement. I've followed Chase's advice. Look closely and you'll see where I've simplified elements and where I've invented shapes to embellish the pattern and composition.

Gloucester.

CONVEYING A POINT OF VIEW

When you compare the two paintings here, you can find obvious differences in arrangement and color. However, the chief difference for me is one of atmosphere and mood; the paintings have two entirely different personalities. It doesn't matter that the same location provided the inspiration for both—they speak different messages to me.

Sounding a Wrong Note

As I was getting my thoughts off the ground for *The Crest*, this early rough was discarded without hesitation when I saw its problems. The convergence of the tree and mountain shapes (1) created an awkward concentration of interest at one point. In addition, the scattered trees (2) were too similar in size and shape. Moreover, the three trees at the top were pretty evenly spaced. This symmetry seemed contrary to the informality of the overall arrangement. Along the same lines, the large rock shape in the foreground (3) seemed monotonously uniform and static. I later varied the contours and broke up the shapes in a way that I felt was more in keeping with the nature of my subject and my interpretation of it.

The Crest, 19″ × 27″ (48.3 × 68.6 cm), Crescent cold-pressed watercolor board.

98

Shapes and Currents, 24″ × 32″ (61 × 81.3 cm), Crescent cold-pressed watercolor board. Courtesy of Gallery of the Ravens, Estes Park, Colorado.

Capturing a Calm Monumental Presence

In *The Crest*, the mountain sits proudly in the background, the dignified ruler of all that lies below. To get the sense of distance I wanted, I began by tinting the sky with cerulean blue and a little raw sienna, shifting to Winsor blue and burnt sienna for the distant mountain. As I moved forward, I added permanent blue to introduce a warmer, more projecting note. When I came to the large foreground shape, I let a virtual explosion of color lend vigor to the heavy rock.

In all of the foreground and middle ground, I sprayed water and then blotted with a tissue. Some license was taken by painting the lighter dead trees at the right with white gouache, Winsor blue, and burnt sienna. Here I preferred using the white to masking the shapes, since masking often leaves too punctuated a shape.

Heightening a Stormy Assertiveness

The contrasting mood of *Shapes and Currents*, with the mountain almost eerily lit up in a turbulent setting, called for a different approach. Its character suggested the use of Payne's gray. In fact, I used only five colors: Payne's gray, Winsor blue, olive green, raw umber, and burnt sienna.

Into the wet sky area I laid washes of Payne's gray and burnt sienna. To get the churning effect, I tilted the surface in various directions, letting the water and color run and flow. For the light of the distant mountain, I left the paper white, adding only very simple tints to indicate its broad, sculpted planes. The larger mountain shape and the craggy foreground mountainside were vigorously painted. Then I sprayed and blotted the surfaces for dramatic textures. The light trees to the right were lifted out when the area had dried, using the damp edge of a flat brush.

CAPTURING THE LIGHT

I'm always fascinated by the way in which light can transform a setting, redefining its character. The subjects for both the paintings here were found along the California coast, on the way to Mendocino. In both cases what struck me was the magic of light. That was the starting point.

"It's Someone Else's Fault, Of Course"

Here's a beginning sketch that almost couldn't promise more compositional problems. Note the monotonous, unrhythmic repetition in the configuration at the left (1). The tangent in the upper left (2) also makes for visual discomfort. And the equal division created by the placement of the central rocks (3) is another sour note. It formalizes the cadence in a manner that fights with the informality of the rest. These are the kinds of misdirection that appall us; there must be some demon that invades our studio now and then. How else could we make such mistakes? It has to be someone else's fault, of course.

Translating the Sparkle

I saw the secluded inlet of *As It Will Always Be* late in the day. The water caught the low angle of the sun's light, causing reflections to dance and shimmer among the giant rock forms. Awesome.

To capture the brilliant gems of light, I decided to use Maskoid for some areas and white gouache for others. Gouache is opaque watercolor, which can be painted over other colors without losing its integrity as a stated pigment. (As I've already indicated, I use gouache very sparingly because it can tend to work against the transparent quality of watercolor.) In addition, I decided to paint around the larger patches of light.

Using my Hake brush, I wet the entire surface, except for the large areas of light. Into this wet surface I

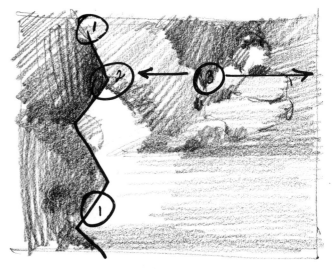

swept large brushstrokes of color—letting the warmth of earth colors mingle with the relative coolness of cerulean and Winsor blue. Where I wanted emphasis, I introduced burnt sienna and violets (cobalt violet plus mixtures of cobalt blue and alizarin crimson). I also delineated textures and edges. The accentuated dark patterns—made from Winsor blue, Winsor green, alizarin crimson, and burnt sienna—added substance and forceful weights. I let the water echo the other colors of the painting, with a note of olive green for a distinctive, warm touch. Last, I lifted the Maskoid and painted more of the dazzling, small lights with white gouache.

As It Will Always Be, 24″ × 32″ (61 × 81.3 cm), Crescent cold-pressed watercolor board. Private collection.

The Quietest Light on the Coast, 16″ × 24″ (40.6 × 61 cm), Arches rough watercolor paper. Courtesy of the Gallery of the Ravens, Estes Park, Colorado.

Intimating Silent Excitement

When I saw this scene, I had to stop. What drama as the last moments of daylight glanced off the inlet of water and the far-off hills, while heating up the already warm color of the grass and scrub in front! In the distance the lit-up window of a solitary house asserted its presence. Compelling!

I laid a thin wash of raw sienna into the sky plane and through the most distant hill. When this had dried, I laid another wash of cerulean blue into the upper sky, blending it into the dry raw sienna. Then, after this had in turn dried, I laid a thin wash of cobalt violet and cobalt blue into the distant and middle ground hills, letting the color mingle. The water was given a thin wash of cobalt blue.

Once all had dried, I identified the contours of the middle hills and glazed these areas with washes of cobalt violet, cobalt blue, and raw umber. While this was still wet, I began introducing the trees in the middle distance, relying on the wet surface to diffuse the contours. The house was brushed in quickly so that its shape would be retained. (The window had been masked, using Maskoid.) From this point, it was a matter of sweeping in bold, rhythmic passages of color, using cadmium red light and Winsor red for the fiery

foreground. At the same time I introduced dark patterns with Winsor blue and Winsor red.

When the surface was dry, I brushed a bit of texture into the foreground, adding burnt sienna to my Winsor blue and Winsor red. The texture here helped carry the plane forward, enhancing the sense of depth. Last, the little patch of Maskoid was removed. The painting now captured what I had found so stirring.

101

DESCRIBING MOVING WATER

As you look at my paintings in this book, it probably isn't difficult to recognize that moving water has a special fascination for me. Maybe it's because I relate to the suggestion of restlessness, or perhaps the ongoing motion without regard for time appeals to my respect for relentless, undaunted effort. Given stolid, unmoving rock forms combined with the persistent rhythm of water, all bathed in the iridescence of light—my hand automatically reaches for my brush!

Rushing Water, 24″ × 32″ (61 × 81.3 cm), Crescent cold-pressed watercolor board. Courtesy of R. H. Love Galleries, Chicago.

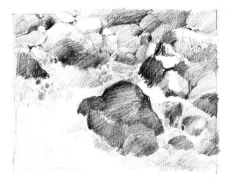

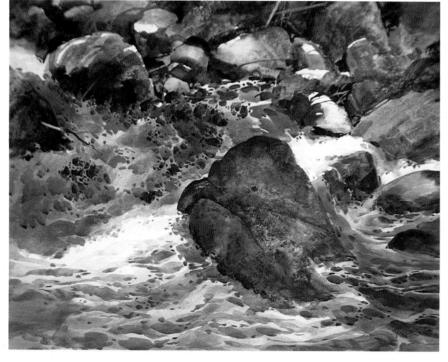

Creating Rhythm and Balance

To heighten the impact of *Rushing Water*, I changed the placement of some elements from my value study. In particular, I moved the large foreground boulder so that it was more off-center. Starting with the background, I let olive green, burnt sienna, raw umber, and Winsor blue mingle, leaving edges and shapes undisturbed where I intended to state the light patterns. Reserving areas in this way requires a constant attunement not only to the parts you're painting, but also to those you're not. While the color was still moist, I sprayed water to increase the intermixing of color and blotted with a tissue to give a distinctive texture to the surface.

The middle ground and foreground were painted more descriptively, using less spray and more structured, academically directed brushwork. In these areas I chose colors of a higher key to add vitality. By using cerulean blue, cobalt blue, cobalt violet, and raw sienna in the water, I balanced (or echoed) the colors I introduced elsewhere. The large foreground rock was painted with Winsor blue, burnt sienna, cobalt violet, and raw sienna; as in the background, the shape was then sprayed and blotted. My final touches were the linear accents that define edges and recess the darks.

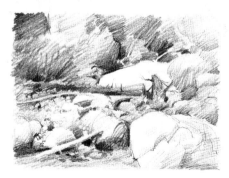

Playing with Contrasts

In the setting for *Meandering*, what struck me was the slow-moving, almost hushed quality of the stream. The note of gentleness among the immense boulders seemed incongruous. The differences in the personality of the elements, as they played against each other, appealed to me.

To begin, I boldly swept large passages of color onto the dry paper surface—carefully painting around and saving the light areas of the boulders, the small foreground stone, and the fallen branch. I kept the value pretty much in the middle range, as I planned to paint the darker interests later, with a more controlled handling.

Although, chromatically, the background color is as high as the foreground color, the delineation of the foreground is much more developed and individualized. By making the background less descriptive, I kept it a receding interest. The light, fallen branches, except for the one in the foreground, have been lifted out, using the edge of a damp flat brush—something that is most easily done on a less textured paper surface.

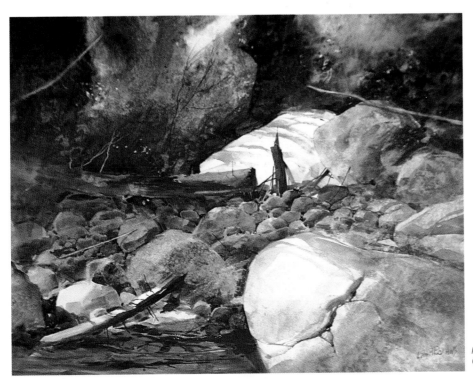

Meandering, 22″ × 30″ (55.9 × 76.2 cm), Crescent cold-pressed watercolor board.

Bringing out Color

I remember my son saying to me after his first trip to Colorado, "Dad, I always thought you tended to over-invent the color of the rock and water, but it's really there!" I think I would qualify my son's comment by saying that there's more color than you think in nature if you let yourself see the possibilities. And, of course, color is always finely tuned by the painter to fit whatever he or she wishes to orchestrate.

In *Movement*, little was painted into the water except for notes of local color. The large light patterns of the water, though, create an element of design that is critical to the composition. Squint your eyes; you'll see it. I painted the boulders energetically and boldly, using the spray bottle and tissue technique. Fun! Finally, when the rock areas had dried, I delineated some of the edges and carved the darkest facets.

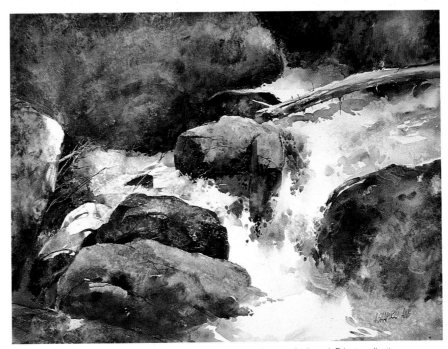

Movement, 23″ × 31″ (58.4 × 78.7 cm), Crescent cold-pressed watercolor board. Private collection.

Throughout the painting, I emphasized the presence of color, accentuating the warmth of burnt sienna, raw sienna, cadmium red light, and raw umber in the rocks. The colors, though muted, sang out as glowing statements—especially against the foil of the water, with its luminous and relatively cool washes of cerulean blue, cobalt violet, and olive green. There is enough of a repeat of the rock color in the water, though, to keep the overall color statement cohesive.

EMPHASIZING THE ABSTRACT

Some subjects cry out for the painter's attention to their design; it's the pattern of the shapes, edges, and planes that attracts the artist rather than the picturesque qualities. I saw both *Gloucester Patterns* and *Near Rockport* as opportunities to organize shapes, colors, and graphic elements into something that would become an abstracted statement rather than an illustrative commentary.

Orchestrating Design

Looking at the setting for *Gloucester Patterns*, I was struck by the organization of lights and darks; the interaction of horizontals, verticals, and diagonals; the way the gentle, rounded movements served as a foil, reinforcing aggressive angles. Since I used no Maskoid, all the shapes were carefully plotted first. In my value sketch I concentrated on the larger elements and their interrelationships.

Turning to the painting, I made the darks colorful, varying their warmth and vitality depending on how I wanted to prolong or project visual interest. All the lightest lights are the white paper. Aside from a few linear accents and the descriptive detail, much of the painting was completed with one presentation of value and hue. I felt that if I applied successive washes, I'd lose much of the punch of the subject.

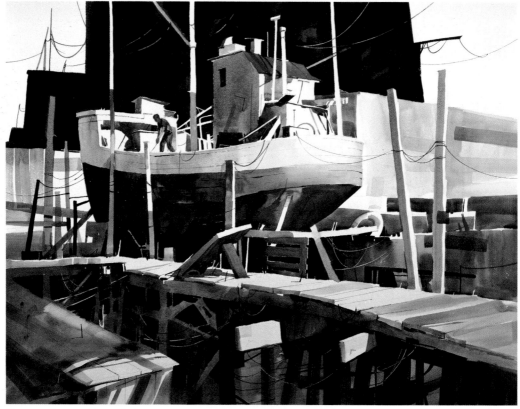

Gloucester Patterns, 24″ × 32″ (61 × 81.3 cm), Crescent cold-pressed watercolor board.

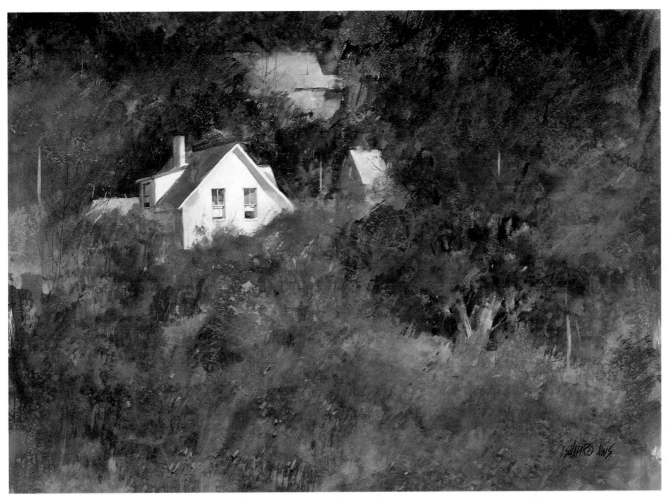

Near Rockport, 23″ × 31″ (58.4 × 78.7 cm), Crescent cold-pressed watercolor board.

Finding Interest in the Everyday

There is a hillside near Rockport, Massachusetts, which I studied one October day. I studied it in early morning, and at various times during the remaining daylight hours. Although I knew that any of those moments could have (and might still) become a painting, it was the late afternoon that, on that particular day, most excited my imagination.

After briefly penciling in the placement of the key compositional features, I vigorously brushed the entire surface of the watercolor board—except for the dominant house—with color that was not very diluted. The colors were selected from every part of my palette. I orchestrated the purer and warmer colors for emphasis and more deliberate eye movements, while I used the cooler and grayer colors to weave more subtle patterns and undulations. The darker values, such as those around the house and in the larger tree, were introduced to underscore contrasts where I wanted projection and more imposing compositional statements. Throughout, I sprayed water to liquefy color and blotted with tissue to texturize surfaces.

ADDING IMPRESSIONISTIC ELEMENTS

What's most important to me is capturing the spirit of the subject as I see it. It's the heartbeat I'm after, not a studied description of "things." At times, as in these two paintings, this objective leads me in a direction that can be described as impressionistic.

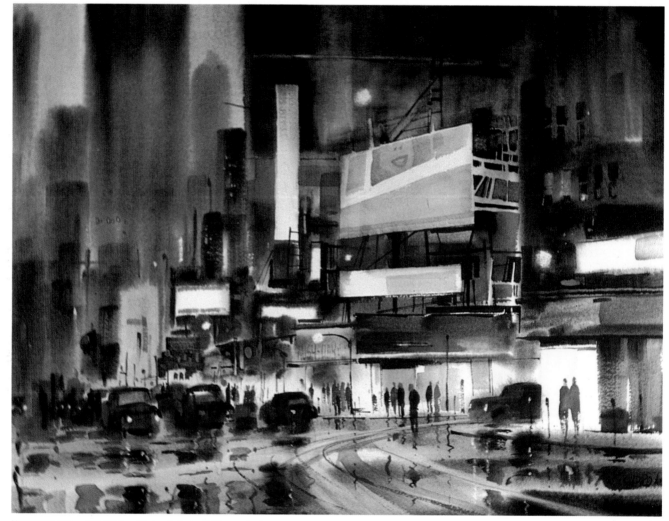

Near North, 20″ × 28″ (50.8 × 71.1 cm), Arches 300-pound cold-pressed paper. Courtesy of R. H. Love Galleries, Chicago.

Discovering the Allure of the City

With *Near North*, I once again took liberties with my actual subject; I'm afraid that if you go looking for this scene, it just won't be the same as the painting. Some signs were left out; building shapes were altered considerably; even the flow of traffic was changed—all in the interests of expressing the character of the subject as I saw it.

After sketching the major shapes, I wet the entire surface with water, using my 2″ (50 mm) Hake brush. Picking up my 1″ (25 mm) flat, I introduced the large shapes and relationships of temperature and value on the wet paper. Notice, for example, how the distant buildings are suggested in grayer, cooler color, without the strong value contrasts of the foreground. The brushwork had to be rapid to prevent the color from spreading too far on the wet paper.

At this early moment the painting was quite abstract. When the paper was dry, I came back, using a more controlled and descriptive handling for those forms with harder edges. The dashes of rich, almost undiluted color accenting the small signs and lights were added last, along with a few sweeping brushstrokes for the street patterns. At about this time I also created the feel of misted street lighting by wiping out the small orbs you see scattered among the foreground shapes. I used damp cotton swabs for this.

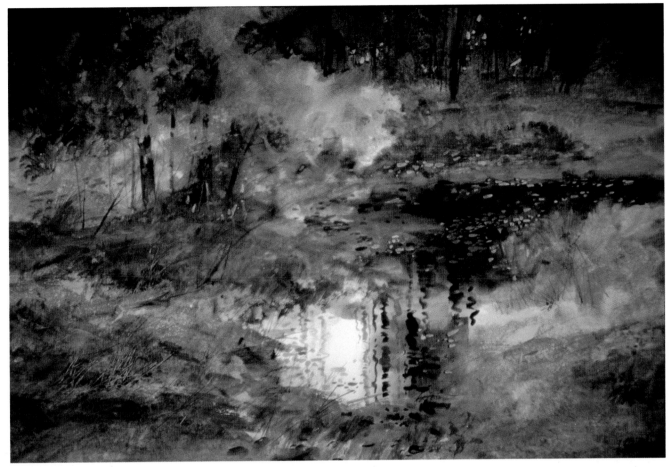

Nature's Lace, 24″ × 32″ (61 × 81.3 cm), Crescent cold-pressed watercolor board.

Unwrapping Nature's Gifts

Nature's Lace came as a surprise. Walking through a wooded area near Chicago, I found myself disheartened by the sudden overcast. I was all geared for dappled light, filtering through the fall foliage. Then, as I turned down one path, I was struck by the stillness of a pool and the soft—almost blurred—autumn color. The quality of light was in fact the opposite of what I had set out to find.

Because my subject did not consist of structured content, but rather of elusive shapes and textures, I decided to accentuate the underlying rhythms and vibrations, making for a design that inferred rather than graphically portrayed the content. Given the interplay of color I wanted, I first wet the entire surface with my Hake brush. Keeping the surface flat, I immediately brushed in generous washes of Winsor yellow, cadmium orange, cadmium red light, raw umber, raw sienna, olive green, burnt sienna, and permanent blue. As the pool of water would be reflecting light, I carefully avoided brushing color into this area. I kept the chroma (or color intensity) high in areas where I intended to use more forceful color as a means of commanding visual interest—for instance, in the large tree.

Once the large passages of interweaving and flowing color had dried, I used a well-charged wet brush to sculpt some of the more defined shapes, including the dark patterns in the background, the larger trees of the middle ground, and the smaller foreground shapes of the grass and reflections. Finally, I returned to the trees to describe the trunks and branches, as well as some of the finer, focused bits of grass in the immediate foreground. For the dashes of high color in the drifting, fallen leaves, I used cadmium orange, Winsor yellow, and cerulean blue, with almost no water. Other flecks of light were scraped out while the areas were damp.

RESPONDING TO THE "UNSIGHTLY"

Sausalito, just north of San Francisco, is the sailor's mecca in the Bay Area. Much to the townspeople's distress, however, among the sleek sailboats and elegant cruising vessels, one finds a cluster of seemingly unsightly derelicts. Yet I have discovered many paintings in this strange huddle of old boats, including *Once a Queen* and *Ship of Another Time*. Collections of disordered shapes fascinate me, since creating any painting requires an ordering of parts. In other words, a seeming disarray presents a special challenge to create your own order.

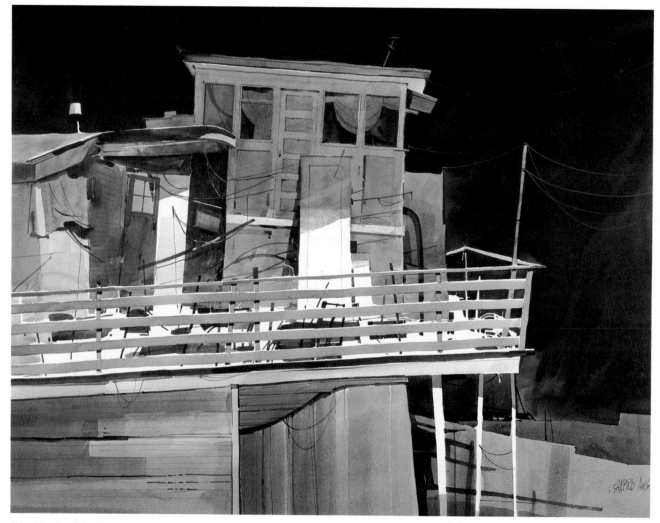

Ship of Another Time, 24″ × 32″ (61 × 81.3 cm), Saunders rough watercolor board. Private collection.

Pinpointing Character

As my title *Ship of Another Time* suggests, this magnificent relic spoke to me of its past; I couldn't help but respond. To accentuate the ship's personality and the drama I saw in its form, I painted the low-value background with a concentrate of Winsor blue and brown madder, dropping massive brushstrokes of this combination into an area first brushed liberally with clean water. I had to be careful, of course, not to let any of this encroach on the boat.

The balance of the painting was developed methodically, without masking material. My focus was on the design of shapes rather than the literal appearance of the ship. It was a matter of creating symbols and patterns that would convincingly convey the subject's personality, without the painting taking on a chapter-and-verse tedium.

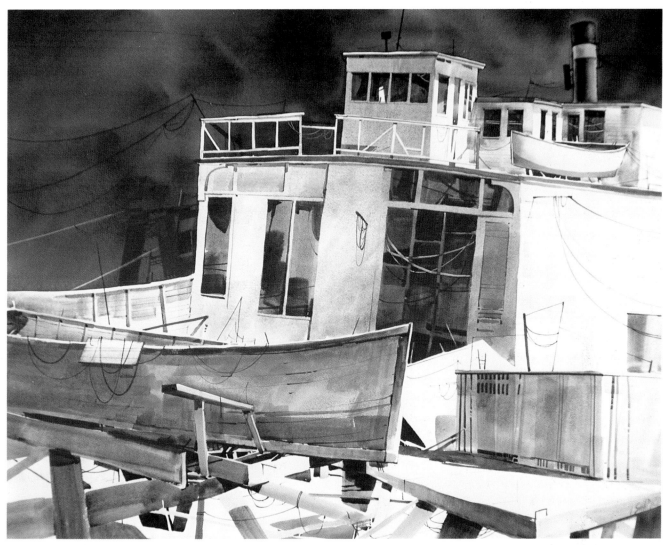

Once a Queen, 24″ × 32″ (61 ″ 81.3 cm), Saunders rough watercolor board.

Defining the Design

Although in *Once a Queen* the subject is presented with what appears to be
objective descriptive commentary, in actuality the vertical and diagonal
constructions were thoughtfully juxtaposed with curvilinear elements—
some gentle and others pronounced, some delicately stated and others (like
the upper contour of the foreground boat) vigorously slashing through an-
gular notes. My pencil drawing was quite studied, but a great deal of deci-
sion making, especially with some of the lesser shapes, was made in an im-
provisational fashion during the painting process itself.

I painted the background first. I say *background* rather than *sky* because
the unorthodox color creates what is more important for me than predict-
able realism—the drama and contrast of an unexpected color statement. A
mixture of alizarin brown madder, Winsor violet (a seldom-used color, but
nice to have around), and Winsor blue was liberally brushed into the "sky"
(which had first been brushed with lots of water). In the rest of the paint-
ing, I deliberately chose colors related to this background plane—cadmium
red light, alizarin brown madder, alizarin crimson, cobalt violet, raw umber,
Winsor blue, raw sienna, and cobalt blue. I didn't use Maskoid; all the deli-
cate, light constructions were either painted around or lifted out.

PAINTING THE SILENCE

The quiet command of nature can be compelling. I'll often observe and commune with a subject for a long while before attempting to capture it on paper. Conveying the power of nature's silence is yet another test of our painting talents.

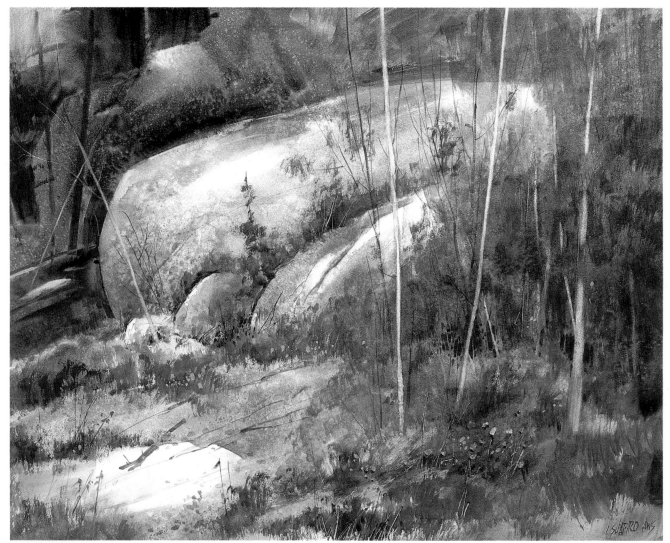

Mountainside, 23″ × 31″ (58.4 × 78.7 cm), Crescent cold-pressed watercolor board.

Deciding What to Describe

In the setting for *Mountainside*, the dappled light and mosaic-like color contrasted with the solid, ungiving granite. All seemed wrapped in an eerie quiet. It was mesmerizing!

Before painting, I sponged the entire surface. I then swept large passages of cerulean blue, raw sienna, cobalt violet, raw umber, burnt sienna, olive green, and cadmium orange into the wet surface. When this had dried, I wiped out lights and defined shapes. I detailed areas that I wanted to be visually commanding and kept other parts more obscure to make certain that they would be supportive, not conflicting, interests. I think you can also see the effects of my spraying water and then blotting in some of the boulders and the grass. The lights of the saplings were lifted out with a damp brush.

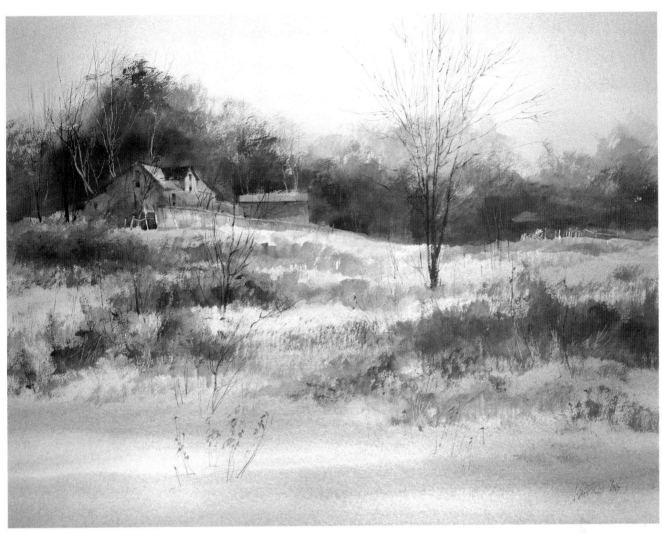

Freshly Fallen, 23″ × 31″ (58.4 × 78.7 cm), Whatman rough watercolor board. Collection of Betty and Arthur Sarlin.

Adding a Warm Glow

With *Freshly Fallen*, I found the hushed aura of the midwestern landscape blanketed with new snow irresistible. I couldn't wait to paint it! As is often the case, my pencil drawing was minimal, serving simply as a reminder of the placement of critical masses and compositional movements. The exception was my more studied statement of the background buildings.

With a 1″ (25 mm) Morilla no. 202 ox-hair brush, I swept the first wash into the sky. It was a fairly flat wash of raw sienna, to which I added a touch of cadmium orange to establish the warm glow of light so characteristic of the end of the day. Once that wash had dried, I began a broad wash of cobalt blue and raw umber at the top, blending it out gradually until, near the horizon, it fused with the glowing warmth. These washes, incidentally, were painted right through the trees and buildings.

Turning to the snow-covered ground, I carried sweeping washes from side to side, starting at the most distant edge of this large plane. I used cobalt blue and raw umber, letting the cobalt blue gradually become more distinct as I carried the wash forward. For the diffuse, dark undulations in the ground, I mixed cobalt blue with cobalt violet to get the warmth and color richness that helps to bring the plane forward.

After letting the painting dry again, I worked on the trees and ground scrub with mixtures of burnt sienna, raw umber, and permanent blue, still using the Morilla brush. Accents of cadmium red light were introduced judiciously. At the same time I carved out the shapes of the buildings and fence by painting around them. While these masses were damp, I also scratched a few light tree and grass shapes with the back of my brush handle or my palette knife. The grass texture and tree edges were conveyed by pushing a drier brush against the paper texture. Finally, I created the dark accents, the tree at the right, and the delicate foreground grass with round bristle brushes, using burnt umber and permanent blue.

BALANCING FREEDOM AND CONTROL

All through this book I've urged boldness and assertiveness. You can't be afraid when you paint. Although the subject matter of *Never Ending* and *Wild Ones* is very different, both were painted with a decisiveness that stems from knowledge of the craft.

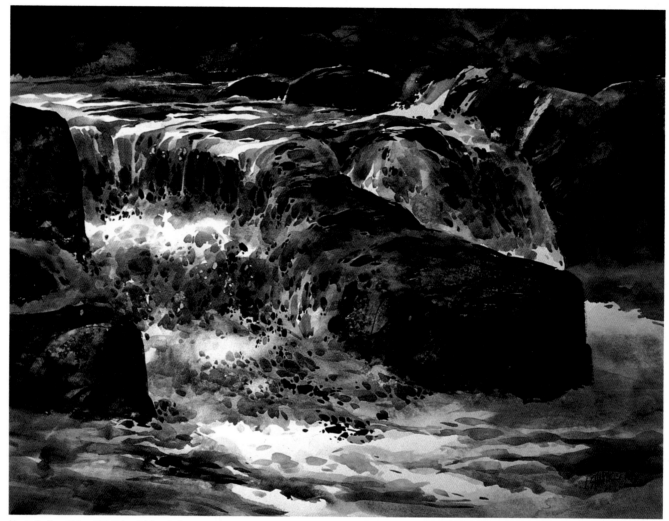

Never Ending, 24″ × 32″ (61 × 81.3 cm), Crescent cold-pressed watercolor board. Private collection.

Letting Washes Flow

After penciling in the large masses and planes, I started on the stream. I didn't paint the water between shapes that were later to become rock areas. I painted the water right through, knowing that the rock would eventually cover the washes. In other words, the rocks were painted into the planes of the stream after the water surface had dried. Since the rocks are darker than the stream, their contours obscure the tints of water underneath.

Now look closely and observe how the lateral, foreshortened brushwork in the most distant part of the water augments the feeling of perspective. Notice how the spaces between brushstrokes are wider in the front of the composition. To further accentuate depth, the brushwork is more complex in the foreground and the rocks are more studied, textured, and colorful. Overall, color is heightened in the foreground and grayed in the background.

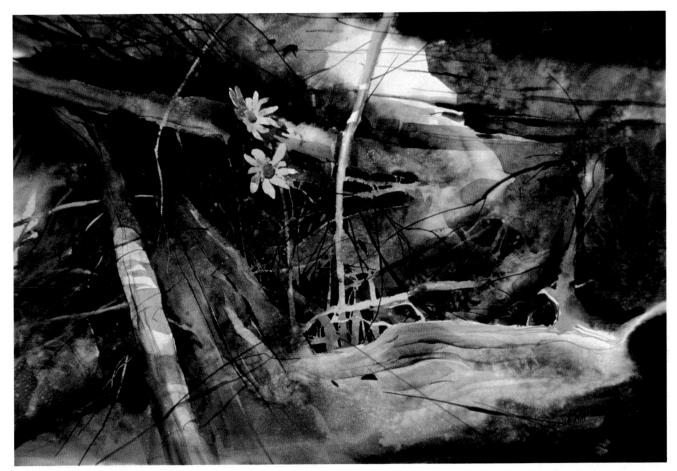

Wild Ones, 24″ × 32″ (61 × 81.3 cm), Crescent cold-pressed watercolor board. Private collection.

Directing the Focus

Sometimes we are struck by the incongruity of what nature presents to us. How, in the midst of such muted color, undulating rhythms, and vague form, could there be such clear-cut, geometrically patterned, highly colored wildflowers? It isn't nature that's incongruous, of course. It is we who are too quick to expect the predictable. One might say that nature is having fun with us, testing our ability to believe the unbelievable.

In my pencil drawing for *Wild Ones*, I focused on the large movements and masses, without much detail. Squint your eyes and I think you'll see the patterns of diagonals and the progression of planes.

For the painting, the areas of the two flowers were first protected with Maskoid. I then wet the entire surface with clear, cold water, using a soft sponge. Into this I mopped large passages of rich, juicy color with my 1″ (25 mm) flat brush. Cooler and grayer colors were introduced where I wanted elements to recede in visual importance. Warmer color, though still grayed, was placed where I wanted the composition to become more focused, where the eye was to be directed.

When all this had dried, I came back to describe line, texture, and accentuated darks. I also wiped out some lights with a clean, damp brush, blotting each brushstroke with tissue to lift the softened, diluted

color. When just about everything had been stated, I let it all dry thoroughly. Then I lifted the Maskoid and painted the flowers with cadmium orange. The modeling of the petals and flower centers was done when the cadmium orange was dry, using burnt sienna and cobalt violet. Finally, I added dashes of cadmium red light to create a color "echo."

Developing Your Artistic Potential

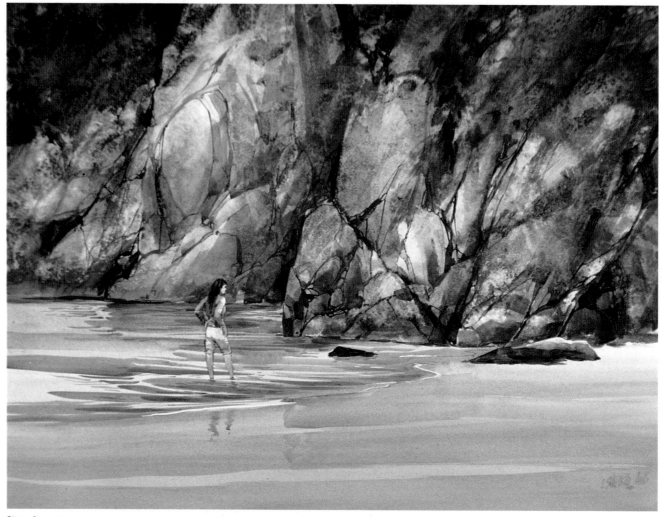

China Cove, 23″ × 31″ (58.4 × 78.7 cm), Crescent cold-pressed watercolor board. Private collection.

It's probably universal for painters to want to present a unique, distinctive style—to mark their efforts as *theirs*. The unmistakable personal imprint. A manner of speaking with paint that will establish this artist as one without predecessor or peer.

Once again, I'll take the role of devil's advocate. A possible stumbling block in the search for an individual style is the use of misdirected values as the criteria for painting. Here I am using the word *values* in the sense of making judgments about what is most important in creating your painting. If you are driven toward individualizing your work above all else, then "style" is apt to be placed on the high altar. Considerations of drawing, value structure, and color—along with just about every other aspect of the craft—may be smothered. Sadly, the result will almost certainly be an exercise in superficiality. True, the outcome may have a degree of cosmetic appeal—the attraction of stylistic flair. A measure of cleverness may also be detected. But when these attributes become the mainstay of your creative direction, they lead to shallow experiences. In short, if style is the most sought-after criterion, you risk being classed as no more than a stylist.

I find it difficult to understand how painters can permit—even encourage—all their works to look the same in their hot pursuit of a trademark. It's as if the integrity and personality of the individual painting were subordinate to the personal "style." I can't agree that the architectural dynamics of a cityscape should be translated with the same inflections as a misted garden. Or that a half-lit, reposing figure should be cut from the same fabric as the roaring white water of a mountain stream. How defeating for the whole experience of discovery! I would certainly hope that any presentation of my collected works would stimulate the viewer, as well as me, through the range of sought-after personalities. The discerning eye, of course, is likely to recognize the threads that reflect a single painting soul at work. But to commit yourself to a narrow painting approach for the purpose of stamping ME on every work is to short-circuit the exciting adventure of real painting.

In criticizing style for style's sake, I am definitely not arguing against developing your own style. But a truly individual style depends on a kind of honesty in translating what you respond to in a particular subject.

Using the Masters

Throughout this book I've expressed my views and teachings with examples from my work. At this point I'd like to pay homage to the brilliance of just a few of the classic figures in American watercolor.

JOHN SINGER SARGENT

John Singer Sargent, *In Switzerland*, 1908, 9 7/16″ × 12 5/8″ (24 × 32 cm). The Brooklyn Museum, purchased by special subscription.

John Singer Sargent was unquestionably the dean of portrait painting in his time, but his renown as a society painter eventually began to distress him. In the early 1900s, in an attempt to throw off a mantle of what he considered superficial importance, Sargent went to Europe. There he plunged into the forthrightness and simple honesty of watercolor. As Adrian Stokes, a close friend, once said after observing Sargent paint a watercolor: "His hand seemed to move with the same agility as when playing over the keys of a piano. What was really marvelous was the rightness of every touch, which conveyed a quick unerring message from the brain. It was magical!"

The figure and setting of *In Switzerland* could hardly be more different from Sargent's elegant portrait subjects and their elitist surroundings. Nevertheless, Sargent's genius for composition surfaces again here, as does his mastery of light and dark patterns. Cer-

tainly his sense of drama is quite evident. Squint and observe the fluid line of the figure, with the right hand sinuously leading across the pillow and then back to the figure. Look at how the contour drawn by the two feet is expertly repeated in the top of the chair and the bed's headboard. And note the verticals of the walls and the diagonals of the headboard and chair—all counterpointed by the informal rhythm of the figure. Structure in concert with grace. Spectacular!

Sargent's love of light and what can be seen within light comes out in his exploration of energizing tints within the light patterns. The geometric, angled constructions, with their grayed earth color, low value, and less vital brushwork, are effective foils for the dashing, accentuated interest of the figure. Finally, reflect on the assuredness and masterfully controlled handling behind this decisive, unhesitant watercolor statement.

JAMES McNEILL WHISTLER

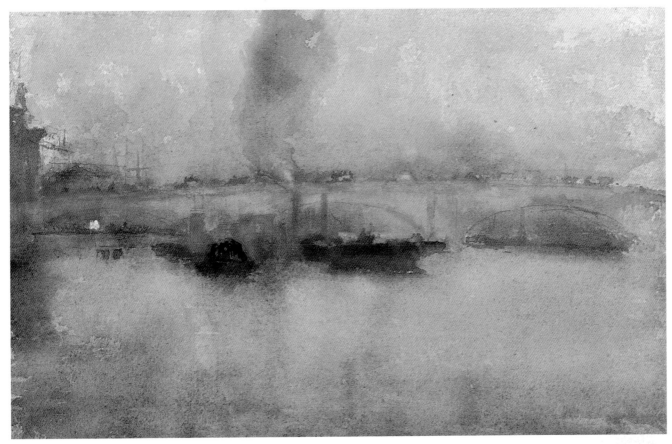

James McNeill Whistler, *London Bridge*, 1880s or 1890s, 6 7/8″ × 10 15/16″ (17.5 × 27.8 cm). Courtesy Freer Gallery of Art, Smithsonian Institution, Washington, D.C.

Close your eyes for a moment and conjure up a nineteenth-century American painter living in Paris, in the frequent company of provocative thinkers, but making every attempt to set himself apart from others. Now name this artist James McNeill Whistler. Outwardly, he was a rebel who sought out ways in which to decry his orthodox New England upbringing. He chose to appear outrageous and ornery. Inwardly, he was extremely self-demanding. For him, the artist faced a special challenge. As he declared, "Nature contains the elements, in color and form, of all pictures, as the keyboard contains the notes of all music. But the artist is born to pick, and choose, and group with science, these elements, that the result may be beautiful. . . . To say to the painter, that Nature is to be taken as she is, is to say to the player, that he may sit on the piano. . . . Seldom does Nature succeed in producing a picture."

Three features of Whistler's *London Bridge* appear, to me, to be of arresting significance. First, the design: the almost stark horizontals of the sky, the bridge, and the water are all carefully composed in varying measures. Had these held any semblance of equal measurement, they would have immediately established a static, rigid arrangement. Observe the sensitively placed, vertical counterpoints at the far left, as well as the less structured note of the rising smoke. The subtle curve of the bridge, repeated in the arches, does a

beautiful job of relieving what would otherwise be woodenly mechanical angles. Notice, also, how the smoke stacks of the boat subtly interrupt the sweep of the arches, adding a touch of unevenness. Finally, look at how the eye-of-the-rectangle principle has been applied in the placement of the darkest boat and the relatively high orange color.

The second feature to observe is Whistler's masterful handling of the value pattern. Although his narrow value range is tightly controlled, he still allows an aura of light to be sensed. The judiciously patterned darks flesh out the range so that depth can be grasped. What all this speaks to is Whistler's genius for subtle expression.

Finally, there is the magic of color. We all know how captivated Whistler was with grays. His best-known painting is titled *An Arrangement in Gray and Black*, although it's better known as *Whistler's Mother*. Yet in that painting and certainly in *London Bridge*, there is a breadth of color that's unmistakable. Perhaps the greens and yellows here are muted to the point where they're barely discernible as hues. But the blacks are not dead blacks; rather, there seems to be a cast of blues and muted reds. The oranges are subtle, but nonetheless orange. It's a concert of color, directed by a virtuoso in orchestrating the wonders of soft, understated color.

WINSLOW HOMER

The name Winslow Homer has become synonymous with American watercolor. This genius was self-taught, driving himself to create two-dimensional images that reflected his crusty, robust attitudes. His first paintings were in oil, and he was quickly acclaimed for his "hearty, homely actuality." His first watercolors, ten years later, just as rapidly brought him attention and renown. Most of his contemporaries considered watercolor to be a sketching medium, not a "serious" means of expression. Homer, however, demonstrated "the value of watercolors as a serious means of expressing dignified artistic impressions, and [he did] it wholly in his own way," as a critic of the time put it.

Studying the design of Homer's *Turtle Pound* is sheer delight. Just look at the horizon line that's exactly centered. A sinful violation of compositional rules? Only until you see that the upper edge of the enclosure shifts the arrangement to a less symmetrical note. Also observe the subtle diagonal sweep of this edge, which—along with the informally arranged clouds and undulating water—echoes the diagonal thrust of the turtle and the two figures. The single bird further animates and repeats the action of the two figures, but it especially repeats the rhythmic movement of the turtle's forelegs. Even the almost unnoticed sailboat on the far left horizon adds a note of movement that knits the whole action, both physical and compositional.

The aggressive immediacy of the brush statements, with no evidence of ponderous second guessing, is also reflected in Homer's clear color and decisive value contrasts. Possibly the most telling quality in this painting is Homer's enchantment with the explosion of color and light that he found in the Caribbean. He reveled in these features, such a contrast to the cool, reticent atmosphere of his native New England.

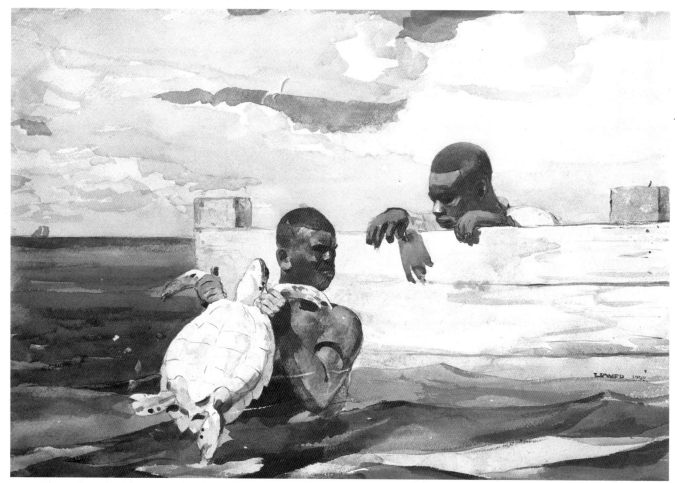

Winslow Homer, *The Turtle Pound*, 1898, 14 15/16″ × 21 3/8″ (38 × 54.3 cm). The Brooklyn Museum, Sustaining Membership Fund; A. T. White Memorial Fund, A. Augustus Healy Fund.

CHARLES DEMUTH

Charles Demuth, *Eggplant, Carrots, and Tomatoes*, c. 1927, 14″ × 19″ (35.6 × 48.2 cm). Norton Gallery and School of Art, West Palm Beach, Florida.

Unlike Homer, Charles Demuth was a product of American academia. The roster of schools he attended and teachers who influenced him is long and impressive. Demuth emerged as a watercolorist of importance in the 1920s. His friends included Georgia O'Keeffe, Stuart Davis, Gertrude Stein, and Sherwood Anderson. His fascination with the theater flavored much of his painting, although his flower and still life paintings did provide contact with the "real."

Although Demuth was not wealthy, a family inheritance enabled him to be financially independent and free to paint what he wished. His experimentation was laced with wit and humor—qualities that are often amplified in those who suffer a physical affliction. (Demuth had fallen when he was four years old, damaging his hip and remaining lame for the rest of his life.) For a taste of his spirit, consider his remark: "Paintings must be looked at and looked at and looked at—the good ones like it!"

In *Eggplant, Carrots, and Tomatoes* I feel that Demuth intended to emphasize his design. By *design* here, I mean a studied arrangement of pictorial or decorative elements. Look at the swirling movement of the carrots, pointing as surely as arrows to the tomatoes through the apples (why the title didn't include apples, I don't know), and then following the curve of the plate—all framing the sturdy, dominant eggplant. The eggplant itself has been masterfully placed just off-center in the painting area, providing a note of eccentric, informal balance. Notice, by the way, how the eggplant rests at an eye of the rectangle.

The expanse of white space is certainly no less studied in its shape and purpose. In its simplicity, the fruit and vegetable arrangement seems almost vulnerable, with the field of white space serving as a cushioning protector. Dramatic? Perhaps, but then remember Demuth's close association with theater figures and his love of the stage.

The color of the still life is just as forthright as the design. As commentaries of pure color, the reds, oranges, yellows, and purples add to the illusion of simplicity and directness. In all this, Demuth skillfully balances delicacy and vehemence, understatement and forceful comment, displaying a sensuous juiciness in his handling.

Artists I've Taught

With about forty years of teaching experience behind me, I still have to pause and consider when someone asks me: "How do you teach?" For one thing, the very word *teach* doesn't seem right. Can someone be taught to be an artist? No. It's more a question of guiding someone who has a gift for visual expression toward developing that gift. I think of a teacher as a mentor, enlightener, inspirer, perhaps even a drill sergeant. What I hope to impart is a foundation of knowledge and skill, from which my students will be able to build toward the highest possible levels of visual expression and communication.

On the next pages are paintings by several of my students—both past and present—who are creating their personal painting worlds, with watercolor as their tool of expression. Their works grew out of the instructions found in this book. Notice the range and variety of their approaches. They absorbed the lessons of the craft and then moved forward on their own.

You may be wondering how you, too, can evolve your own personal style. The lesson is simple. Don't be content with formulas or apprehensive about investigating the unfamiliar. Cultivate your curiosity. Explore. Be inventive. When you feel that you have the answers, ask more questions.

And don't worry about failure. All of us come up with sour notes in our paintings, but we can hope that, in time, they will become fewer and less rattling. Besides, there is enrichment even in our flops. We can learn what not to do. We can be stimulated by being edged into other thought directions and new objectives. Disaster lies in wait for those who declare, "I can't." They can't because they've already drawn the curtain on success by not only admitting defeat but actually inviting it. Many times I've been happily startled to see a student turn the corner of remarkable advancement as the result of positive, driving stubbornness. It's a marvelous thing for a teacher to see—and an incredible thrill for the painter! What a terrible loss it is to turn off promise by embracing the negative.

Nathan Greene, *Play Ball!*, 14″ × 21″ (35.6 × 53.3 cm).

Nathan Greene

I'm especially enthused over this painting by Nathan because it's so positive in its declaration of free, yet controlled spirit. The painting's dynamic content is accentuated by Nathan's bold use of color and powerful value contrasts.

Larry Paulsen, *Sculptures*, 15″ × 22″ (38.1 × 55.9 cm).

Larry Paulsen

I've tried to impress on my students that *anything* is paintable, waiting for us to respond to it. Larry saw these sculptures in the garden of the Chicago Art Institute on a blustery day and, indeed, he responded, lending movement and drama to the immobile forms.

Theresa Einhorn

I remember well when Theresa faced what seemed insurmountable barriers to departing from the literal. In this small gem of a painting, she has obviously seen more than the facts of her subject matter. Her interpretation of the subject has been expertly woven into a more abstract value pattern to make this painting stirring.

Theresa Einhorn, *Cascade*, 14″ × 18″ (35.6 × 45.7 cm).

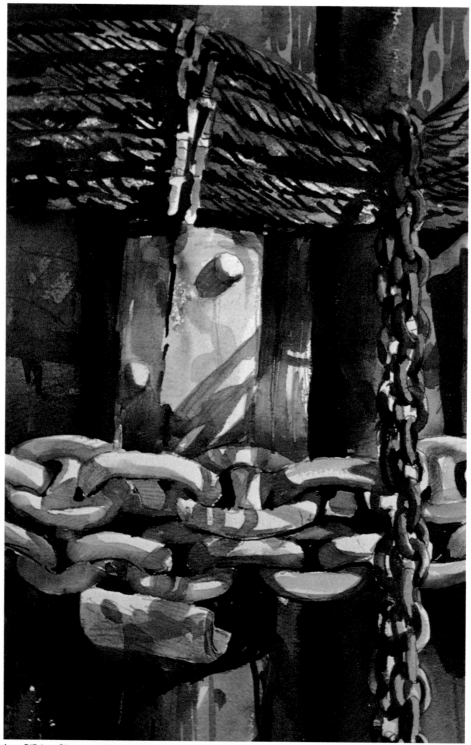

Amy O'Brien, *Chains and Tethers*, 16″ × 10½″ (40.6 × 26.8 cm).

Amy O'Brien

Choosing as subject matter the intimacy of a closeup instead of a more panoramic view can easily lead to overattention to trivia and superficial interests. What Amy has done, however, is to give her subject vigor and substance through designed lights and darks and adventurously interpreted color. Plus, she makes her statement with a breadth of brushwork that defeats any possibility of tedious or picky handling.

David Becker, *Party Time*, 12″ × 18″ (30.5 × 45.7 cm).

David Becker

Aside from the clearly evidenced craftsmanship, the presence of humor raises this painting to a level of humanness not often found in art. David has skillfully expressed content while bringing smiles. Marvelous!

Betty Zahn, *At the Shore*, 14″ × 21″ (35.6 × 53.3 cm).

Betty Zahn

The lyrical use of line to punctuate the shoreline contours and movements is quite effective in this painting. A more predictable way of interpreting this subject would be through vigorously presented masses and textures. Betty has chosen to explore a less expected direction, while observing basics in matters of design and organization of shapes. I like that.

123

James Ostlund

I know of no subject matter that tests the abilities of the painter more than the human form. Look at the personality and unspoken word that Jim has caught here! It's impossible to see this painting without trying to fathom what the "Old Man's" thoughts are.

Rick Nichols

How many times have you seen architectural subjects that became rigid, as if they were simply drawings filled in with color? Rick has animated these forms into something more than a report of man-made structures. He has given them mood, character, and personality.

James Ostlund, *The Old Man*, 10″ × 12½″ (25.4 × 31.7 cm).

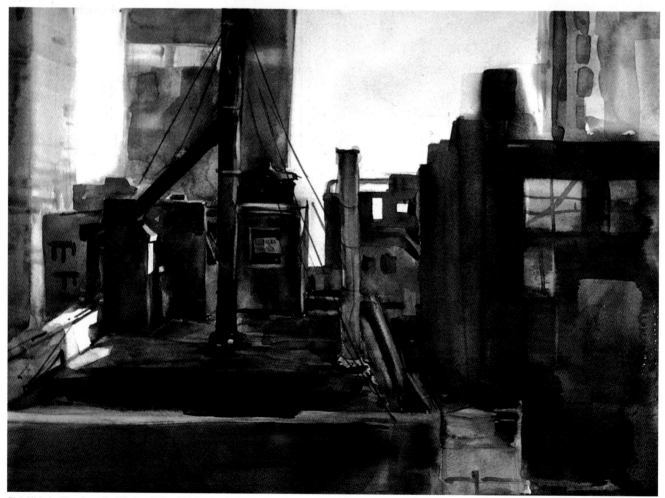

Rick Nichols, *View from the Window*, 14″ × 20″ (35.6 × 50.8 cm).

L. Keith Raub, *The Garden*, 14″ × 20″ (35.6 × 50.8 cm).

L. Keith Raub
Keith's painting is a beautiful combination of strength (indicated by assertive value contrasts), impressive drawing skill, and a harmonious orchestration of color. With all this, he has managed to convey a fragile delicacy that can often—through lack of skill—become weakness.

Heather Bartmann, *Hard Times*, 19¾″ × 26½″ (50.1 × 67.3 cm). Collection of Mr. and Mrs. Daryl Mercer.

Heather Bartmann
Heather, in my opinion and that of wildlife experts, is one of this country's outstanding painters of wildlife subjects. By choosing to live in a remote and untouched part of Colorado, she has immersed herself in the world that she paints. She combines her outstanding craft with a love of her subject matter. The result is an awesome medley of her talents, instrumented with a profound awareness of nature's truth.

David Acuff

When a view from one of Chicago's expressways caught David's eye, he selected from the maze and clutter of what he saw those shapes that stirred his thoughts. The drama of the contrast between the forms of the past and the symbols of the present is underscored by the energetic, directly stated brushwork and the bold use of white paper.

David Acuff, *Then and Now*, 29″ × 21″ (73.7 × 53.3 cm).

Frank Lalumia

Frank's painting of this Mayan fresco does more than transport us to another time; we sense the secrets and mysteries of ancient Mexico before us, waiting to be deciphered. How striking this painting is as an example of craft coupled with searching insight.

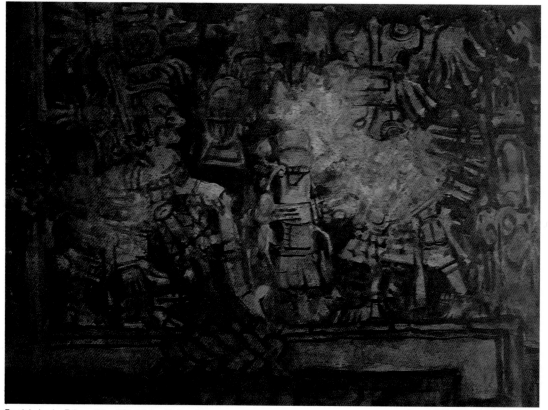

Frank Lalumia, *Tulum*, 22″ × 30″ (55.9 × 76.2 cm).

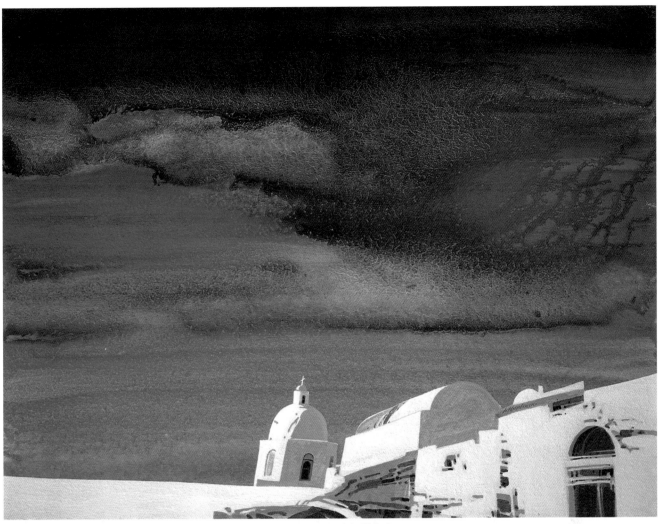

Buffalo Kaplinski, *Aegean Purity*, 18″ × 24″ (45.7 × 61 cm). Collection of Mr. and Mrs. John Kinkade.

Armando Vilches, *Shapes and Forms*, 14″ × 21″ (35.6 × 53.3 cm).

Buffalo Kaplinski

Buffalo's painting is an insightful portrayal of the virginal, sun-bleached whites and pristine geometry of classical Greek structure, contrasted with a free-flowing, animated sky. It's an example of beautiful simplicity, with an almost sensuous presentation of fluid, as well as graphic, design.

Armando Vilches

Too often when a landscape is used as the basis for a more abstract statement, it becomes an unstudied mélange of parts. What Armando has done, however, is to observe some of the order and symmetry of nature, capturing these flavors, while sensitively constructing his design in a manner that exudes dash and vigor.

Appendices

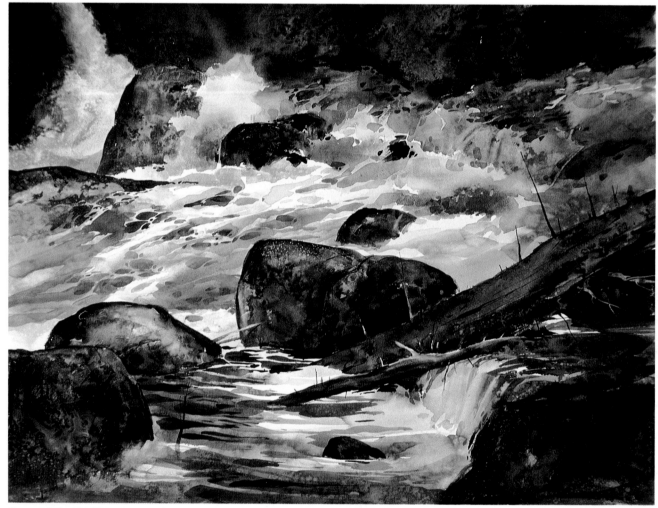

Currents, 22″ × 30″ (55.9 × 91.4 cm), Crescent cold-pressed watercolor board. Private collection.

A Student-Teacher Dialogue

Over the many years that I've taught watercolor, some of the most meaningful times have come when students opened their minds during our "gab fests." These moments of discussion added dimension to our painting excursions. As I prepared this book, I asked my students to present me with questions that they wanted to have answered between these covers. I think they came up with some gems.

FACING THE CHALLENGE OF PAINTING

As a watercolor teacher, is there any single obstacle that seems especially important for the student to overcome?

If there is one obstacle that will discourage a spirited, vigorous, thoughtfully developed painting, it is the fear of failure. All of us experience unsuccessful efforts from time to time. So what's to be done? We can find a corner, crawl into it, and allow ourselves to be paralyzed by imagined threats of incompetence. Or we can accept our human frailties, analyze our flop, and go on to the next painting. One alternative bows to defeat. The other sets the stage for bigger and better things.

What can I do about the slumps I experience pretty regularly? I sometimes feel that I'm going backward.

If we were to graph our development as painters, we'd find that there are periods of advance, plateaus, and periods that seem regressive. In time, with any kind of luck (and doggedness), the periods when we "go backward" will become shorter and occur with less frequency. It might very well be, though, that you're not really regressing, but that your standards and expectations are becoming higher. You are becoming, simply enough, more difficult to please. Is that bad? I don't think so. It's disquieting, frustrating, even angering, but these, too, can be constructive energies.

Any possibility of a watercolor hotline for those times when I'm distressed or verging on panic?

What a great idea—in principle. I'm not sure of the practicality, though. Rather than becoming overly introspective and possibly letting upsetting moments fester, try to share your painting thoughts with others. Ventilating your ideas with those who are attuned to painting can clear the air beautifully. This might very well be the element that has encouraged so many community painting groups, art leagues, and workshops. They're great ways to bring concerns and ideas to the surface. It has to be kept in mind, though, that there can be no placebo for your discomforts, and heaven forbid that the painter could ever be easily desensitized. The answer lies not in finding ways to do away with gnawing discontent or even distress, but rather in channeling these energies toward continued effort. I don't worry too much about students who gnash their teeth. I do worry about those who never seem to be ruffled. If they're content with where they are, they'll go no further.

Will I ever get over my fear of the blank sheet of paper? It seems so intimidating. I feel as though I'm accepting a dare each time I begin a painting.

I've always felt that painters are in trouble if they *don't* experience the anguish of self-questioning and the disconcerting possibility of falling short of the hoped-for painting results. But unless you permit "fear" and "intimidation" to defeat you, you are simply experiencing the emotions that serve as fuel for future efforts. On the other hand, I would be concerned if you were to simply go through the motions of painting—becoming an automaton, a spiritless brush-wielder, remaining unthreatened. With no adrenalin, there is no kindling spark; the spirit is gone.

Take the dare! Although you won't win every time, those times when you do gain a few points are absolute magic! I can assure that when starting a painting, every painter I know—including myself—has a bead of sweat on the brow, actually or figuratively.

I find that listening to music seems to help my state of mind when I'm painting. Any comments?

Same here. We can find ourselves in trouble, though, listening to the *William Tell Overture*.

As a beginner, it seems that my paintings are dull-looking, with no sparkle. What might be the problem?

Once again, let's examine the words and their implications. What lies behind what we call *dull*? Could it be that a lack of vitality and directness in the painter's attitudes has reduced the clarity and vigor of the painting? It could well be. Has timidity led to restrained value contrasts and cautious brushwork, negating any sparkle and dash? Probably. Freshness can't result when you smother your spirited, animated responses. I know that when you are reaching to grasp the basics of the medium, such concepts as boldness, directness, uncluttered brushwork, and strength of value relationships seem impossible to absorb. But these, too, are objectives you should aim for.

DECIDING WHAT TO PAINT

When looking for subjects, what do you look for? Good composition? Striking value arrangements?

It's almost a waste of time to look for well-composed arrangements "in the flesh." When I'm scouting for painting material, I'm struck by textures, atmospheric qualities, dynamic shapes, subtle contours, or whatever else triggers a reaction that shouts "Paint it!" The working out of composition, light patterns, and so forth, takes place in the studio, especially as I explore the possibilities through rough value sketches. I often caution my students not to look for perfect subjects when surveying the landscape. It's easy to discount the possibilities of one spot because you feel that "better" subjects lie ahead. If you keep doing this, though, you can spend the whole day looking for better subjects without finding them. Try to see painting possibilities everywhere, and when you respond to something, stop right there, sketch, and take photographs. Leave whatever lies beyond for another time.

Why do you suggest that students paint such subjects as barns and other countryside structures?

First, I have to say that I have no love affair with barns, old sheds, or other similar structures. Often, though, they offer a patina, a time-worn character, as well as an intriguing geometry, that I find extremely paintable. Also, and of more fundamental importance, countryside buildings, in their structured architectural form, serve as foils for the horizontals and diagonals of the ground plane and more informal natural shapes. Just consider the range of landscape characteristics in the play of light on faceted constructions rising from undulating horizontal planes.

What kind of easel do you recommend for painting on location?

My favorite is a metal Italian easel that has telescoping legs to adjust the easel's height. The upper parts of the easel that hold the paper can be adjusted for angle, and they are tension-controlled by thumbscrews. An excellent item.

You've often said that the painter should "know the subject" before attempting to paint it. What does that really mean?

Let's accept the reasonable premise that our more successful paintings will be those in which we've conveyed an intimate awareness of our subject, in which we've responded sensitively to what we've chosen to paint. It then follows that unless we give ourselves the chance to acquaint ourselves thoroughly with the nature and character of the subject, the resulting painting is likely to be superficial. Of course, I'm assuming that the painter is aiming for more than reportorial images.

What is your opinion on copying other artists' works?

It's traditional in some art schools to have students copy museum works. The matter that's of critical importance here is one of motive. To copy a painting, to mirror the original technical facility, is a shallow experience that provides no benefit. However, to go beyond the "flesh" of the painting, to try to plug into the thoughts of the original artist, can provide exciting revelations. If you copy, try to duplicate not *what* was painted, but *why* it was painted.

Do you think it's helpful to do a painting more than once?

Not if your intention is to duplicate what you've already painted; such replication tends to dull the spirit of your work. If, however, you're reinterpreting a subject for compositional interest, atmospheric variance, rethought color patterns, or something of that nature, it can be invigorating. Each of your works, however, should be a new and different experience. I'm reminded of Claude Monet, who designed and constructed a garden at his home near Paris. Virtually all the paintings he created during the later years of his life were inspired by this garden.

What's your feeling regarding use of an opaque projector?

I wouldn't be comfortable using an opaque projector because I feel that the spontaneity of drawing may well be reduced. Also, and more basically, the sensitive refinement of drawing skill is likely to be dulled by the use of such equipment. Once again, the acid test is the quality of the end result. There are painters who use opaque projectors to create fine, painterly works. For myself and my students, no.

HANDLING VALUE RELATIONSHIPS

Why is making a value sketch so important? Can't I just envision the values without actually putting them on paper before I paint?

Certainly, you can visualize the value pattern in your mind's eye. Indeed, you *need* mental images to inspire the painting's development. But a sensitive realization of the painting's directions requires that you be quite graphic. By actually creating preliminary value studies, which are usually abstract statements of pattern and design, you're better able to attune your thoughts to the painting that follows.

When should I paint my darks? I've heard that a watercolor should be painted from light to dark.

I've never understood the line of reasoning in the statement that watercolors should be painted from light to dark. It's more a matter of planning, of knowing where you want your darks to be. True, if you put your darks down and then expect to lighten them by painting over them with lights, you'll be disappointed and you'll lose transparency. But the dictum that darks are never to be introduced during the early phases of a painting's development is, I think, a dangerous one. In fact, I like to introduce a rich, contrasting dark as soon as possible to establish a range of value. It's like the old "plunge into the pool" theory rather than the timid "toe-dipping" test. I've seen so many students begin their light passages with honorable intentions of introducing darks—later. Along the way they meander, putting off vigorous darks, so that, finally, when they arrive at the darks, everything else has been overworked. Frequently, the darks never *do* materialize. Yes, it may require courage to be bold and immediate with value, but I can't recall ever seeing a fine painting by a timid painter.

What is the difference between a high-key and a low-key painting?

A high-key painting is one in which lights dominate; conversely, a low-key painting is one in which darks dominate. One might also say that a high-key painting does not include darks at all, but instead is limited to the light end of the value scale—with a low-key painting being the reverse. Visualize a value scale numbered from 1 to 10, with 1 standing for white (the surface of the paper) and 10 for black. A high-key painting, then, might be one in which there is a range of values from 1 to 3. In this example, a number 5 or 6 value might be introduced as a relatively forceful statement of dark. In turn, in a low-key painting where number 8 or 9 values dominated, a number 4 or 5 value would be a relatively sparkling light. For a really dynamic dash of contrasting power, an accent of 8 or 9 in a high-key painting, or a highlight of 2 or 3 in a low-key painting can be dazzling.

Can you explain how to make dark areas, such as open doors, more interesting?

If you dismiss darks, whether in recessed interior areas or otherwise, as being automatically devoid of color, they're very apt to become negative, uninspired parts of your composition. Ask yourself what you want the darks to contribute to your composition. Is, for instance, the dark a feature of a receding plane? Is it near the edge of your composition? Do you want the dark to be a minor interest in order to reinforce the dynamics of other elements? In such cases, choose a color that is more neutral and even, perhaps, closer in value to neighboring areas. However, if you want the dark area to be energetic, forcefully projected, or emphatic in the design, then create it with a more adventurous statement of color. One danger that you need to watch out for, of course, is that in creating such colorful darks, you may prevent these statements from taking their proper place in space. However, even a colorful dark can recede if the neighboring color is lighter, if the edges of the dark area are at least in some part diffused, and if there is a lack of description within the dark compared with a greater study within the interests in the projecting areas.

Is it OK to use liquid friskets for masking my lights?

I'm not a purist in the sense of thinking that there are certain unforgivable sins in the creation of paintings. Nevertheless, I find that liquid friskets are too often used to the disadvantage of the painting. For one thing, the white that appears when the frisket is removed can be unexpectedly bright and brittle-edged. In fact, it can upset the harmony of the overall value relationships. True, such whites can be tinted, but the shapes created by liquid friskets are often so harshly defined that they become detached elements, even when tinted. Obviously, liquid friskets have important uses, and I do use them in some of my work. But you must be aware of the effect you'll get when the frisket is removed and plan your painting accordingly.

A few pointers: Remember to apply the liquid frisket with a more delicate line or weight than the one you eventually want because when you later remove the frisket, the line will appear heavier. Compensate for such illusions. Also, if you use an electric hair dryer to quicken the drying time, never put it on a hot setting if you're going to direct it toward an area that's been masked. If you do, you'll find that the heat will bond the frisket to the paper surface and it won't lift up. Ask me how I found *this* out!

As I indicated in one of my demonstrations, it's a good idea to test the liquid frisket on a scrap of your paper before applying it to the painting area. Some fine papers are too soft for the frisket—you may find that later, when you try to remove the frisket, you'll shred the paper, picking up bits with the frisket.

EXPLORING COLOR

How should I choose my palette of colors?

A palette is a personal matter. However, I would advise you to limit your palette to no more than fifteen or sixteen colors. More colors than that are superfluous. On the other hand, fewer than eight or ten colors tends to restrain the adventurous use of color.

Avoid using black as a dark in your palette unless you are using a limited palette as an exercise. On the other hand, black can be exciting in a mixture with other colors. Combining ivory black and olive green, or ivory black and burnt sienna, or ivory black and Thalo blue, can offer magnificent adventures in limited color. In paintings that are not limited-palette studies, the use of black as a dark value tends to subvert the dynamic color that might otherwise be read into your composition. It's simply too tempting to reach for black when you want potent darks—closing the door on a more positive and energetic attitude toward color. Instead, try testing Thalo blue and burnt sienna as a blacklike dark, or Thalo green and alizarin crimson. These can be stimulating, *live* darks—not dead, neutralized voids.

How do you find out how permanent a color is?

Manufacturers of artists' colors identify their colors by their degree of permanence. Check the paint tube or chart of colors from the manufacturer. However, unless you use a poor grade of color, almost all colors have acceptable levels of permanence.

I tend to automatically associate certain subjects with certain colors. I know instinctively that this is wrong, but can you tell me why?

It's a human trait to want to find neat solutions to problems, to want a formula that will "guarantee" success. But what usually happens in art is that if such a formula is applied, achievement is diminished. It's simple enough to say, "The sky is blue." But, as painters, do we just want to mimic clichés? Furthermore, not all terms mean the same thing to all painters. What does *blue sky* mean? Does it mean warm blue, cool blue, grayed blue, light blue, dark blue? Can it mean all of these? Of course!

It's exciting, I think, to explore statements of color that are not predictable, that do not fit preconceived molds. To experiment with less orthodox interpretations of color, try selecting colors for your palette that defy the "normal" choice. For example, paint a landscape with full foliage using a palette of burnt sienna, raw sienna, and Payne's gray. Or paint a composition that includes a massive sky plane without any blue in your palette. Create the unexpected—not for the sake of being different, for this is apt to appear forced and contrived, but rather to stimulate the discovery of varied painting approaches.

My darks seem muddy. Can you tell me what the problem might be?

Let's analyze the word *muddy*. I've found that students often confuse grayed or muted color with muddiness.

Muddiness is usually the result of *how* color is stated in the physical process of painting, rather than descriptive of the particular hue or value. Indecisive brushwork, rehashed passages without purpose, aimless handling, hesitant or picky statements—*these* are apt to convey muddiness. It's the result, really, of muddy *thinking!* There is, however, a special problem with darks: they can become less lucid and fresh if they result from an excessive buildup of color. Piling up relatively undiluted color will just about wreck any feeling of freshness in your darks. As a rule of thumb, consider that the darker you want your value to be, the more directly you should arrive at it. Overhandled surfaces can be a problem regardless of the value, but the problem is greatly magnified when the value is a dark one.

What's your opinion on scrubbing color out of a painting?

My response depends on *why* and *how* the color is being scrubbed. If scrubbing color is used to correct flaws in the painting, then I think it can be detrimental. What the painter is, in effect, saying is, "If I goof, I can scrub." Scrubbing then becomes a crutch, an easy "out." Don't plan to make mistakes. Plan *not* to. We all have our share of flops. Let them be and go on to the next effort, approaching each painting with no thought of having to "scrub to save."

On the other hand, I know of spectacular paintings by super talents in which lifting and scrubbing have been just the right notes of techniques. There it is—a matter of thoughtful, sensitive, *intended* technique. More power to anyone who arrives at painting quality by way of thought, design, and purpose—whatever the technique. I'm reminded here of a session with my students some months ago, in which I mentioned that patterning a painting might be related to the traditional blocking-in of a figure in a figure study. The analogy I drew was that just as the figure painter doesn't introduce facial features until the head has been blocked in, so the landscape painter should not express refinements until the large masses have been given their basic relationships. Immediately following this discussion, I showed my students a videotape on one of this country's finest portrait paiters. Sure enough, in her demonstration of portrait painting, this artist started at the top of the head and worked her way down—without ever blocking in the masses. To borrow a parable: "How did Rembrandt paint? Any way he wanted to." That's life.

A final thought on scrubbing. Some papers can be scrubbed free of almost all color, leaving a surface on which to create another painting. Other surfaces can't be scrubbed without being destroyed. Also, some colors are so penetrating and staining that they can't be completely removed. You might try applying acrylic gesso to the surface and, when dry, developing your painting. This surface can be a real eye-opener. Practice. A gessoed surface is a lot different from traditional surfaces, and loads of fun.

THINKING ABOUT COMPOSITION

I know that the masses and planes should be well planned before actually painting, but should the details also be planned?

Here we might get into issues of personal preference and style. For myself, I feel that if my overall pattern and my arrangement of masses are thoughtfully developed, detail can be stated as I feel it might be useful. However, if I intend a highly descriptive statement in which detail is given a vital visual importance, then its personality and character must be thoroughly planned as well. Not only for the degree of explicitness, but also for the degree of understatement and suggestion. Just as preliminary value studies are, I feel, essential to plant the broad design qualities and the personality of composition, so should detail studies precede a painting in which a great deal of description is planned. In any case, and for whatever purpose, preliminary studies enable the painter to become sensitized—tuned in, if you will—to the spirit and pulse of the painting.

I tend to overdo details. How can I learn to simplify my work so that the painting doesn't look so labored?

Students often tend to "overdescribe" their details. I must say here that there is no virtue in simplification for simplicity's sake. But if detail is developed at the expense of broad, boldly stated masses, then you are using detail as a security blanket. If you've created a painting that is overstudied with detail, and if as a result you failed to establish or have smothered the larger patterns, then do the painting again. This time, tell yourself that you're not going to create a painting; instead, you'll make a sketch. This will free up your attitudes, since the very word *sketch* carries the implication that it's not going to be the masterpiece of the month, a candidate for framing, or, for that matter, a test of your painting prowess. Such attitudes tend to intimidate boldness and, instead, encourage a "crocheted" painting. Also, redoing your painting as a sketch should take half the time that the painting took, so there simply won't be time for noodling out the fussy work. You might try to redo it with the hand you're *not* accustomed to painting with. Right-handed painters painting with their left hand can manage a sketch in which masses are stated, but they will usually have a pretty difficult time creating refinements. Another idea is to take off your glasses, if you wear any. What you can't see, you can't paint! In all, these exercises will show you that a study *can* be done with a minimum of detail. More important, though, is your realization that, if pushed, you *can* think and paint large.

How do you feel about letting the pencil drawing show as part of your finished painting?

I have no objection to having the underlying pencil drawing show. My feeling is that if the pencil work is distracting, either the pencil marks are too strongly stated or the painting is not forceful enough to make the pencil appear inconsequential, if it is noticed at all. If the white of the paper is intended to be of dazzling importance as a high or crisp value note, then there is good reason to erase any pencil marks that might be visible within these parts.

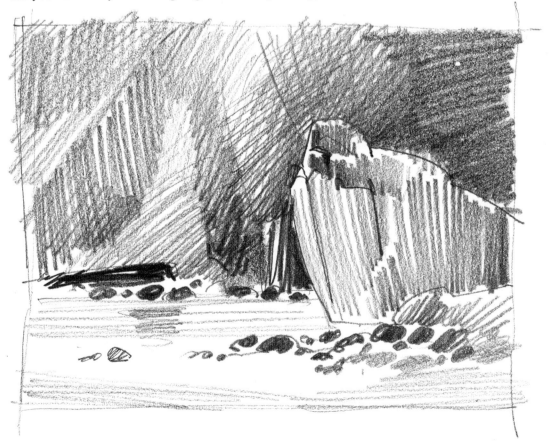

SHOWING YOUR WORK

At what point should you show your work publicly?

I see nothing wrong in displaying your work as good opportunities arise. Banks, shopping malls, outdoor art fairs, corporate offices—these and other exhibition opportunities have represented the first public displays for many noted painters. I would aim for participation in juried shows, as opposed to nonjuried exhibits, or for invitational shows where you're asked to be part of a limited selection of painters. You might, however, start out by entering a nonjuried show, trying to be selective enough to avoid those that seem to have little, if any, overall integrity or quality. Although invitational shows are usually higher in general quality, there are nonjuried shows—especially some that are community-sponsored—that are above average. After exhibiting in these, you may well receive invitations to show in others. Every invitational show that I know of has scouts looking at other shows and noting those exhibitors they feel should be invited to be displayed in their exhibit.

What is of greatest importance is that you take the position that you will exhibit what, in your judgment, is the best work you're capable of doing at the moment, hoping that it will be favorably accepted by others. Don't paint for what you think are the tastes of the visiting public or for the jurors. That may well backfire, reflecting only your own lack of confidence. And it can narrow your ambitions. Worst, you may begin to denigrate and resent your own work.

Is it necessary to enter competitions?

It isn't necessary, of course. However, let's examine some of the implications of entering competitions. True, it can be depressing—even shattering—to be rejected, and I don't know anyone who hasn't suffered from a bruised ego at being rebuffed. But I think the *reason* for entering competitions is the critical matter. If you want to remain insulated and undisturbed, then you won't submit your work to a jury. However, you also won't be goaded into the increased effort that is itself an educational and maturing process.

Of course, the only way to avoid rejection is to not compete. To try to avoid rejection at all costs is, I feel, only a few steps removed psychologically from sucking your thumb. By the way, it's a tremendous help to have a good sense of humor. Obviously, no one's *pleased* by rejection, but the discomfort can be dulled by tossing it off with a symbolic (or actual) shrug of the shoulders. On to bigger and better things! Or, if it makes you feel better, you can grouse a bit over the inadequacies of the jurors and their incredible lack of astute judgment. To dwell on such matters, though, is a waste of valuable energies that should, instead, be put toward more painting. Conversely, when there is a roster of shows to which you've been accepted (thanks to the brilliant observations of *these* jurors), such credits can look pretty good on your résumé. If you can point to an award here and there, so much the better.

What do you look for when you judge a show?

That's difficult to answer. I try to base my judgments on a combination of painting knowledge, a refined eye for aesthetic merit, and a measure of humility that tries to remove unreasonable prejudices. Though I admit to some subjectivity, I try to cultivate a positive attitude that embraces a broad range of interpretations and painterly statements.

If you are arranging an exhibit, there are several ways you can try to get objective judges. One way is to choose a judge from another area of the country. Or you can use three or four judges instead of just one, though you'll need an odd number in case of a tie. You can also let one judge select the exhibit and another (or a jury) select the award winners.

In the best situation, entries are judged on the basis of original paintings. That, however, may be impractical (especially if the entries come from widely distant parts of the nation), so slides may be used. Be sure your slides present an accurate portrayal of your work. If you're not a good photographer, have someone else do it.

Now let's get back to the original question—what do I look for when I judge? Probably of uppermost importance is honesty. If I detect that the painter is slanting his or her effort in an attempt to appeal to my "taste," there are serious strikes against that piece of work right off the bat. I don't know whether to be upset with or sorry for those who feel such insecurity that they think they should paint for the judge.

Another popular practice among some who want to "try the art game, y'know" is to be as outrageous as they can be in theme, materials, style, and presentation, adopting the morals of the well-known "philosopher" who said that "art is anything that you can get away with."

What I look for is insightful, sensitive painting that shows craft, skill, and conscience. The painting need not be a ponderous, humorless, wrung-from-the-guts statement. However, I like to be able to sense the painter's involvement, something beyond a transient and superficial commitment.

In the end, whatever my personal leanings, if a painting's good, it's good. I would have my own paintings judged by the same criteria.

EXPANDING YOUR GOALS

In a serious effort to fulfill myself as a painter, should I stop doing commercial art?

There is, for some, a stigma attached to the term *commercial art*. I must say that I'm grateful for the discipline and professional attitudes that resulted from my earlier career in commercial art. It might surprise you to know how many artists who are now in fine art either were or still *are* involved in some area of commercial art. I can't help but feel that some painters see fine art as an arena in which discipline and principles are done away with, as if fine artists were encouraged to be outrageous. How misguided! By all means, remove yourself from commercial art if you want to focus exclusively on the structure and substance of fine art. But don't dismiss the fact that commercial art and the broad experiences offered there can be effectively woven into your identity as a fine artist. Over recent decades, the line between commercial art and fine art has become delicately thin, almost to the point of being inconsequential. Recognition of an artist's value and contribution to the art world is no longer so easily tainted by superficial labeling.

Who should you paint for—others or yourself?

To thine own self be true. Trite, but I can't think of a more appropriate response. Aim for the fulfillment of your own standards and expectations. Of course, we all want others to like what we create, but you will have a greater respect for your efforts if you keep your integrity intact.

Should a person change his or her style intentionally or should it just happen without any conscious effort?

If there is an insightful approach to painting—that is, if you don't paint "from the hip"—you need curiosity, an unending search for more . . . or better . . . or for what will always seem elusive. This ongoing search and gnawing dissatisfaction, the disquieting feeling that there is *something* yet to be discovered, will not only allow you to change and grow, but it will make such growth unavoidable. One of the most frightening nightmares that any artist can have is the prospect of stagnating. You must simply not allow it! As for consciously cultivating changes in your painting style, beware of making your efforts contrived and superficial. Explore, of course, but don't make a religion of being "different." Strive for distinction, but don't let your values merge with artificiality. These are delicate balances.

What were your goals when you were a student?

Probably the same as most art students: to dazzle the world with an unmatchable talent. God must be thanked for giving us our ability to dream.

What are your present goals?

I've come around to feeling that artists are not special people, walking a different path from the rest of the world. I think, instead, that artists are ordinary people who have been gifted with special talents, people who stroll the same paths, but *see* them differently. In this way we can commune with other human beings, while adding seasonings to our shared world that offer revelations, insights, and poetry to all.

If I can stir positive responses within myself, as well as in others, responses that are more than two-dimensional pleasures, my paintings will have brought me something approaching fulfillment. I don't know of any professional goal that could be more important.

Who or what has helped you the most in reaching your goals as an artist?

Assuming that there is a mysterious genetic trait that might be called talent, I don't believe that's enough. Talent alone is *formless*; you also need perseverance, stamina, curiosity, stubbornness, focused direction, unswerving ambition, assertiveness, a tough hide, and the ability to imagine unlimited possibilities. I know some who deny that talent has any importance at all, but I would argue with them. Talent is a vital ingredient that can't be taught; it is the heartbeat of artistic performance. But the other qualities I mentioned are also essential. And you must add in the energies of thought and discipline. Realizing this has aimed me toward my goals and given me thrust. As for "who" has helped me, I must say that I've always felt that "the man upstairs" has been without equal as my senior partner in a joint venture.

Do you ever stop learning or reaching for ultimate goals?

I hope not! Try never to lose the ability to be stirred by what is around you. I'm not suggesting that you go into orbit over what you find beautiful, but rather that you allow yourself to see the wonder of what some might see as ordinary. It's this quality in children that means so much in their development. If this sounds as though I'm advising that we be childlike, then so be it—at least in the sense that we try not to deaden our responses to what is paintable. Although we will inevitably be attracted more to some subjects than to others, let's admit that *everything* is paintable—if we permit our senses to remain alert. What this means is that if we are sensitive to all that can be painted, if we are eager to extend thought into action, we will never stop learning—nor will we ever be able to fulfill our goals completely. The most exciting moments in painting are those that we'll experience tomorrow. It might be somewhat of a cliché, but my most intriguing painting is my *next* one!

Materials and Preparation

CHOOSING PAPER

Watercolor paper comes in a broad range of weights and textures. What will affect the flavor of your painting is not so much the paper's weight (or thickness) as its texture. A rough surface—the "toothiest" paper—is especially well suited for developing graded washes, uniform values (especially within large areas), and textured brushwork. Although the smoother, hot-pressed papers are less adaptable to these techniques, they will let you use "runs" of liquid color more aggressively and experimentally. In addition, their smooth surface encourages the display of brushwork. For an intermediate texture, try a cold-pressed paper, sometimes called "not" paper (meaning that it's not rough).

As with all materials, each brand of paper offers its own distinguishing characteristics. In fact, there seems to be little standardization in paper textures. For example, a rough paper from one paper mill will be comparable to the cold-pressed surface from another mill. There is a rough handmade paper from Italy that is made in the oldest paper mill in existence—going back to the fifteenth century. This paper is so rough that it makes other rough papers appear to be almost without texture. Yet this same Italian mill produces a mold-made rough paper that is very similar in tooth and texture to other cold-pressed papers. Confusing? Possibly at first, but you'll become familiar with the differences as you use a variety of papers.

Machine-made or Handmade
Papers are described as being either machine-made (mold-made) or handmade. The quality of the paper is not affected by either designation, though many watercolorists prefer handmade paper because it's less uniform in overall texture. The slight variations are attractive to these painters just as handcrafted goods of other sorts are considered "distinctive."

Watercolor Board
One of my favorite painting surfaces is watercolor board, a rag watercolor paper bonded to heavy rag cardboard with noncontaminating adhesive. It's available in rough, cold-pressed, and hot-pressed surfaces. I especially like its absolute stability, since it won't wrinkle when wet. Also, it's unnecessary to stretch the paper; in effect, watercolor board can be thought of as prestretched paper. Perhaps the only drawback is that watercolor board can be painted on only one side, whereas conventional paper can be painted on either side.

Rice Paper
Still another kind of surface that can provide you with fascinating painting experiences is rice paper. It's

really more accurate to describe it as a cereal or grain paper, since rice paper is derived from a wide selection of grains. You can thus choose from a variety of "rice" papers, but keep in mind that almost all are unsized (meaning that brushwork on them will feather) and they are quite fragile (meaning that they cannot be stretched). The shrinking that accompanies paper stretching would make these papers split.

Weight
Watercolor papers are milled in a considerable range of thicknesses, or weights. Personally, I recommend using a weight no lighter than 140-pound paper. If you want a more substantial weight, a 200- or 300-pound paper can be used.

What do these measures mean? Obviously, the single sheet of paper doesn't weight 140 pounds! What we are referring to is the weight of a ream (500 sheets of paper) that measures the standard $22'' \times 30''$ (55.9×76.2 cm). Therefore, if 500 sheets of $22'' \times 30''$ paper weighs, in total, 140 pounds, a single sheet of that paper will be identified as 140-pound paper.

Acidity
Pure rag papers can be depended on to retain their whiteness, but papers with a cellulose content will yellow, sometimes acquiring an ocher cast. The rate of discoloration can be determined by the degree of the paper's acidity. Fortunately, this acidity can be neutralized, so that you can find reliable blends of rag and cellulose—described as pH-neutral—that retain their whiteness.

Moreover, this neutralizing process has been extended to mat boards to make them colorfast, noncontaminating surfaces. If your mat is not 100% rag or neutralized, you must place a piece of rag paper as a barrier between the acid-active mat and the watercolor paper. What is often overlooked is that the *back* of the watercolor paper must also be protected from acid-active surfaces. One of the most frequently used backings for watercolors is corrugated cardboard—which also happens to be extremely acid. Although an acid-free corrugated board has been developed, it is not yet in common use. If a noncontaminating surface is not placed between the back of the watercolor and the corrugated backing, the acid of the backing will gradually penetrate the watercolor paper and affect the front surface, even to the degree that the lines of corrugation will appear as lines on the face of the painting. The weight of the paper you paint on will determine how long it takes for the discoloration to become apparent.

STRETCHING AND PREPARING PAPER

Stretching paper means saturating the paper with water and then securing it to a surface that won't bend or warp. Although 300-pound paper is heavy enough not to require stretching, other lighter-weight papers will wrinkle badly when you paint on them unless you stretch them, or unless you saturate them (making them wet enough to cling to the board) and then paint on them while they're this wet. Painting wet-in-wet in this way, of course, eliminates the possibility of a controlled-edge painting. By the way, I even stretch my 300-pound paper to ensure absolute flatness when I paint, as 300-pound paper can bow with a wet handling—especially if it's a full-size sheet.

Trimming the Edge First
It helps to begin by trimming the deckle edge off the sheet of watercolor paper so the paper will lie flat when it's soaked.

The original edge has a tendency to wrinkle when it becomes saturated. To trim the edge, use either a sharp mat knife or a single-edge razor blade. Never use double-edged razor blades unless the sight of blood pleases you.

Soaking
Soak the paper in a tub of cold or room-temperature water for several minutes. (Don't use hot water, or you'll find yourself with unpalatable gruel on your hands.) Be careful not to crease the paper in any way, since the creases will weaken the paper fibers and the paper may split at the creases as it stretches.

Transferring to the Stretching Surface
Place the limp, saturated sheet of paper on a piece of ½″ or ¾″ (13 or 19 mm) plywood, or on a pine or basswood drawing board. A piece of Masonite can also be used. With the side of your hand (which is almost oil-free), carefully press the paper from its center toward its outer edges. This helps to flatten the paper while at the same time squeezing the excess water from the paper. Blot the excess water that collects at the paper's edges and then secure the paper to the board with brown paper tape, staples, or long-pinned thumbtacks.

If you use Masonite as your stretching surface, you'll have to use tape since staples or tacks won't penetrate the Masonite.

Taping
The tape must be the type that will stick only if moistened. It's commonly called Kraft tape. Test the adhesion with a scrap of the tape first, though, since some tapes will stick only if they're quite wet while others need to be only dampened. Making the latter too wet will simply rinse the glue off the paper tape.

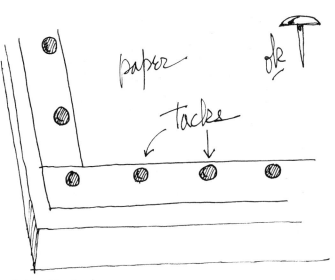

Using Tacks
If you use tacks to reinforce the stretching, use the type with a lightly rounded head and a pin ½″ (13 mm) long. The standard tack has a ¼″ (6 mm) pin. Stay away from tacks with tall glass or plastic heads; they get in the way as you sweep your hand across the paper. A real pain.

STRETCHING AND PREPARING PAPER

Drying

Once the stretching has been completed, allow the paper to dry as it lies flat. As the paper dries, it shrinks and becomes taut, providing the watercolorist with a marvelously flat surface that won't buckle or wrinkle. When the paper is completely dry—and the drying can take anywhere from an hour or so to overnight, depending on the weight of the paper, the degree of saturation, and the humidity conditions—it can then be sketched on with pencil in preparation for painting.

A final point: I have two basswood drawing boards in my studio, and there is always a sheet of watercolor paper stretched and waiting. It's frustrating to plan a painting, build up steam, raring to go—and then have your enthusiasm squelched by discovering that you have to stretch a sheet of paper and wait several hours for it to dry.

Removing the Sizing

To complete the preparation of the watercolor paper or board for painting, it's advisable to remove some of the *sizing* (also called *binder* or *starch*), which is added to the paper as it's being made. Some of this sizing is necessary in order to ensure that edges will be controllable when you paint. Without the sizing, the brushstroke will feather—even if the paper is dry. On the other hand, with too much sizing, the surface will resist the wet brushstroke, much as when you try to paint on a surface that has a waxy or oily content. Under these conditions, you have to keep repeating your brushstroke just to cover the paper with color. Given the importance in our medium of a direct and immediate statement, paper with too much sizing is a definite deterrent to a vigorous painting message.

Some of the sizing will be lifted from the paper when you soak the paper in preparation for stretching. To ensure a properly receptive surface, however, I sponge the paper gently but thoroughly after it has dried from stretching, using a soft sponge that's sopping wet, with the water anywhere from cold to room temperature. Again, *never* use hot water. If the paper is soft or fairly fibrous, making it inadvisable to sponge it, just liberally brush clear, cold water on the paper. In either case, let the paper dry completely before drawing on it with pencil.

Mounting Rice Paper

Rice paper cannot be stretched, but it can be mounted. Mix a thin, but not watery, wheat paste—the same kind that's used to apply wallpaper. Make certain that the paste is free of lumps by mixing it thoroughly, preferably with an electric mixer or blender. Choose an acid-free board for mounting the paper. Foam core is excellent since it is lightweight and offers stability. Gently roll up the sheet of paper, making absolutely

certain that it does not wrinkle or crease as you roll it. Place the rolled-up paper at one end of the board, brush paste on the board, and carefully unroll about 2 or 3 inches (5 or 7 cm) at a time, until the entire sheet of paper is mounted to the board. Now put a heavy, flat surface on the entire piece of paper. A sheet of plate glass is ideal since it lies uniformly flat. Finally, place weights evenly on the glass to equalize the pressure. Books and magazines make fine weights. When the paste has dried—and you should allow several hours for drying—remove the glass and you have a mounted piece of a rather exotic paper waiting for you.

As an additional, though not always necessary, step, you can mount a piece of brown wrapping paper to the back of the board on which the paper has been mounted. This will provide added stability, making it unlikely that the board will curl or warp from the moisture used in either the mounting or the painting process.

Now that the paper has been mounted, you can also, if you wish, size the surface. Use a large, soft brush and apply a generous amount of a thin gelatin solution, using no more than about ¼ ounce of gelatin to a 1 gallon of cold or room-temperature water.

Applying Acrylic Gesso

Before leaving the subject of painting surfaces, I'd like to mention one more. Acrylic gesso, if applied to a surface, can present you with a whole new experience in watercolor. The gesso can be applied in almost any imagined fashion. You can brush it on liberally, with uneven brushstrokes, leaving all sorts of irregular contours on which to paint. Or, for a uniform surface, you can thin the gesso and brush it on evenly. When it's dry, you can sand the surface with a fine sandpaper; then apply another thin coat and again sand it smooth when it's dry.

The possibilities for creating different surfaces with gesso are vast. Try using a pocket comb to striate the gesso before it has dried. Or raggedly notch the edge of a plastic credit card so that "combing" the gessoed surface will provide you with irregular asymmetrical striations. For still another texture, drop a piece of clean window screen onto gesso that's still "tacky" and then lift the screen quickly and carefully. No matter how you apply the gesso, after you paint on it, you can use sharp points and blades to lift out highlights and to create other "reversed" statements—much like the handling of a scratchboard. Have fun!

Storing Paper

If possible, store your papers flat and in large drawers or boxes. This will keep your paper flat and clean, Also avoid excessive handling of your watercolor papers to prevent the oils from your fingers from leaving traces that may later act as resist spots.

SELECTING PIGMENTS

Not long ago, several of my students and I visited the department of one of this country's major art museums where watercolors are stored for preservation. The gentleman in attendance at the moment handled, with proper reverence, matted watercolors by Prendergast, Demuth, Sargent, Homer, Flint, and other masters of our medium. As he showed us these works, he explained that they couldn't possibly be exhibited in the museum's galleries because, as he put it, "Watercolors are fleeting, you know." What he should have added was the fact that today watercolorists can find stable, permanent papers and colors—*if* they look for these qualities in purchasing their materials.

Consider, for example, Prussian blue, a color that was notorious in the past for turning black over time, losing its original hue with sustained exposure to light. Today, as a replacement for Prussian blue, we have phthalocyanine blue (Thalo blue)—the same hue, but offering permanence. Another example of a fleeting color is gamboge—a lustrous, warm but impermanent yellow. In a relatively short time, gamboge becomes less vibrant. To prevent this sort of disappointment, we now have the same hue in a permanent form: new gamboge. Obviously, unreliability is less of a problem today—provided you use products with a generally accepted level of quality.

Assessing Pigment-to-Vehicle Proportion

One of the hallmarks of quality in watercolor pigments is a high proportion of pigment to vehicle (the material that allows color to be suspended in a state of work-ability). Glycerin and gum arabic are commonly used vehicles. If there's too little vehicle, you'll find it difficult to extend the color with water—the color will seem gummy or sticky. On the other hand, with too much vehicle, you'll encounter difficulty in getting a "gutsy" display of color within the painting.

Arranging Your Palette

I always place fresh color in my palette, putting a generous amount on top of any color that remains from an earlier painting session. Nothing is so inhibiting to vital, snappy painting as having to coax color that has hardened into vibrance, wasting precious time as you try to bring the dried, tired palette to life. To take a vigorous approach, you want the colors in your palette to be moist and completely responsive to the most fleeting touch of your brush. That's why I don't recommend cake or pan watercolors. They invite tendencies to tint, discouraging panache and juicy painting.

By the way, your palette of colors can be kept moist for long periods by wrapping the palette with plastic after putting a damp sponge in with the palette. However, it's quite important that you ventilate the palette now and then to prevent mildew from forming on your colors. Another handy tip: Get a small bottle of glycerin from your local drugstore. When you take the cap off a new tube of color, dip the cap in the glycerin so that the inside of the cap is coated. Put the cap back on the tube and wipe the outside dry. The glycerin will act as a lubricant for the lifetime of that tube of color, and the cap will come off easily every time.

This sketch shows the placement of colors in my palette:

1. Winsor blue (or Thalo blue)
2. Cerulean blue
3. Cobalt blue
4. Permanent blue (or French ultramarine blue)
5. Alizarin crimson
6. Cadmium red light
7. Cadmium orange
8. Cobalt violet
9. Winsor green (or Thalo green)
10. Olive green
11. Winsor yellow
12. Burnt umber
13. Burnt sienna
14. Raw umber
15. Raw sienna

One section has been left empty. That's where I'd put one of the colors I use less frequently, such as Payne's gray or Winsor red.

SELECTING AND MAINTAINING BRUSHES

Watercolor brushes come in all sorts of shapes, and you can choose from natural or synthetic bristles, sable or squirrel ones. There's even a watercolor brush that is a combination of natural and artificial fibers, appropriately called a *blend*. Although the selection of brushes depends on personal preference, I strongly urge you to acquire the best possible brushes. In evaluating the quality of a brush, ask yourself:

- Does the brush snap back into its ideal shape when wet and "flicked"? To flick the brush, wet it and, with a quick wrist action, remove the excess water. (Watch out for anyone standing behind you when you flick the brush, lest you shower some innocent observer.)

- Does the brush hold a generous amount of liquid so that you won't have to replenish it with wet color too often? A well-charged brush can cover an astonishing amount of paper.

- With a round brush, is it supple enough to allow a variety of brushstroke gestures?

If you were to visit my studio, you would see a collection of fifty or more brushes. I find it difficult to resist experimenting with all sorts of brushes, but I find myself relying on three or four trusty friends. They are a no. 12 round Kolinsky sable, a no. 5 or 6 round red sable, and a 1″ (25 mm) flat ox-hair brush. Although I do, on occasion, reach for others, such as my Repique, these are the three brushes with which I create almost all of my paintings.

Now, it's only reasonable that good brushes should be given the proper care to ensure a long period of service. Here are some essential steps:

1. When not using your brushes, lay them aside so that the bristle is not resting against anything. Do *not* let your brushes stand in water for extended periods. Not only will the shape of the brush be adversely affected, but constant soaking will loosen the metal ferrule from the wood or plastic handle.

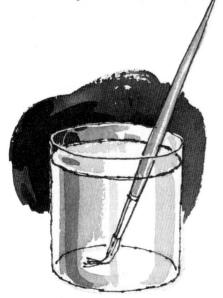

2. After rinsing your brushes, wipe them on a paint rag or damp sponge. If you choose a sponge, make sure it's the kind that absorbs liquid readily. (Incidentally, I find that old-fashioned cloth diapers make perfect paint rags: they're certainly absorbent, and they're a pretty good size. T-shirts are good, too.) Use a wiping action that follows the contour of the bristle.

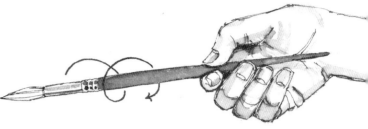

A round brush should be wiped with a spinning action as the brush is dragged off the paint rag or sponge, so that the brush comes away properly pointed.

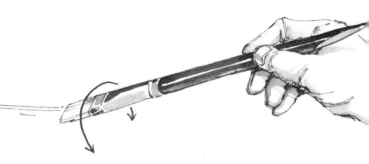

A flat brush should also be wiped to follow its shape. Wipe it flat-side to the rag or sponge, and then flop it over to wipe the other flat side.

3. Do not touch the bristles of your watercolor brushes with your fingers unless absolutely necessary. Frequent handling transfers oils from your skin to the brush; the oils collect at the base of the bristles where they meet the ferrule; and the brush gradually swells, losing its proper shape.

4. To clean your brushes at the end of a painting session, just rinse them thoroughly in cold or room-temperature water. *Never* use hot water! Don't use soap! I feel that, if soap works as a cleanser, it must have an abrasive quality. It seems illogical to subject your brushes to such a potentially damaging material. I've always cleaned my fine brushes by rinsing them in water only, and they've stayed in prime form for many, many years.

5. Moths find some bristles a gourmet's delight. If you don't use your brushes daily—or at least with some frequency—put them in a container with a few moth crystals, making certain that the container is large enough for your brushes to either stand up straight or lie flat without having the bristles rest against anything.

When I travel, I place my brushes in a flat box and put a strip of masking tape across the handles so that they're completely separated from each other. Another handy brush carrier is a rattan placemat with elastic ribbons toward each end. Tuck the brush handles into the elastic at 2- or 3-inch (5 or 7 cm) intervals and roll up the placemat.

6. If your brush does happen to dry misshapen, you can probably reshape it by dipping the bristles into a solution of household starch. With your fingers (one of the few times that you're advised to handle the brush in this way), coax the brush into its proper shape and let it dry. Then, once it's dry, rinse off the starch. You may need to repeat this process a few times.

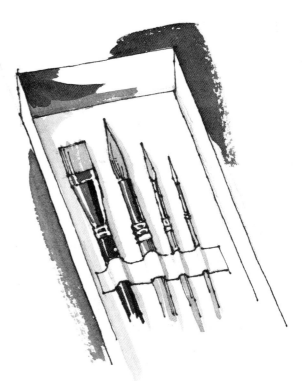

MATTING AND FRAMING YOUR WORK

Classically, watercolors are presented with a mat. Aside from aesthetics (which can be argued), there is a practical need for a mat: it separates the surface of the glass from the surface of the painting. Direct contact may not only disturb the surface of the painting, but condensation can sometimes form under the glass, and this will ruin the watercolor if the glass rests against it. If the watercolor is to be framed without a mat, or if the paper is mounted on a board with the board's outer margins serving as a mat, you can separate the painting surface from the glass by putting a thin bead of wood (usually balsa wood) under the rabbet of the frame. This bead, which is not visible from the front, will provide the necessary separation. Another way to separate the surfaces is to use a metal frame that has one channel for the artwork and another channel for the glass.

I strongly feel that when mats are used, they should be neutral enough in color, value, breadth, and texture not to detract from the painting. The same is true of the frame. Your choices are subjective, of course, but I know of no more necessary a time for considering the virtues of simplicity than in choosing mats and frames. Keep the personality of your painting in mind and evaluate the setting that will best complement it. I've judged exhibits from slides and then been horrified to see the artist undo the effectiveness of a painting by selecting an inappropriate mat or frame.

Personally, I prefer double mats, with the inner mat (called a *fillet*) ⅛" or ¼" (3 or 6 mm) wide and of a contrasting value to the edges of the painting. The outer mat—usually 3" to 4" (7 to 10 cm) wide—should be white, off-white, or a judiciously selected darker value. Be sure the mat does not compete with or impose on your painting. Iridescent or vibrant colors, fancy silks, velvets, exaggerated textures, and dazzling metallic surfaces are out! Incidentally, a double white treatment in your two mats can be a striking foil for a painting. In any event, use *rag* mat boards or separate the mat from the painting with rag barrier paper to ensure noncontamination of your watercolor paper. (Wood pulp yellows with age.)

As I just indicated, keep your frames simple and choose a neutral material that doesn't interfere with your work. Metal frames are convenient, relatively inexpensive, and usually unimposing. In fact, some museums and group exhibits prefer them because of the sense of uniformity they provide within the exhibit area and the absence of busy, overwhelming moldings.

Finally, don't use nonglare glass. It can alter the color and clarity of your painting. Use either regular glass or the plastic glazing that looks like regular glass. If you're disturbed by the prospect of distracting light reflections, place the picture wire just above the midpoint of the frame. This will tip the painting forward from the wall, making for a slight angle that will reduce the amount of reflection. On the other hand, the higher the wire, the flatter the painting will rest against the wall, and the more reflection you'll have. If your budget allows it, you might consider Denglas, a glass that has minimal reflective qualities. It's expensive but effective.

Index

Concept and structure by Bonnie Silverstein
Edited by Sue Heinemann
Designed by Jay Anning
Graphic production by Hector Campbell
Text set in 10-point Century Old Style